Claude Monet

Water Lilies & The Garden of Giverny

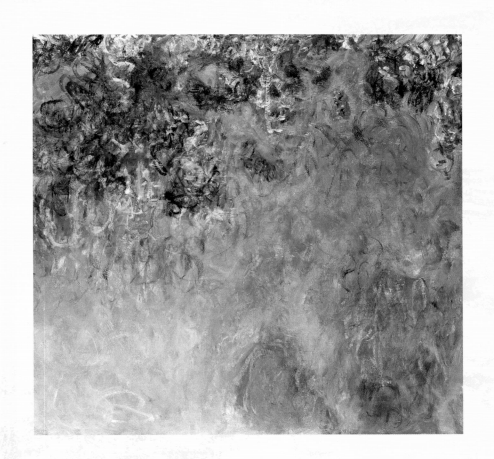

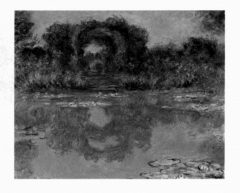

Publisher and Creative Director: Nick Wells
Project Editor: Polly Prior
Picture Research: Gillian Whitaker
Art Director: Mike Spender
Copy Editor: Ramona Lamport
Proofreader: Dawn Laker
Indexer: Eileen Cox

Special thanks to: Laura Bulbeck and Gillian Whitaker

FLAME TREE PUBLISHING
6 Melbray Mews, Fulham,
London, SW6 3NS
United Kingdom

www.flametreepublishing.com

First published 2015

15 17 19 18 16
1 3 5 7 9 10 8 6 4 2

ISBN: 978-1-78361-607-7

Printed in China

Claude Monet

Water Lilies & The Garden of Giverny

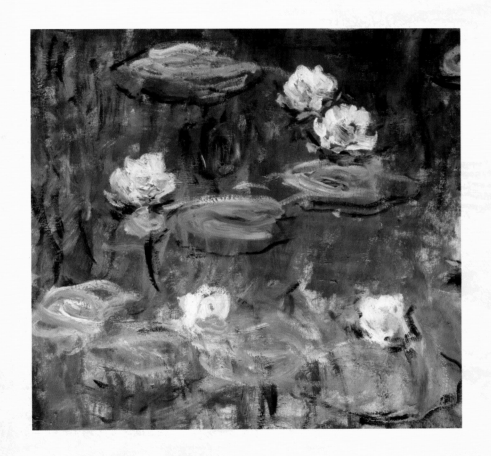

Julian Beecroft

FLAME TREE
PUBLISHING

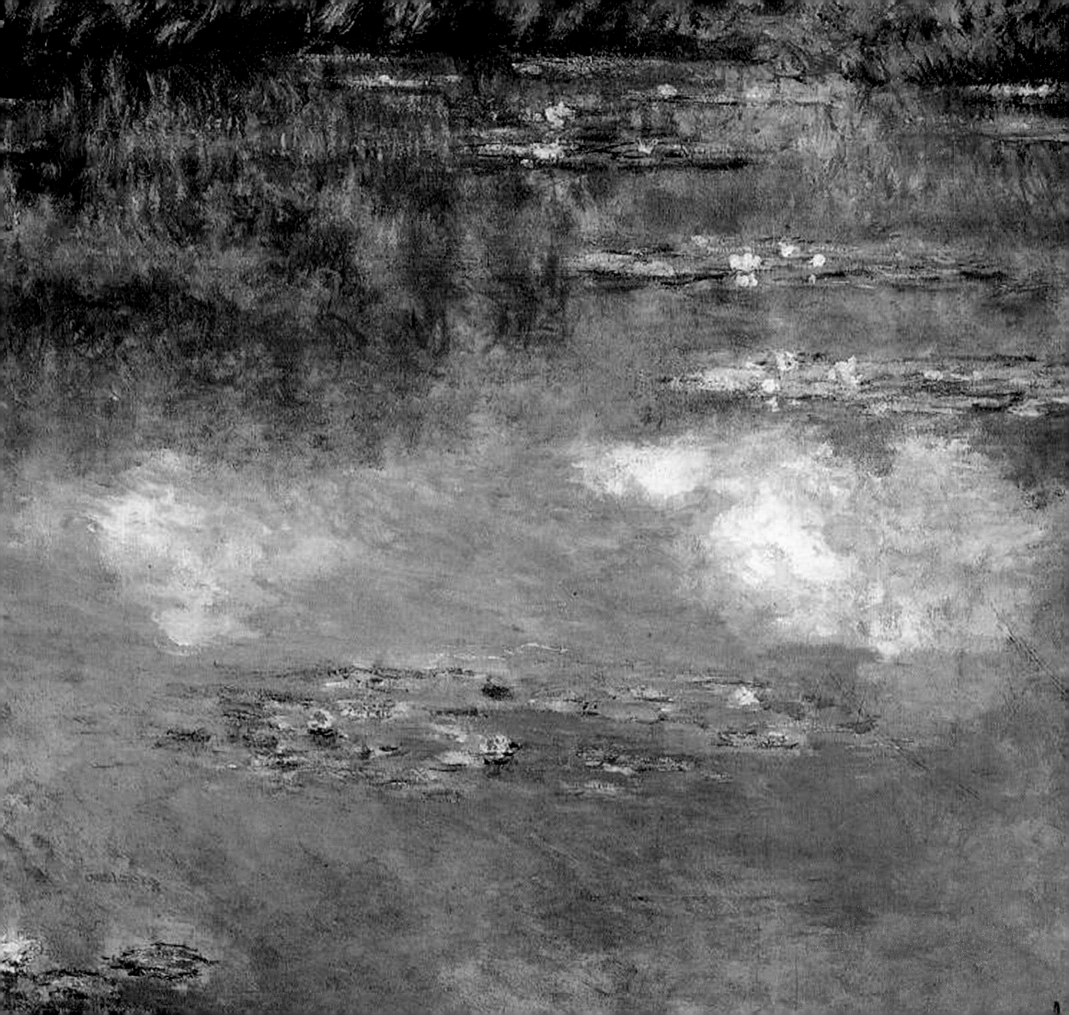

Contents

Water Lilies, the Cloud (1903)

Introduction to Claude Monet
A Painter of Modern Light

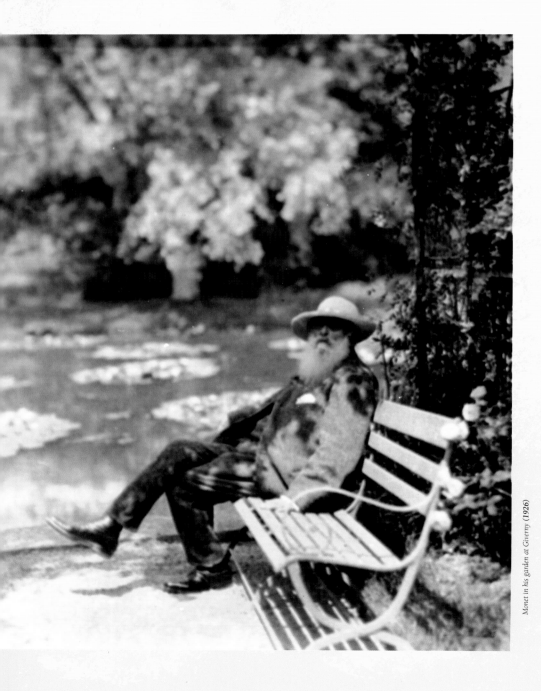

Monet in his garden at Giverny (1926)

THERE IS A PHOTO of the elderly Claude Monet (1840–1926) in the summer of 1926, the last of his life, sitting on a bench in his garden at Giverny some 50 miles north of Paris; behind him is the lily pond whose subtlest features he had studied so patiently and for so long. Wearing a panama hat to protect him from the sun, he turns towards the camera, his face barely emerging from beneath the froth of beard he has worn for decades and the bottle-top glasses through which he stares at the lens. Over the previous year, Monet has come to depend on these spectacles simply to see the world without distortion, following the operation to remove a cataract that he submitted to just a few years earlier.

He knows that his work is almost finished, that – as he has recently told one journalist – his days are numbered. But even now he is still thinking of adjustments he would like to make to the huge suite of murals that stand in the enormous studio beside the house – the revolutionary work we now know as the *Grandes Décorations*, which today stand in their permanent home at the Musée de l'Orangerie in Paris, just as Monet had intended.

The Lure of Landscape

But the ageing painter in the photograph, who had spent so much time in that garden simply looking, was perhaps preoccupied with another kind of study from which the camera seems to have awoken him, a world of reverie from which the paintings he made in the last decade of his life seem to have emerged. It had been, after all, an improbably rich and productive life, driven from the start by restless ambition and a huge natural talent that was first noticed by the marine painter Eugène Boudin (1824–98). The older artist had come across some caricatures by the 17-year-old Monet in the window of a picture framer's shop in Le Havre, the port town at the mouth of the Seine – the river that would run like an artery through Monet's entire life – in which the precocious youth had lived since the age of five. Boudin is now regarded as a forerunner of Impressionism, the mode of artistic perception with which Monet would soon become ineluctably entwined, and the painter would always acknowledge his decisive early influence, writing as late as 1920 that 'I owe everything to Boudin and I attribute my success to him.' It was accompanying Boudin on trips to sites along the coast of Normandy that convinced Monet at a stroke to dedicate himself to painting *en plein air*, capturing landscape subjects, as did Boudin, by painting them and (so the mantra went) finishing them in situ, without the usual recourse to a studio. An adventurous image of spontaneous creation, it was one which until late in his life – and despite its increasing distance from the truth – Monet did little to dispel.

This was partly a generational challenge to the traditional methods of picture-making whose results could be seen at the all-powerful Paris Salon, the annual exhibition that was the principal and almost the only means by which French artists of the mid-nineteenth century could establish their credentials. Monet's early pictures, those from the mid-

1860s which still betrayed the influence of Boudin and the Dutch painter Johan-Barthold Jongkind (1819–91, another *plein air* artist from whom a few years earlier he had learned much), won the approval of the Salon's selection panel; it seemed that a good career was in the offing. But Monet's ambition, like that of other younger artists with a similar modern outlook – such as his friend Édouard Manet (1832–83) – was rooted in a yen not to produce polished, well-made pictures that flattered existing tastes but to render the truth of his experience, whether or not the results were welcome. In 1867, following his earlier success, Monet's huge canvas of

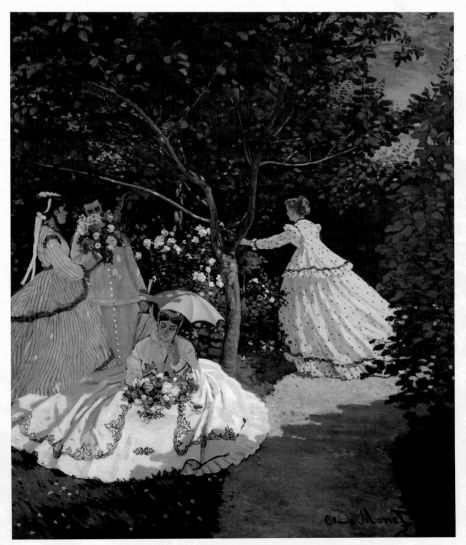

Women in the Garden (1866)

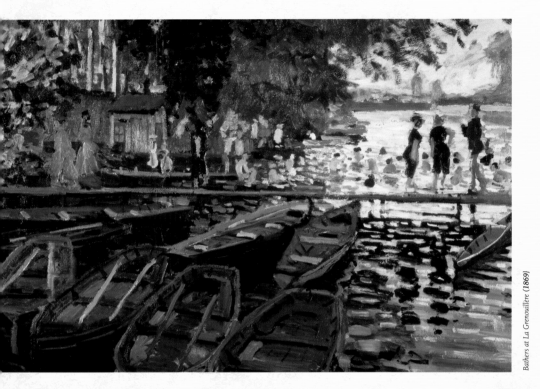

Bathers at La Grenouillère (1869)

the previous year, the enigmatic *Women in the Garden* (1866), was flatly refused by the Salon. It was clear that if he was going to make a name for himself, he would have to do it on his own terms.

A Mosaic of Light

By this time, a loose group was beginning to coalesce around a common commitment to modern subjects depicted in a modern manner, among them the young Pierre-Auguste Renoir (1841–1919), with whom in the summer of 1869 Monet made a trip to the fashionable watering hole of La Grenouillère on the Île de Croissy, an island on the Seine just west of Paris. The two painters worked side by side and clearly with similar aims, as the images from that trip are almost identical in both viewpoint and technique. Monet's studies (for a canvas now lost) of the revellers, the boats moored at the jetty, the trees, the bathers in the Seine and the water itself – but above all the light reflecting the painting's various forms and colours onto the

water – are exemplars of the coming revolution in how we see the world that Monet and his friends would set in motion over the next few years. It is in a painting such as *Bathers at La Grenouillère* (1869) that Monet first seems to grasp the symbiotic relationship of colour and light, such that he portrays the reflections of foliage or boats in the rippling water with strokes of equal weight to those with which he renders the forms – the dark heads and naked bodies – of the distant bathers themselves, the putative subject of the picture. The implication is clear: that human figures are only of passing interest in our total field of attention, mere fragments of the overall mosaic of colour the eye takes in when viewing such a scene. The truth of what we see resides not in what we should see, the painting announces, but is in fact a far more subjective, even renegade act when measured against the supposedly objective values espoused by the Salon.

The painting technique using short strokes and dabs of colour – what we now think of as the classic Impressionist treatment – also pointed to a new way of unifying a picture, whereby colours that feature prominently in one part of an image would be echoed in accents elsewhere, providing an overall sense of colour harmony that accorded with the way the mind resolves a complex set of visual information into a readable scene. But this sense of pictorial colour harmony, so central to Impressionism, was in Monet's case an attitude to the world that informed everything he did, from the insouciant images of La Grenouillère to the care-filled canvases of dreamlike water lilies that increasingly came to preoccupy his last decades.

A Chance Meeting

Idylls such as the paintings of La Grenouillère are precious to us because we know they cannot last for ever, and so it proved. The year after these artistic breakthroughs France was plunged into war with Prussia, and Monet fled with his wife Camille (1847–79) and young son Jean

(1867–1914) to London. There, with the artist Camille Pissarro (1830–1903), another who had made common cause with the new painting, he sat out the struggle. But he must have been fully aware that other friends, such as his first painting buddy and supporter, Jean Frédéric Bazille (1841–70), young Jean's godfather, had volunteered to fight in a conflict in which Bazille, for one, would be killed.

It was in London, while Monet was sitting by the Thames painting the first of his many images of the Palace of Westminster, that Charles-François Daubigny (1817–78) ran into him. A painter of the Barbizon school of landscape artists – controversial in their time but by the 1860s, in the shape of Daubigny and Jean-Baptiste-Camille Corot (1796–1875), members of the Salon's selection committee – Daubigny (and, for that matter, Corot) had resigned in protest when Monet's *Women in the Garden* had been rejected three years earlier. He recognized the boldness of what the new generation was trying to do and resolved to help them if he could. It just so happened that Daubigny's young and energetic dealer, Paul Durand-Ruel (1831–1922), had also taken refuge in London, where very quickly he had managed to open a gallery. Introductions being extended to Monet and Pissarro, the dealer, immediately recognizing the excitement of the new painting, readily agreed to purchase everything they had.

Unfortunately for both artists, in their absence the advancing Prussian army had destroyed many of Monet's paintings and all of Pissarro's – his entire life's work to that point – at the older painter's house near Paris, where the two artists had thought them safe. But in other respects, on returning to the capital the following year, when the conflict had subsided, they plunged once again into work, confident of the financial backing of their enthusiastic dealer. It was at this point, partly because of the destruction wreaked on the city, first by the recent war and then by the strife of the Paris Commune that followed it, that Monet decided to take

up lodgings for his family at Argenteuil to the north-west of Paris. A steadily industrializing suburb on the Seine, when the Monet family moved there the town was still making do with a temporary wooden bridge in place of the one destroyed in the war. Monet painted both the wooden bridge (in 1872) and then, a couple of years later, its cast-iron replacement, by which point his ability to project light across the canvas (both direct and reflected from water) had attained new levels of subtlety.

Domestic Arcadia

In the mid-1870s, Monet was still notionally attracted to identifiably modern subjects, above all to apprehending the world as it appears in a fleeting moment in time, recording 'the ephemeral, the fugitive, the contingent' advocated by Charles Baudelaire (1821–67) in his famous

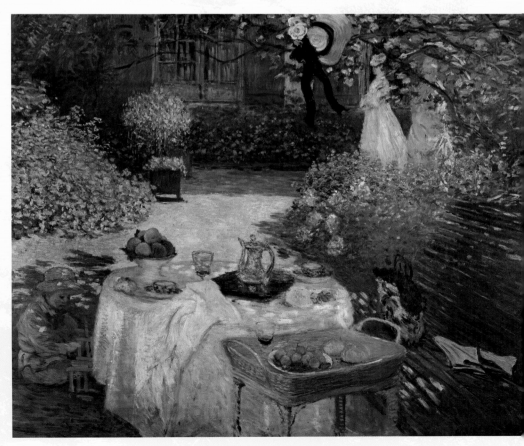

The Luncheon, Monet's Garden at Argenteuil (**1873**)

essay 'The Painter of Modern Life', first published in 1863 and now viewed as an unofficial manifesto of Impressionism. But at the same time, the avant-garde artist was also a devoted family man, and beginning with this period at Argenteuil his interest grew steadily in both gardening and the seemingly timeless Arcadian images, such as *The Artist's Garden in Argenteuil* or *The Luncheon* (both from 1873), that he saw he might extract from such a subject. Key to these paintings is the dominant motif of flowers, beside which the human presence seems almost ornamental – as

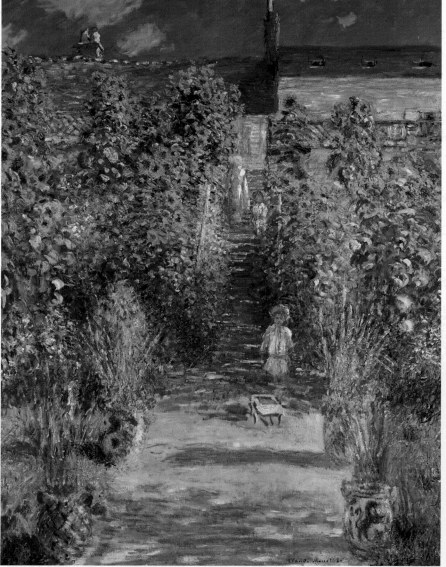

The Artist's Garden at Vétheuil (1880)

if the profusion and beauty of nature is something in which human beings are merely a component element. It was an attitude to the world, first suggested in the images from La Grenouillère, which would increasingly come to shape Monet's entire artistic programme and also his life.

Not that the critics knew what to make of it when in 1874 this radical group of self-proclaimed independents, consistently rebuffed by the Salon for their impudent pictorial experiments, held their first – now infamous – show. The first Impressionist exhibition, so called in retrospect after a critic had tried to turn the name of Monet's pared-down painting *Impression, Sunrise* (1872) into an insult with which to rebuke them, was a collective show of strength that clearly stirred up the Parisian art world. But sales did not ensue, and by the following year Durand-Ruel was running into financial difficulties, having bought too many modern paintings for which there was not yet a market.

A Growing Family

The next decade would be difficult for Monet and his family. It is true that he could count on the support of certain loyal patrons, such as the opera singer Jean-Baptiste Faure (1830–1914) and Monet's friend and fellow artist Gustave Caillebotte (1848–94), the heir to a significant fortune who bought steadily from his Impressionist colleagues during these fallow years. Matters improved further when the businessman Ernest Hoschedé (1837–91) began collecting the new art and inviting the artists to his grand chateau for weekend parties. But then in 1878, Hoschedé himself went bankrupt and, unable to face his responsibilities, fled to Belgium, leaving his wife Alice (1844–1911) and six children at the mercy of his creditors. By this time, the Monets and the Hoschedés (and particularly, it seems, Monet and Alice) had become very close friends, so in spite of his own significant debts and continuing difficulties with selling work, the artist felt it was at least his duty to take in Alice and her offspring under his own roof. As if this wasn't enough to deal

with, in 1876, Camille had begun showing signs of illness, which over the following few years, and especially after the birth of their son Michel in 1878, grew steadily worse. In the same year, they moved further out of Paris to the more rural setting of Vétheuil, also on the Seine, where again Monet made bountiful images of his garden, such as *The Artist's Garden at Vétheuil* (1880). But Camille's health continued to decline and she died in September 1879, leaving eight children to be fed and raised by Monet and Alice Hoschedé. To put it mildly, such a domestic arrangement was unusual for the time.

A Run of Bad Luck

The early 1880s saw no improvement in the artist's fortunes and in 1881, the makeshift family unit moved back towards Paris, to Poissy, where Monet found it impossible to paint in the house they had rented. In the summer of 1882, the Monet-Hoschedé clan decamped to Pourville on the Normandy coast in the hope of better luck, but bad weather prevented him from working. Then, in the winter, the Seine at Poissy flooded the ground floor of the house, forcing Monet and Alice to move everything they could carry to the upstairs rooms. As Monet wrote to Durand-Ruel, who by then was again representing him, he was 'no longer a painter, but a lifeboatman, a ferryman, a removal man'.

When the lease on the house ran out in April 1883, following the failed solo show of his work that Durand-Ruel had mounted earlier that year, Monet sailed down the Seine in the vessel – his so-called studio boat – which he used for painting on water, looking at the villages he remembered seeing on family outings during their time at Vétheuil. Finally, alighting on Giverny, a tiny settlement on a tributary of the Seine called the Epte, he came upon a farmhouse to rent in a setting that he recognized was as close to perfect as he would ever find.

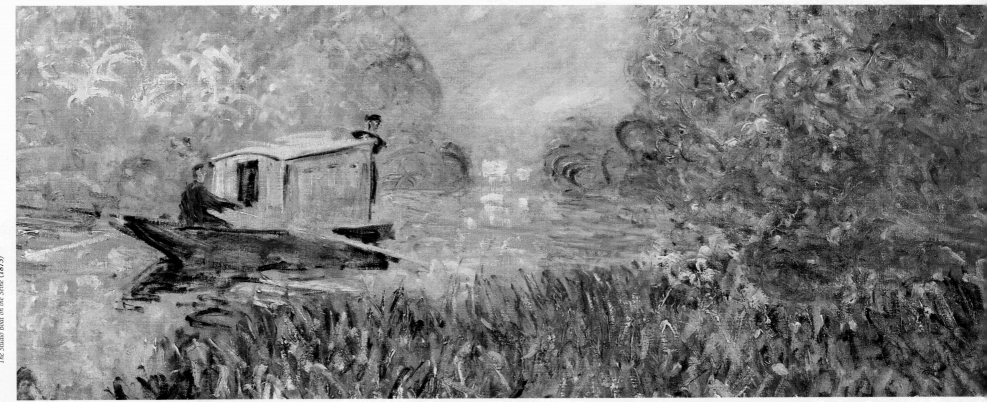

The Studio Boat on the Seine (1875)

Giverny ◦

A Prospect of Paradise

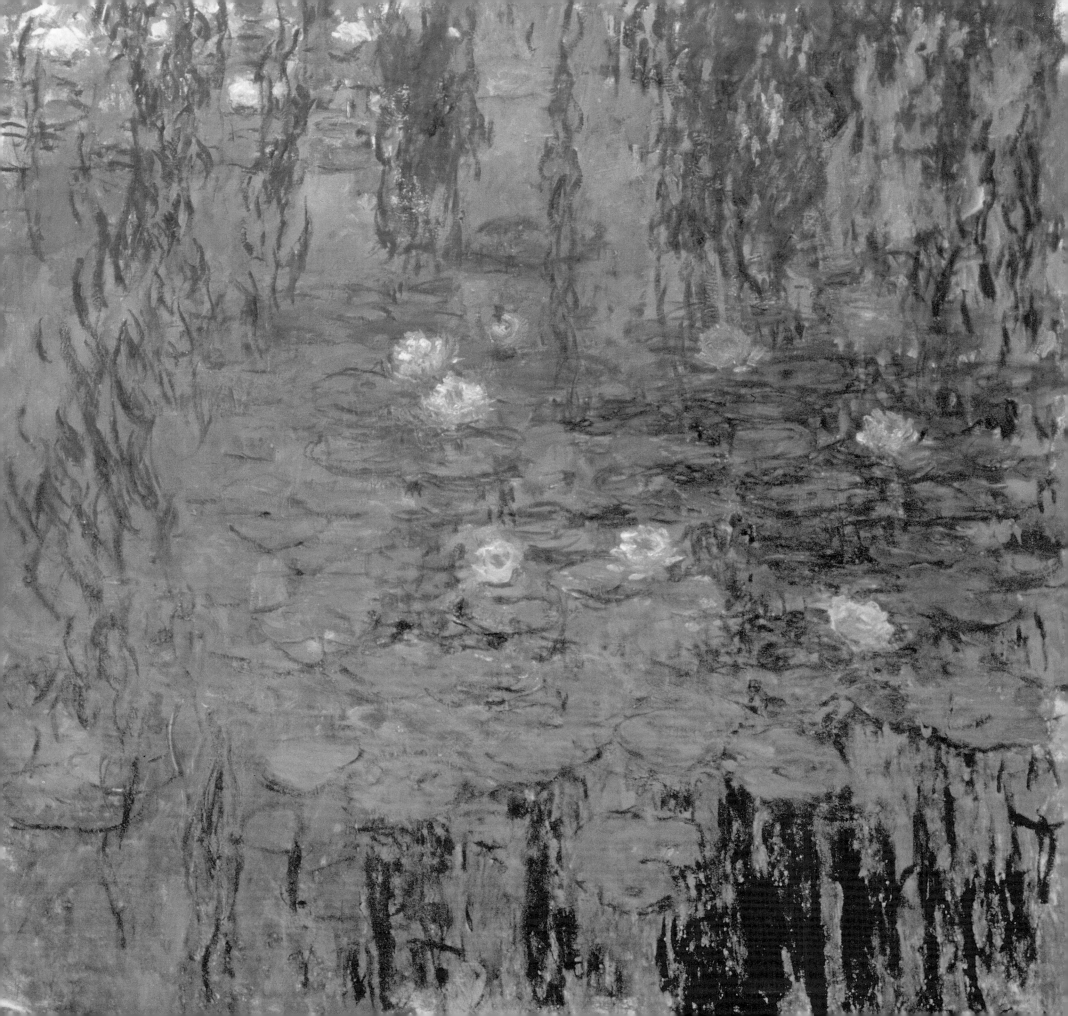

WHAT DID MONET SEE that day at Giverny which so convinced him that this must be the place they should settle? Well, for one thing, the former farmhouse he had discovered was big enough to accommodate a family of ten; in addition to his own two sons, Alice had two of her own as well as four daughters to bring up. Perhaps, better still, at this distance from Paris, some 50 miles north of the city, the house was not only cheaper to rent but was situated in the kind of rural paradise Monet had been seeking for a decade. But most important of all for a *plein air* painter must have been what he immediately recognized was a special quality in the light.

Monet signed the lease and, with the help of the older children, in the course of ten trips along the Seine in his studio boat, completed the arduous task of hauling the family belongings from Poissy to their new home. At this point, his finances were at such a low ebb that there was no money to pay for Alice and the younger ones to travel by train along the river to Vernon, the town nearest to Giverny; leaving them behind at Poissy, not for the first time Monet had to prevail upon his dealer to send them money for the fare. And no sooner had they all assembled at the new house and begun to unpack than Monet received the terrible news that Édouard Manet, his great friend and the artist against whose example he had tested his early achievements, had died. He rushed back to Paris to be one of the pallbearers at the funeral but, with that solemn duty discharged, was soon returning to Giverny to begin work in earnest on the garden.

Nymphéas (1914–17)

'Gardening was something I learned in my youth when I was unhappy. I perhaps owe having become a painter to flowers.'

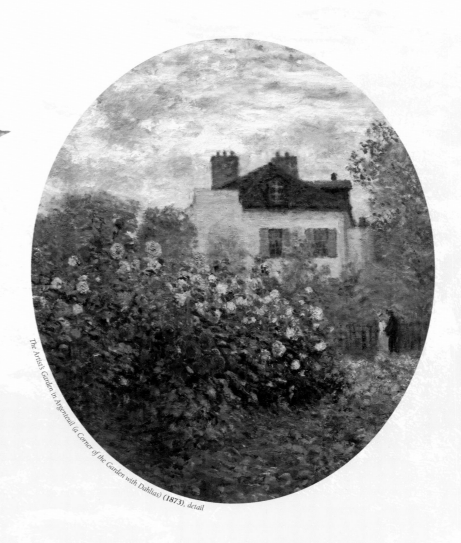

The Artist's Garden in Argenteuil (a Corner of the Garden with Dahlias) (1873), detail

Working in the Garden

Normandy is well-known for its cider making, and the property Monet had rented, a former cider farm in an area of the village known as Le Pressoir, included a small apple orchard on one side of the garden. In other respects, it was a typical French provincial garden of the time: rather formal, largely devoid of colour and offering very little to a painter with such keen sensibilities. As the family worked on getting the place in shape that first spring, Monet had probably already taken the decision to remove the fruit trees – they would gradually disappear over the coming years – just as he had soon ripped out the box hedging that surrounded the tired set of flowerbeds in front of the house.

So, having planted vegetables to give them good things to eat later in the summer, Monet began to sow flowers, initially the annuals he had been used to growing in the gardens at Argenteuil and Vétheuil, to give himself 'flowers to paint on rainy days'. As he said, looking back on this period years later, 'I dug, planted, weeded myself; in the evenings the children watered.' It's an image of familial co-operation born of necessity, though there was also no lack of affection between the painter and the children, his own and Alice's, under his care. And Monet was now in his element as, slipping into the seasonal rhythms the garden imposed on him and despite the continuing financial difficulties which saw them almost lose the house the following year, he felt at last that he had found a place to settle down.

A Landscape Rich in Motifs

In part this was due not just to the garden but to the landscape surrounding the secluded village, which it would gradually dawn on him was rich enough in painting motifs that in theory he need never leave the valley. Raising his head from the backbreaking work that first summer, he would have looked across the garden towards the low hills, striped with vineyards

Water-Lilies, Evening Effect (1897–99)

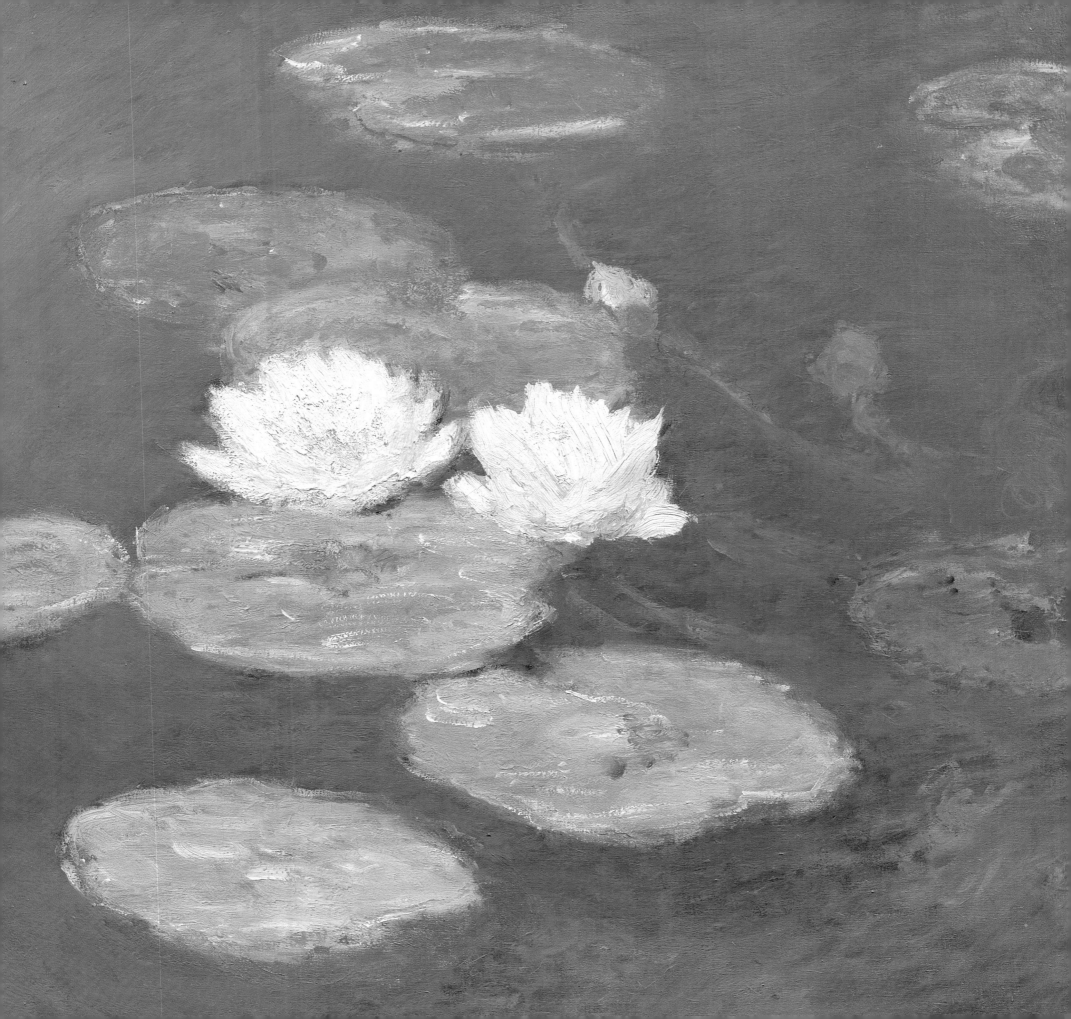

and orchards, which shadowed the west bank of the Seine. Turning around, there were more vineyards on the hill to the north and, behind the house to the east, whispering in the warm breeze, were fields of grain which at harvest time were cut and piled into distinctively roofed stacks.

Down in the valley was the River Epte, its banks lined with willows and the colonnades of poplars so characteristic of northern France and, as depicted in *Field of Yellow Irises at Giverny* – a windblown painting from 1887 – bordered by marshland carpeted with wild irises in spring. As these disappeared,

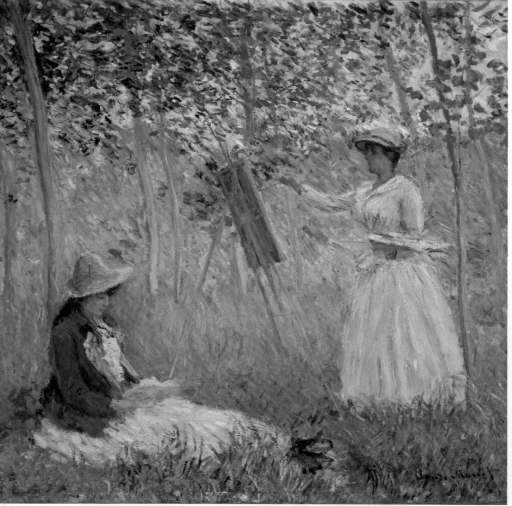

In the Woods at Giverny (1887)

poppies emerged in the fields through which the family sauntered to the boathouse Monet had had built on the Seine in the weeks after their arrival. Poppies had been a favourite subject in some of his paintings from the periods at Argenteuil and Vétheuil, and once again he found them a compelling motif for such peaceful canvases as *Field of Oats and Poppies* (1890).

The Days of Summer

Reaching the river, Monet often took the studio boat on to the water while some of Alice's daughters took one of the smaller craft that were kept in the boathouse, rowing themselves gently against the stream as he painted. Here they came that first summer and for the next several summers, Alice sitting in the shade reading or sewing, his son Michel (1878–1966) and Alice's son Jean-Pierre (1877–1961) collecting botanical specimens, including a new species of accidentally cross-fertilized poppy, a mix of Oriental and common varieties which still bears the name it was given at the time, *Papaver moneti*. With his family so wholeheartedly embracing life in the country, it is not surprising that Monet's paintings from this period (some of the last he did of the human figure) depict them, especially his favourite model, Alice's daughter Suzanne (1864–99), either boating or picnicking or, in the case of Blanche (1865–1947), painting in the manner of Monet himself. Indeed, the various paintings he made of the Hoschedé girls on these outings, such as *The Boat at Giverny* or *In the Woods at Giverny* (both 1887), convey something of the simple pleasure he clearly felt in the joyous confluence of art and nature and family that he experienced in his daily life at Giverny.

By mid-afternoon, with the light stark and, as far as Monet was concerned, unreliable for painting, the party would amble back to the house, with Blanche and the others carrying some of the many canvases he usually brought along; then, in the softer light of dusk, the artist would usually set out again to tackle perhaps a different subject that appealed to him. Such

Spring at Giverny (1886)

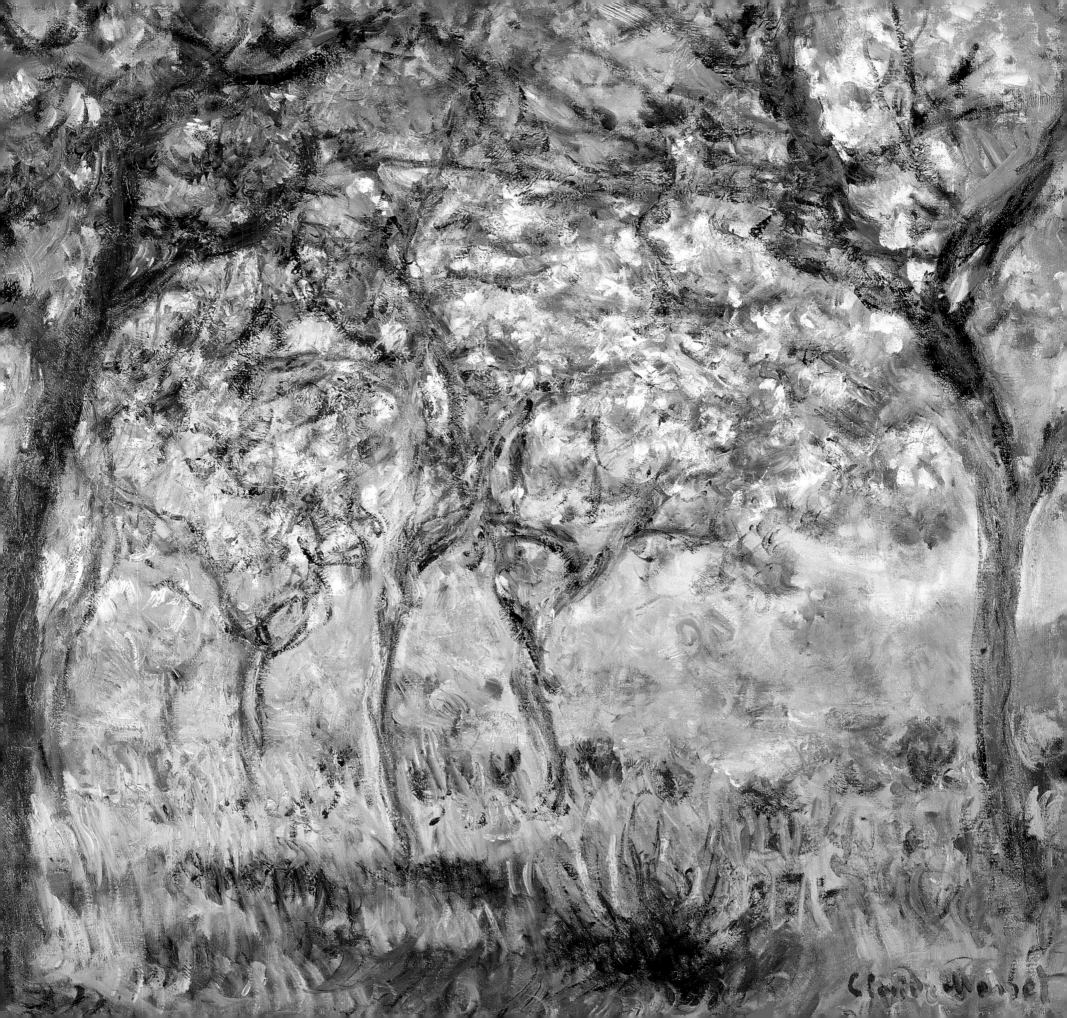

a strict schedule – with unvarying times for breakfast, lunch and a late supper – became quickly well-established, with Alice doing all she could to accommodate Monet's art and livelihood as, increasingly, his painting would be governed by the seasonal cycles of daily light.

The Farmhouse

The house itself was slightly unusual for the area, its walls covered with pink-tinted rendering, the choice of the landlord from whom they rented, a wealthy businessman from Guadeloupe who seems to have hankered after the bright colours of the tropics. Inside, Monet imposed a colour scheme of his own, the kitchen being painted a pale blue and the dining room a pale yellow, with painted furniture throughout. He also quickly converted an old barn attached to the house into a usable studio, installing a big north-facing window and putting in a wooden floor on top of the previous surface of beaten earth. In later years, this space would become the painter's salon, where the family would come to relax and Monet would entertain guests or potential buyers in a big room whose

Field of Yellow Irises at Giverny **(1887)**

walls were covered from floor to ceiling with unsold works from every period of his life. And elsewhere throughout the house were modern paintings by other artists, mostly his friends, with a few by older French painters with whom, in any case, he had been acquainted.

There was also a steadily growing collection of Japanese prints by the great masters of that art – among them, Kitagawa Utamaro (*c.* 1753–1806), Katsushika Hokusai (1760–1849) and Andō Hiroshige (1797–1858) – collectively representing, as Monet later admitted, the most important

influence on his own painting: 'If you absolutely must find an affiliation for me, select the Japanese of olden times.' He was not alone in that influence, as other Impressionists such as Edgar Degas (1834–1917), or Post-Impressionists such as Paul Gauguin (1848–1903) and Vincent van Gogh (1853–90), employed similar strategies in many of their works. Monet spoke for them all when he said of the great Japanese printmakers, 'In the West, what we have most appreciated is their bold way of cutting their subjects: those people have taught us to compose differently, there is no doubt of that.' The debt that he himself owed is immediately apparent in paintings such as

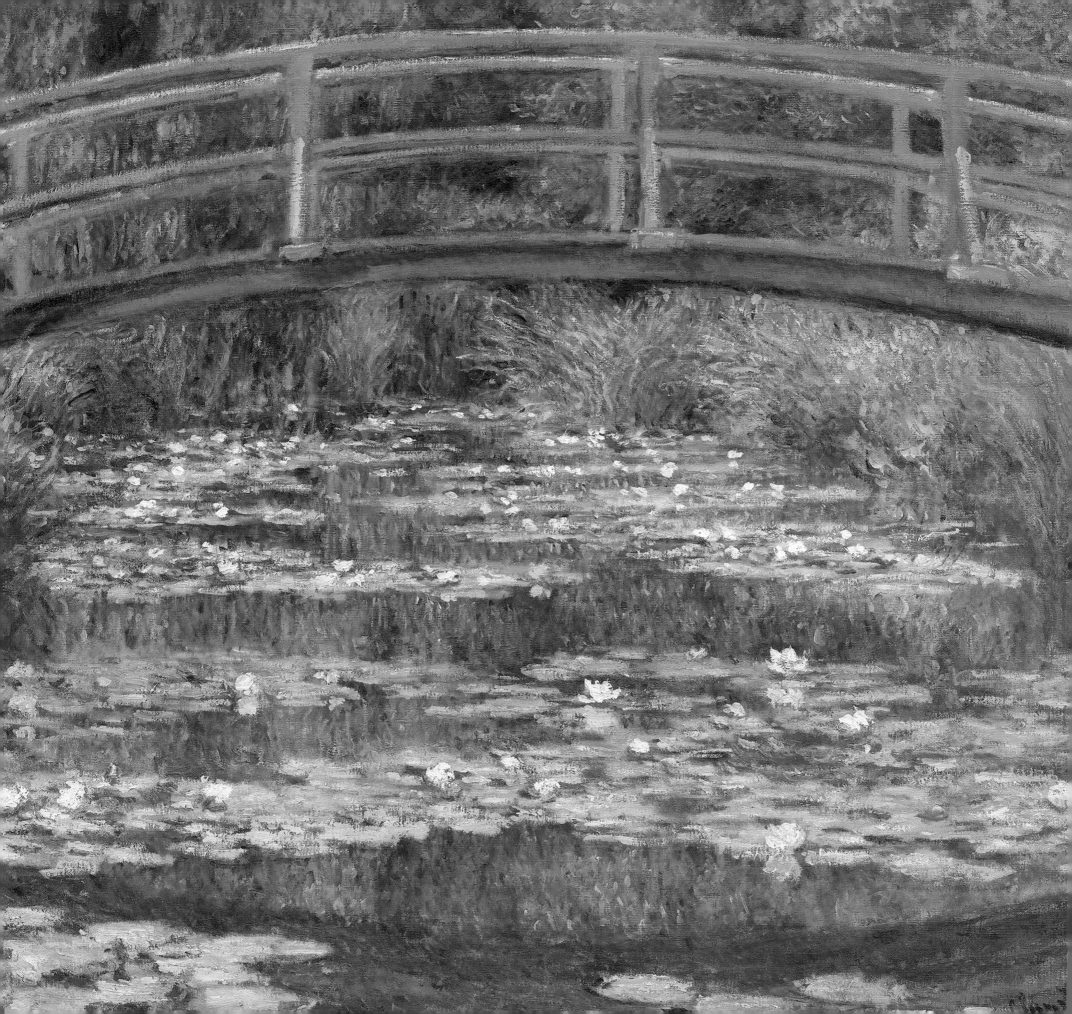

Boating on the Epte (*c.* 1889–90), a scene of everyday leisure that could almost have been copied from Hiroshige himself, and whose deceptively informal, deliberately off-centre composition is a typical Impressionist tactic learned directly from the Japanese masters of the casually cut-off image. For a glimpsed moment such as this canvas seeks to convey relies for its effect on appearing to be casual, spontaneous and uncomposed.

The Lord of his Manor

By the time *Boating on the Epte* was painted, Monet's name was becoming firmly established in the public mind, but even in earlier years, when money had been a constant worry, the struggling artist had insisted on employing servants and on dressing and eating well. This is confirmed by changes in his always robust figure, which grew ever more rotund in photographs taken as the years went by and a succession of cooks laboured to satisfy his whims. In fact, it seems Monet was something of a domestic tyrant, with a tendency to moodiness exacerbated when the weather was poor or when a day's painting had yielded nothing of value – setbacks which sometimes saw him take to his bed in despair. But at mealtimes on good days, Monet would sit with a view through the double doors to his garden (which in summer were flung wide open), delighting in its richness as he pondered the one quality above all others that had made him fall in love with the land around Giverny: the light, softened at either end of the day by the hills and, especially in the hours around dawn or dusk when the sun rose late and sank early behind them, constantly and often suddenly transformed.

As Monet sat there after supper, indulging his lifelong habit of cigarette smoking, immediately in front of him was the Grande Allée, as they called it, a wide pathway running away from the house between two rather long and, as he had found them, rather formal flowerbeds next to the garden

wall. Behind this ran a dirt road, the Chemin du Roy, and a railway track, a branch line from nearby Vernon, along which trains would pass four times a day. The Grande Allée was another part of the garden with which Monet was less than satisfied, a gloomy thoroughfare brooded over by cypress and spruce trees that contributed to the staid atmosphere which Monet wanted to change. Alice loved trees and hated to see them removed, but Monet wanted the garden to be open to the light that he saw as the main agent of beauty and life; gloominess was an aesthetic that belonged to the history of both art and French society, a history that from the start he had deliberately eschewed in both technique and subject matter, as also in life. Alice resisted his efforts to topple the spruces, which instead would suffer death by a thousand cuts over many years, their crowns eventually decapitated, their lower branches gradually hacked away until all that remained were a few solid poles that Monet smothered

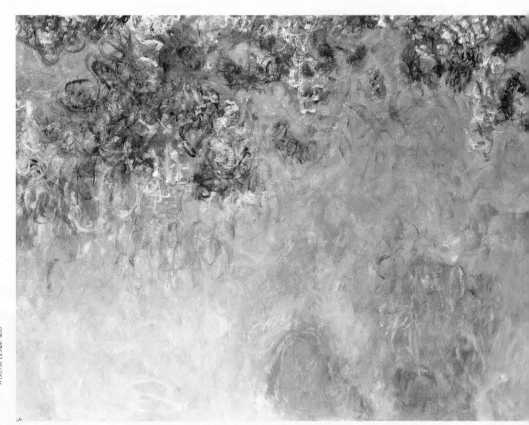

The Japanese Footbridge (1899)

Wisteria (1920–25)

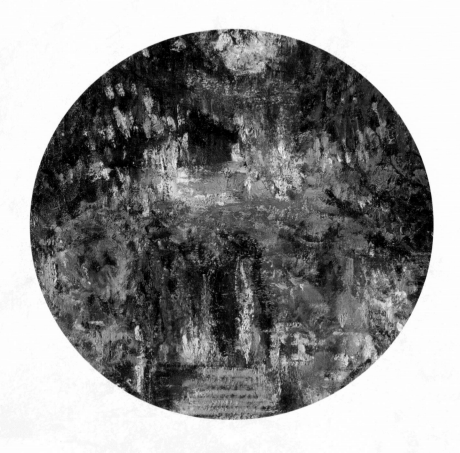

'We are still in the throes of moving house. In the past week I've experienced every kind of difficulty imaginable.'

with clouds of climbing roses. However, the cypresses had no such champion and, before long, had been unceremoniously felled.

The Dealer's Decorations

During that busy summer of 1883, Monet's artist friend and sometime patron Gustave Caillebotte was among the first visitors to the house. During the Argenteuil period, he had lived just across the river at Petit-Gennevilliers, and in recent months had inherited the family estate, having suffered the triple bereavement of mother, father and brother in close succession. A very experienced gardener, he came to advise Monet on plans for Giverny, and even with so much to organize, the new householder still found time to take a painting trip downriver of several days in his wealthy friend's well-appointed boat. But before long, he was back, initially to work in the garden and then, as winter drew in, on a series of door panels Durand-Ruel had commissioned Monet to decorate for the dealer's Paris apartment. Taking flowers grown in his own garden – daffodils, peonies, poppies, sunflowers, Christmas roses, jonquils and chrysanthemums – Monet laboured over the work for almost three years.

By the time the panels were finished and ready to be installed, Durand-Ruel was preparing to open the first Impressionist exhibition in America. It was almost a last throw of the dice for the dealer, who was still struggling to generate European sales for these painters to whom he had long since committed the future of his business. Luckily, the Americans brought none of the historical baggage that made the French art establishment react so haughtily to these fresh new images. As a result, the show was an immediate success. Sales flowed and then another show the following year both consolidated the impressive holdings of Impressionist work in American museums and, finally, turned public opinion at home firmly in its favour.

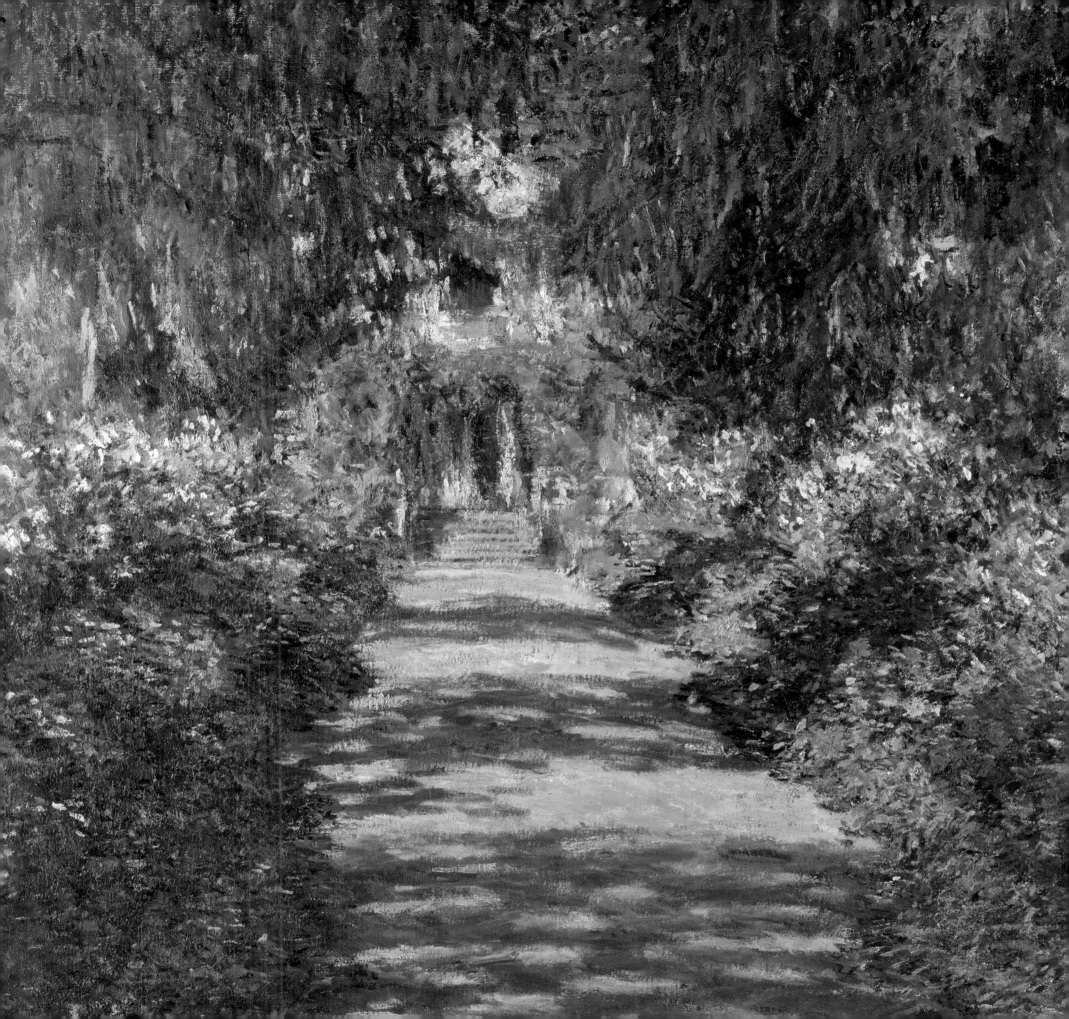

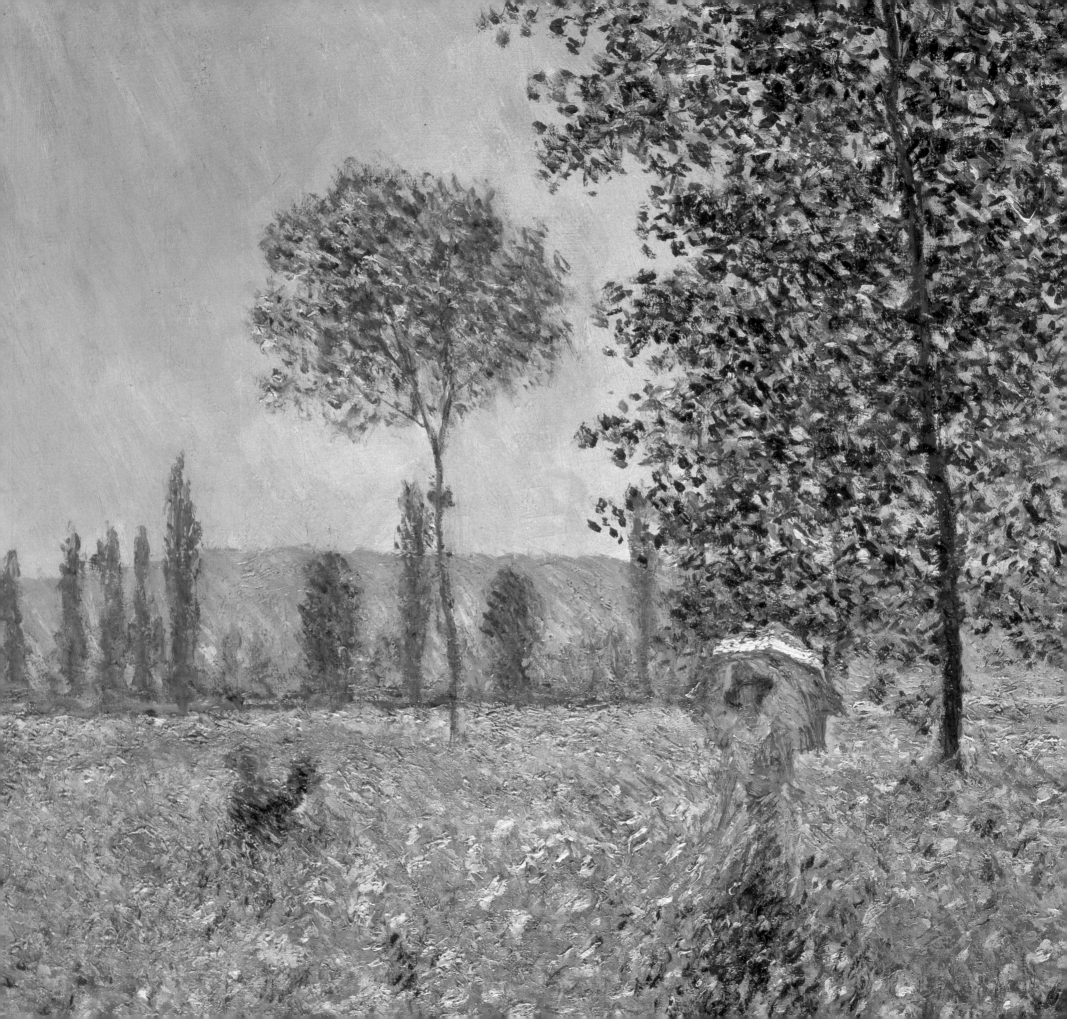

Fields in Spring (1887)

The Reluctant Impressionist

The year of that first American show, in fact, saw the eighth and last of the official Impressionist exhibitions, an event at which the old hands were upstaged by the Neo-Impressionism of *La Grand Jatte* (1884) by Georges Seurat (1859–91). Monet was not represented, having participated in the group shows only once in that decade. The independence which at one time he had claimed from the Salon he now asserted from his fellow Impressionists. He still maintained friendships with Pissarro, Renoir, Berthe Morisot (1841–95), Alfred Sisley (1839–99) and Paul Cézanne (1839–1906), and continued to attend the Impressionists' monthly gatherings at the Café Riche in Paris, but when at home in Giverny, he felt increasingly less inclination to leave it. Over time, Monet's feelings for the French capital had changed, and it had long since ceased intriguing him as a subject. Indeed, his last significant urban pictures had been the group of paintings he made of the Gare St-Lazare in 1877. At that time, he had lived away from the family in a studio situated close to the station and paid for by his friend Caillebotte. It was one of a number of studios Monet had kept up in Paris during the previous decade, all of which were now things of the past.

Moreover, Monet had left the city not only to find a better environment in which to live and work but also to escape the caprices of the art world and the petty subterfuges of society life, which were now at best an irrelevance and at worst an unwelcome distraction from his increasingly well-defined artistic project. He later declared, 'How can one live in Paris? It's hell. I prefer my flowers and this hill that surrounds the Seine to all your noises and nocturnal lights.' This is not an unusual arc of cultural reorientation for someone approaching the age of 50, but in Monet's case, it was the opposite of the retreat into conservative values that often accompanies the onset of middle age. For the painter of the *Boulevard des*

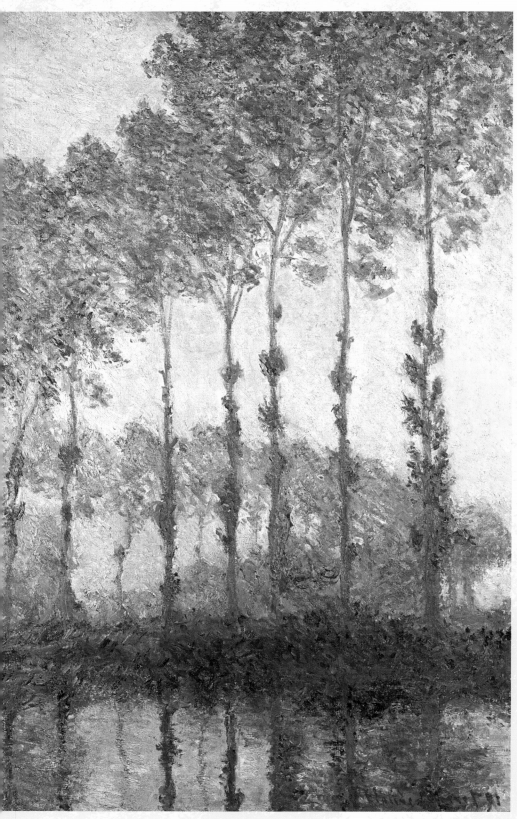

Poplars on the Banks of the Epte, Autumn (1891)

Capucines (1873) and the *Gare St-Lazare* series, along with most of his Impressionist colleagues, had been steadily reappraising what it meant to be a modern painter.

The Meaning of Modern Vision

Baudelaire's 'painters of modern life' increasingly considered an attachment to the trappings of modernity – urban street life, modern engineering marvels and so on – to be beside the point. What mattered was not what you looked at but how you saw it; the modern gaze need not be tied to the material accoutrements of modernity. In Monet's case, what he sought to express was not so much the times he lived in but the isolated moment that, in being expressed, would speak of its time. Thus modern reality could be apprehended not only by means of those explicitly modern themes but just as readily through traditional scenes and subjects associated with the history of his preferred medium of landscape. So even the unassuming pastoral works from this period, depicting subjects that the Barbizon School might well have tackled, have a freshness of colour and composition that mark them out as bold, modern works.

For instance, in *Poppy Field in a Hollow near Giverny* (1885), the recessionary bed of bright red flowers forms a two-dimensional trapezium rising to meet the open cup of the hollow in the background, whose clumps of shrubbery are predominantly green, the complementary colour of red; while on either side, the poppies are framed by wedges of grassland respectively in green-yellow and pale blue, themselves suggestive of the other primaries. The Impressionists had long known that complementary colours placed in close proximity would make each one seem more vibrant; it was a basic tenet that Monet and Renoir had applied to the bright modern scenes that emerged from La Grenouillère. But this image is almost a statement of that basic principle, a covert colour wheel

that vividly exemplifies Monet's increasing preoccupation with pattern and design, with the pictorial possibilities of decoration, which would only grow in importance in the years that followed.

New Friends

Now, in this new environment of Giverny, as his outlook and interests changed, so did Monet's friendships, as new allegiances with writers such as Octave Mirbeau (1848–1917) and Georges Clemenceau (1841–1929) assumed great importance to him. Both men were keen gardeners and Monet, increasingly disinclined to talk about art, liked nothing better than discussing his garden. But Mirbeau and Clemenceau were also both keen observers of art who would come to play significant roles in his future career. It was the former, indeed, in later years often the writer of Monet's catalogue essays, who first identified the artist's preoccupation with conveying precise conditions of light as opposed to the generalized atmospheres of earlier generations of landscape artists. In that regard, Monet would learn most about the vagaries of light, its particularity at any given moment, in the paradisiacal laboratory of Giverny.

The only threat to that rural idyll in those early years was a want of money, and in that respect, the US sales of the late 1880s could not have come at a better time. In fact, Monet, who harboured a certain possessiveness towards his work even after it was finished, chafed at the idea of his pictures going so far away, though he surely did not complain at the boost in his income which allowed for a steadily growing outlay on the developing garden. For now, he was still obliged to do all the hard work himself, and he planted as he painted, with blocks of colour speckled with sharply contrasting, often complementary hues from tulips or the self-seeding flowers, such as poppies, which Monet encouraged. He had no doubt been impressed by the sight of the tulip fields he saw and

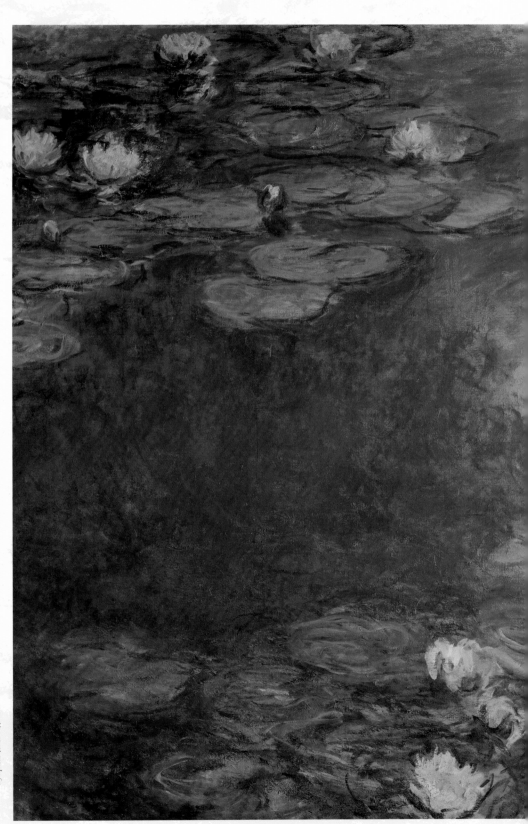

Nymphéas (c. 1914), detail

'Once settled, I
hope to produce
masterpieces, because
I like the countryside
very much.'

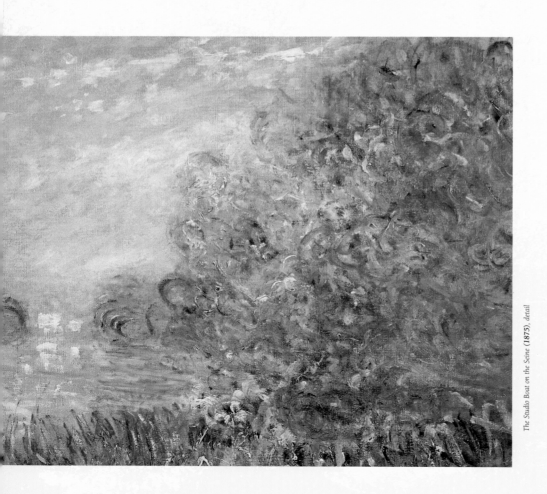

The Studio Boat on the Seine (1875), detail

painted at Sassenheim, near Leiden, on a visit in April 1886. It was here that he watched the bulb farmers pluck off the blooms at their peak so as to strengthen the bulbs for future growth, a technique he added to his own methods; he marvelled at the discarded petals floating in great piles on the canals like 'coloured rafts in the blue reflection of the sky'. And as the decade progressed, Monet began to plan the planting schemes of his own beds according to seasonal blooming cycles, allying his colourist's instinct with information from the plant catalogues in which he was taking an increasing interest, so as to imagine the spectacular swathes of contrasting hues for which the flower garden at Giverny would later become renowned.

An Itinerant Decade

However, aside from rare images like *Peonies* (1887), the garden was not as yet a subject with which Monet was much engaged. Indeed, in the mid-1880s, notwithstanding the peasant attire of beret and sabots (wooden clogs) he liked to wear when he went out painting, perhaps he had still not settled sufficiently into country life to be able to see the full potential of what surrounded him; the major groups of paintings from those years arose from other places. No doubt the affectation of peasant dress expressed a need to belong to his surroundings the better to understand them, but beneath his painter's smock, he was still something of the dandy, with a penchant for pastel-coloured shirts ruffled along the front and suits cut to his own slightly eccentric tastes. Moreover, no matter what he wore, there would be no substitute for the passing of time in helping him see the abundant possibilities that surrounded him. Instead, confident of Alice's unwavering support for his work and her equal devotion to the care of their joint family, over the next several years, Monet accepted offers to travel to far-flung locations across France and elsewhere, an itinerary which would also include a trip to Norway to stay with Alice's son Jacques (1869–1941).

Poppy Field in a Hollow near Giverny (1885)

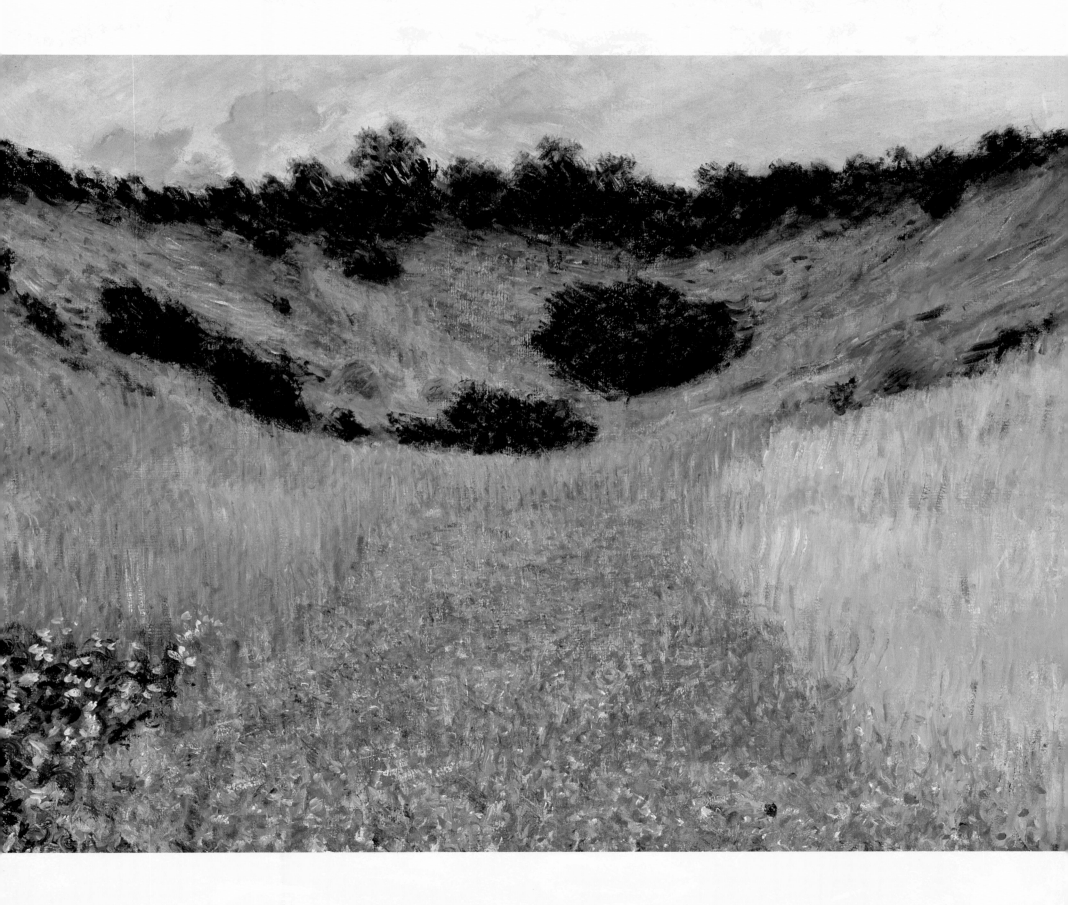

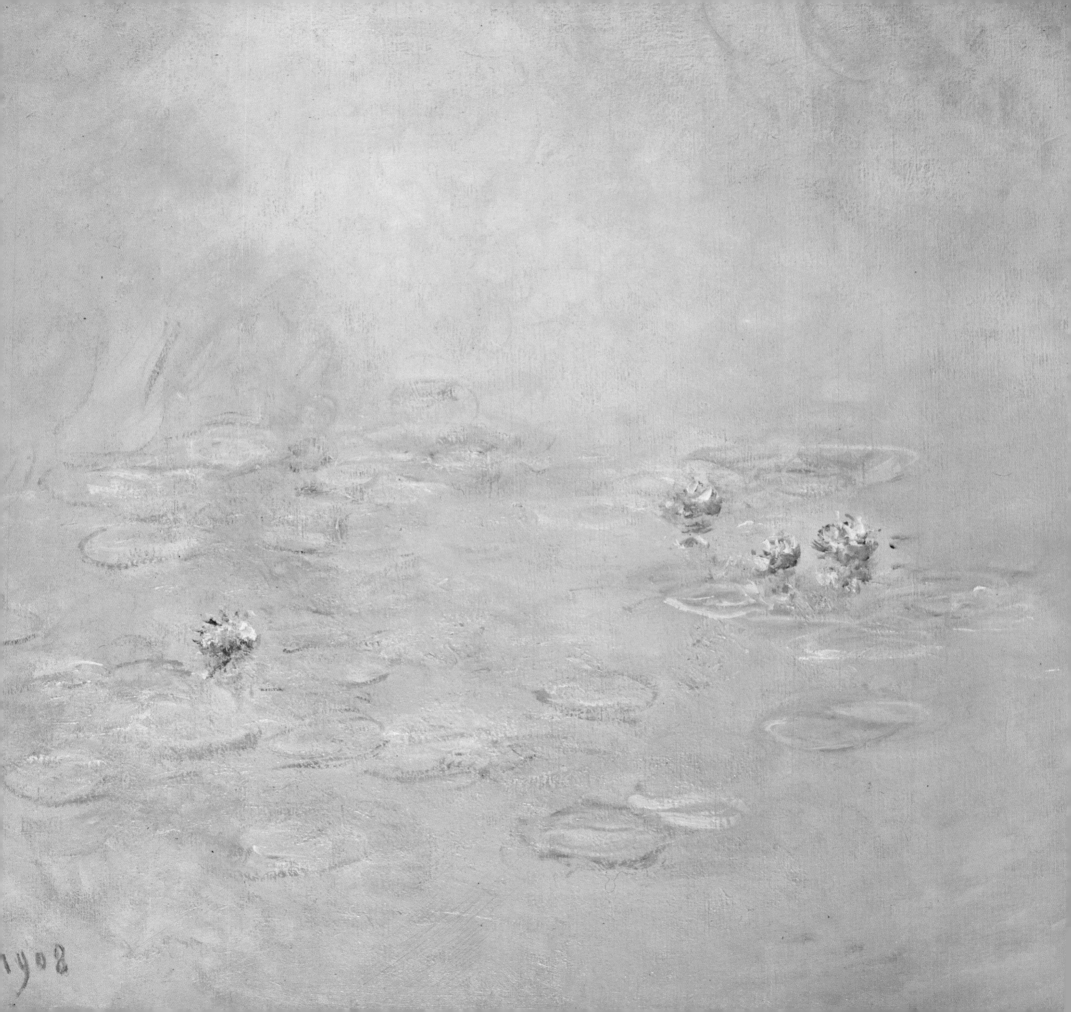

1908

With summers being spent at home in Giverny, these painting expeditions were made mostly in winter in search of new motifs and dramatic conditions from which Monet hoped to create pictures that would sell.

In the first instance, in December 1883, Monet travelled to the Côte d'Azur with Renoir, ostensibly to visit Cézanne at L'Estaque, before returning for a longer trip in the new year, where at Bordighera on the Italian coast across the border, Monet came to revel in the roseate Mediterranean light. The task of depicting such vividness of colour was certainly a challenge, one he would return to later in the decade at Antibes and then again much later still on a trip to Venice, his last significant journey. And there is no doubting the effect such light-saturated colour would have on the range of illuminations in the work that followed, initially the series paintings of the 1890s, such as the *Grainstacks* and the paintings of Rouen Cathedral, and then eventually the singular colouring of so many of the *Water Lilies*.

The Pull of the Sea

The following year, 1885, Monet returned to his old haunts on the Normandy coast, to the Manneporte at Étretat, a geologically eroded arch in the chalk cliffs that by then had become well-known to tourists. It was by this measure a commercial subject and one, moreover, with a history in art, most notably in a painting of the feature from 1870 by his old friend Gustave Courbet (1819–77). From this visit comes an episode that demonstrates the lengths to which Monet would go to secure his picture, a level of heroic obsessiveness that recurred in other forms in later undertakings, most tellingly in the *Water Lilies* series that consumed him in the last two decades of his life.

The sea in various manifestations features prominently in Monet's pictures until the 1890s, from his early Normandy images to the adventurous

'**I felt the need, in order to ... refresh my vision in front of new sights, to take myself away for a while from the area where I was living...**'

Peonies (1897), detail

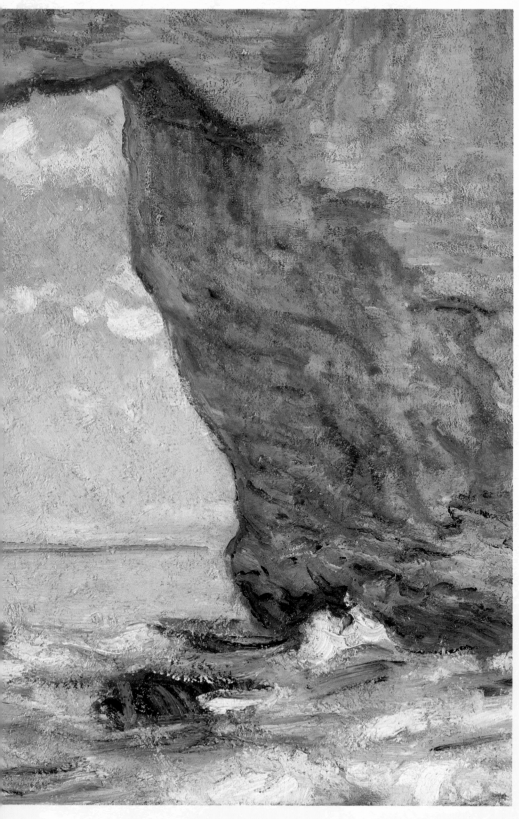

paintings of the 1880s in places like Bordighera and Antibes in the south, at Belle-Île off the coast of Brittany, and in favourite locations along the Normandy coast such as Pourville and Étretat. Having grown up on this threshold of earth, air and water at Le Havre, it was probably inevitable that the vast presence of the sea would draw him back, time and again. Indeed, he was later to declare his wish to be 'buried in a buoy', both a tongue-in-cheek remark and a very revealing image. Even as late as 1917, after a trip to the Normandy coast, he wrote upon returning to Giverny of being 'delighted with my little trip: I saw and dreamed about so many memories, so much toil.' By 'toil', it seems likely he meant the particular vagaries of marine weather – shifting tides, angles of sunlight and conditions of surf – which meant constant revision of images that attempted to fix on canvas a subject that was so inherently unstable. At one point in these coastal adventures, vexed at the difficulty of repeatedly realigning all the factors he needed at one and the same time, he was given to lament that, 'I often have the weather I need but the tide is low when I need it to be high.'

The Challenge of Waves

On the occasion of the incident at Étretat, Monet's misreading of the tide nearly had fatal consequences. The artist had taken to the beach in rough weather and was sketching with rapt attention, oblivious to an incoming tide he thought was receding, when a freak wave swept him into the sea. To his great good fortune, two local fishermen were on hand to rescue him, pulling the painter half-drowned from the waves, still clutching his palette, though canvas, easel and all other painting implements, it seems, were lost.

Undeterred, the following year, he visited the even rougher seas that pounded the island of Belle-Île off the Atlantic coast of Brittany, from which emerged some of the most tempestuous images of his career. In a

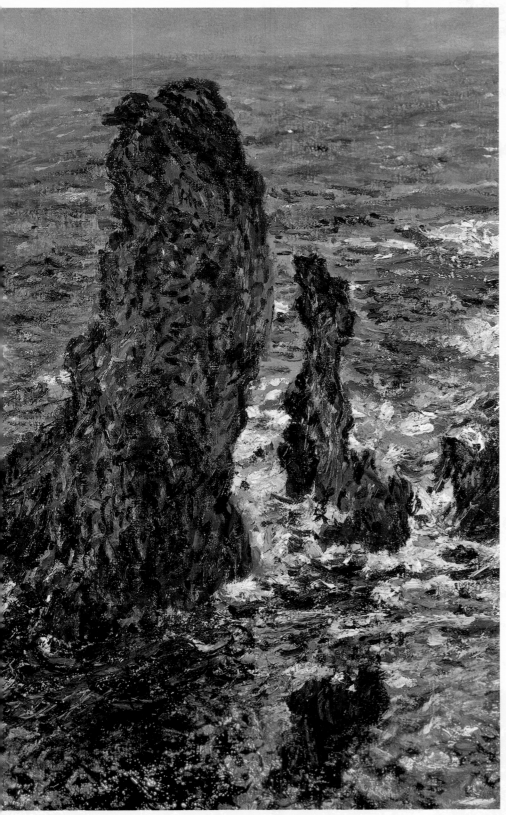

The Rocks at Belle-Île (1886), detail

letter to Alice from his lodgings on the island, he wrote of his 'tremendous efforts to work in a darker register and express the sinister and tragic quality of the place, given my natural tendency to work in light and pale tones'. Indeed so. For an artist so accomplished at painting subtle effects of gentle light, these pictures are a departure that might have been considered a commercial risk, but prompted, it seems, by a growing distrust of the very facility – the speed and sureness with which he worked – that made other painters both admire and envy him. Indeed, the range of subjects and locations he took on during the trips of the early years at Giverny was undoubtedly an attempt to challenge himself – to force himself to work differently and find new solutions.

The Creuse Valley

At times, this thirst for the new took Monet to places that otherwise he might never have considered. Indeed, a few years later, the great friend he had made at Belle-Île, his future biographer and fellow gardener Gustave Geffroy (1855–1926), invited him to stay in the village of Fresselines in the Creuse Valley, a rugged and little-visited part of central France. From this winter campaign, a very homogeneous group of paintings emerged that carry more than a hint of the increasingly systematic series that would come to occupy Monet's thinking over the following decade. But there was also an alarming incident, openly related in letters home to Alice, which reveals the battles he was having not so much with nature or even art during this period, but with an inability to accommodate one with the other.

Monet had been working on a set of pictures of the River Creuse at low ebb in early spring when torrential rain forced him indoors for the whole month of April. Some of these paintings include the presence of a craggy old oak at the bottom of the valley, whose bare branches subtly articulate the bleakness of the scene. But when in early May, conditions improved

sufficiently to enable him to work, the month-long torrent had caused the river to swell, so that it rushed down the valley in mineral-enriched colours he had not encountered before. But more intolerable still, the oncoming spring had brought the oak into leaf and Monet's planned and now long-delayed set of paintings, in which the oak tree featured prominently, was suddenly imperilled by this unwelcome recrudescence of life. It is debatable whether Monet was ever fully content with any of the canvases he produced from his forties onwards, such were his increasingly exacting standards, but the older painter of the *Water Lilies* might well have shrugged his shoulders and begun another picture, content to follow nature wherever she led him. The restless artist of the 1880s, on the other hand, struggling with worries of all kinds, could not countenance this threat to a substantial amount of work from that year's winter campaign.

Thwarted by Man and Nature

Thus, in a fit of pique or desperation at nature's spoiling of his plans, Monet wrote to Alice that 'I'm going to offer 50 francs to my landlord to see if I can have the oak tree's leaves removed.' Fearing he would be refused, he wrote again the following day, 'I'm overjoyed, having unexpectedly been granted permission to remove the leaves from my fine oak tree'. Two workmen were quickly paid to bring ladders into the ravine and strip the tree of its leaves, whereupon Monet, declaring it 'the final straw to be finishing a winter landscape at this time of year', proceeded to complete his now semi-fictitious pictures. Happily, it seems the tree survived to come into bud the following year, but the incident demonstrates not so much the carefree *plein air* artist of popular imagination, happy to record whatever nature has to offer, but an obsessive arranger of facts, almost like a still-life painter under outdoor light. Such a tension between control and spontaneity (in relation to both

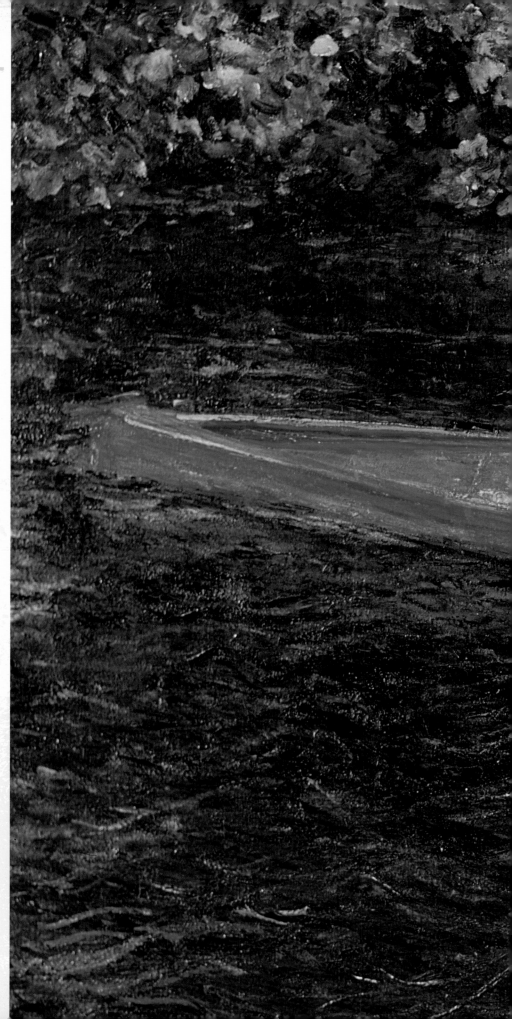

Boating on the Epte (c. 1889–90)

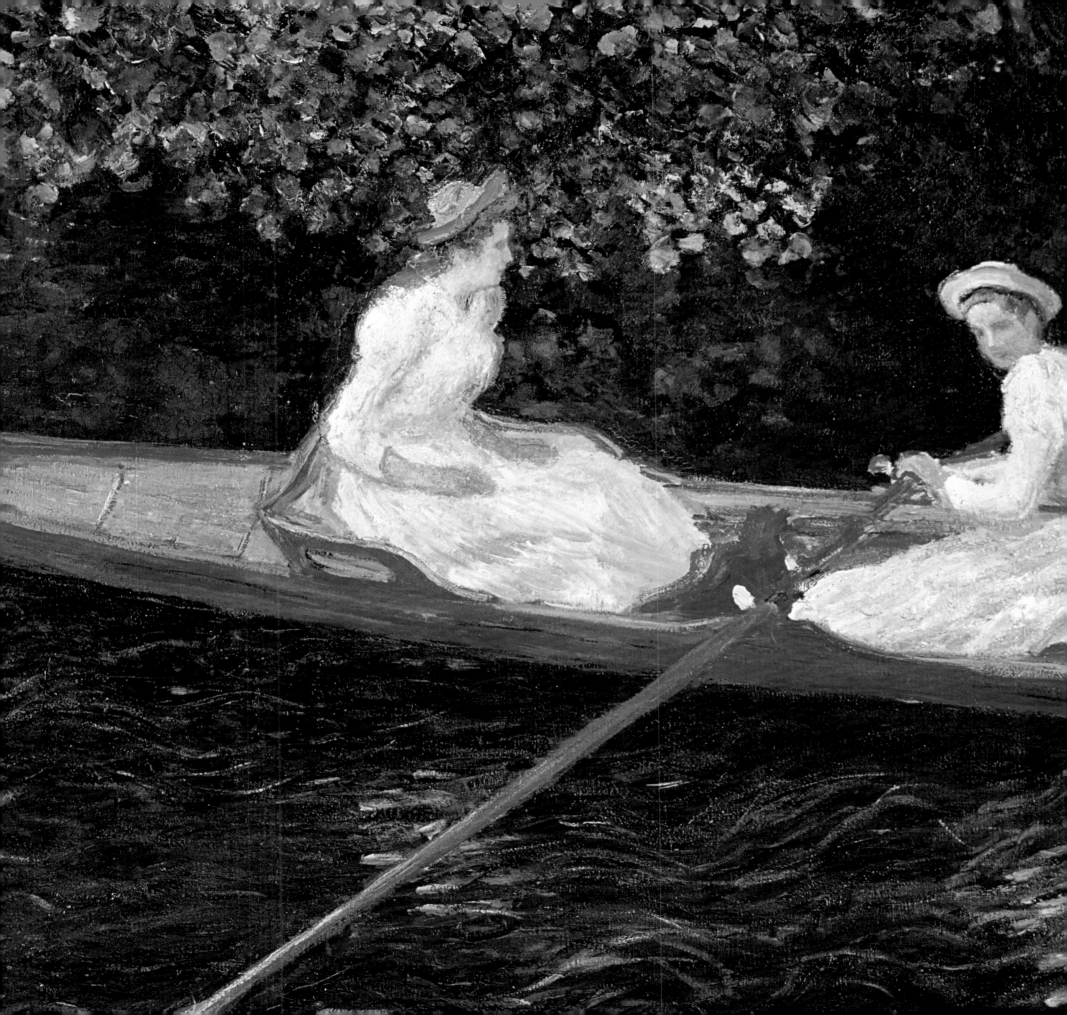

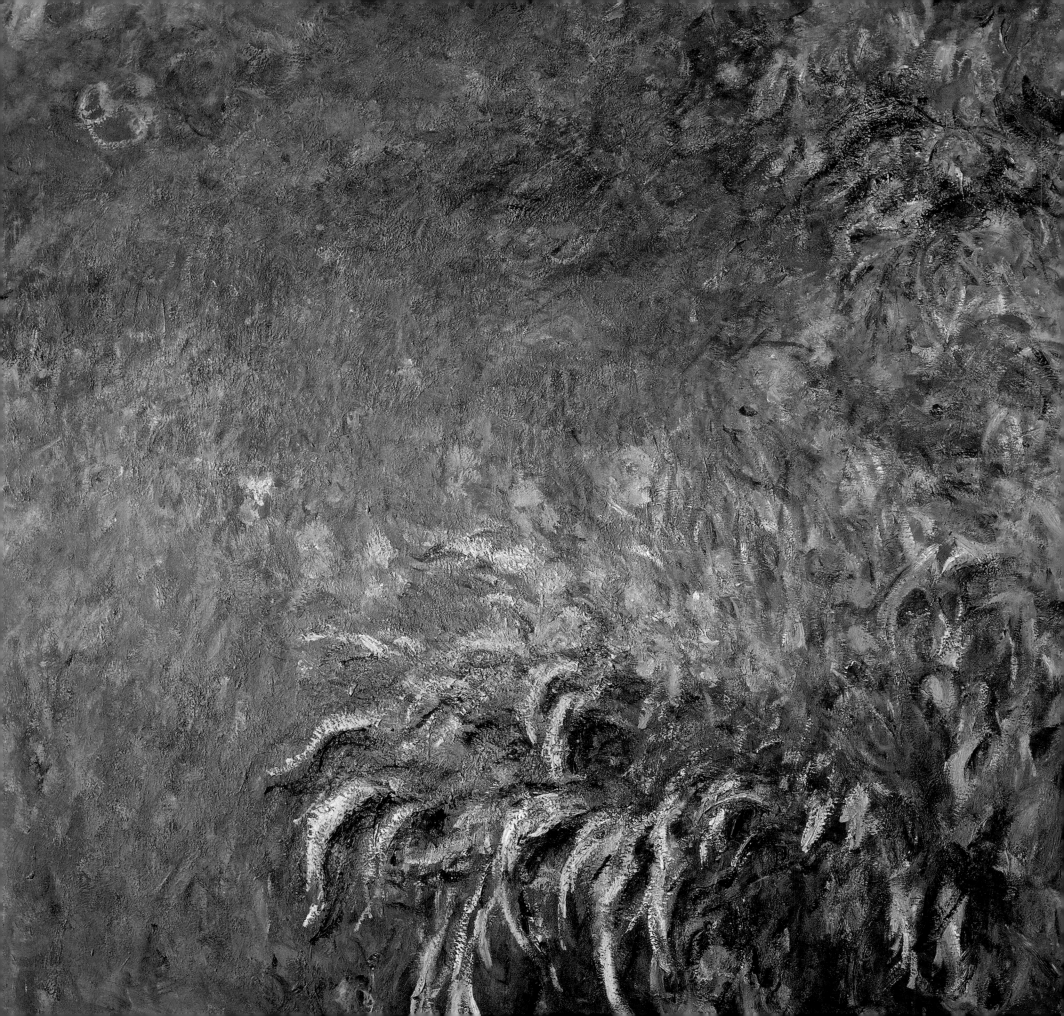

nature and the images he made of it) is one that would increasingly come to characterize the work he did from this point on.

For a landscape painter, such calamities are an occupational hazard, of course, and it may have been partly impatience with elements beyond his control that caused Monet gradually to withdraw to his own domain at Giverny in later years. Certainly, an ability to prevent such mishaps rarely presented itself, though it was usually human activity which thwarted his plans, whether that be apples in an orchard being picked before a canvas speckled with the fruit was finished, or fishing boats on the beach at Étretat being moved, or a stand of trees in the Creuse Valley being cut down, their former presence reduced to a pile of logs cluttering up his carefully composed image. On the one instance he got wind of such imminent despoliation of his plans, in the case of the *Poplars* series of 1891, he acted decisively – a case not so much of man against nature but of art against commerce. It was all a continuing lesson in the transience of appearances – the 'fugitive effects' he had spent his whole career attempting to reproduce.

The Search for Harmony

Crucial to his disquiet at these seemingly minor changes was Monet's attitude to composition. As noted in the case of *Bathers at La Grenouillère* of 1869, the ostensible subject of an image was often just a single relatively insignificant part of its overall effect. And for Monet, for whom the overall harmony of a painting was so important that he would always work on all parts of a picture at once, the removal or drastic alteration of any one element affected the balance of the entire scene.

Without doubt, harmony in art and harmony in life became an increasing preoccupation for Monet. If the discovery of Giverny had offered the

Iris in Pond (1914–17)

Water Lilies (1903)

'I know very well that to really paint the sea, one must observe it every day at every hour and from the same place.'

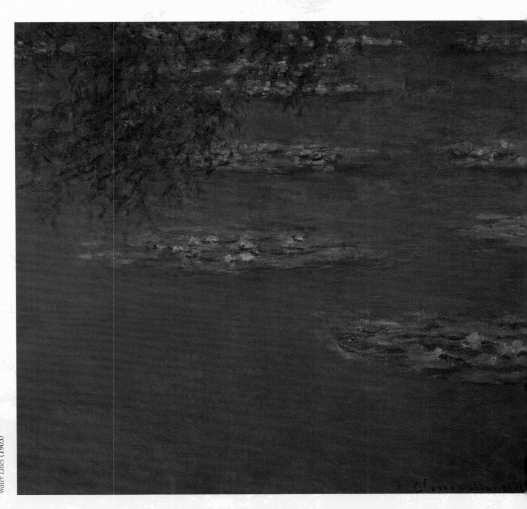

'I do what I think best
in order to express
what I experience
in front of nature.'

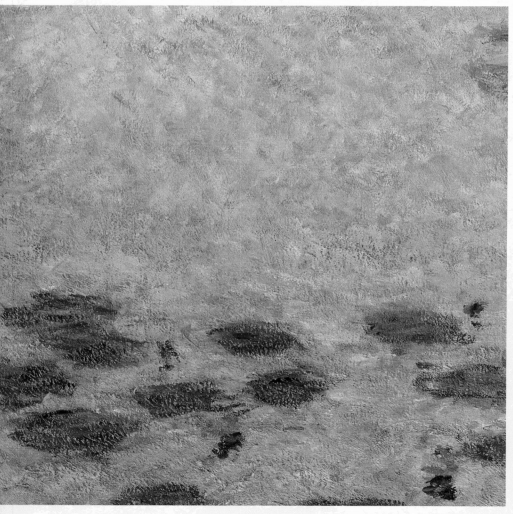

Water Lilies (1906), detail

promise of a harmonious life, as his letters to Alice make clear, the financial difficulties that persisted until the late 1880s made that harmony seem difficult to sustain. In a similar way, despite occasional attempts to convey the magical environment in which he now found himself, Monet's main painting campaigns in these years had happened mostly far away from home, tackling subjects with which he was frequently doing battle to paint in ways that convinced him, a struggle that is often apparent in the images themselves. Only success in America and then, finally, the official recognition he gained from a joint exhibition in Paris in 1889, which showed his paintings alongside sculptures by his exact contemporary, the much more celebrated Auguste Rodin, at last began to quell the financial and artistic anxieties which had plagued his career to that point.

It was only now that, with his life seemingly settled and secure, Monet's vision opened quite suddenly to the full possibilities of light which for so long had intrigued him. The richness or strangeness of colour and light he had spent the past seven years observing at all points of the compass across France and beyond – the 'delicious colour harmonies' of the south, the opulent hues of the Dutch tulip fields, the bleak pallor of the northern coasts in winter – he now began to realize he could find at home. He started to look more attentively at the motifs all around him, the kind of everyday phenomena that are so familiar we almost do not see them at all. With the exotic and the windswept locations of the previous few years having taught him much, he was returning now to his original Impressionist vocation of finding beauty in the ordinary and the overlooked. It was a process that would lead eventually to the most ordinary subject of all: a patch of water lilies on the surface of a pond.

Water Lilies (1906)

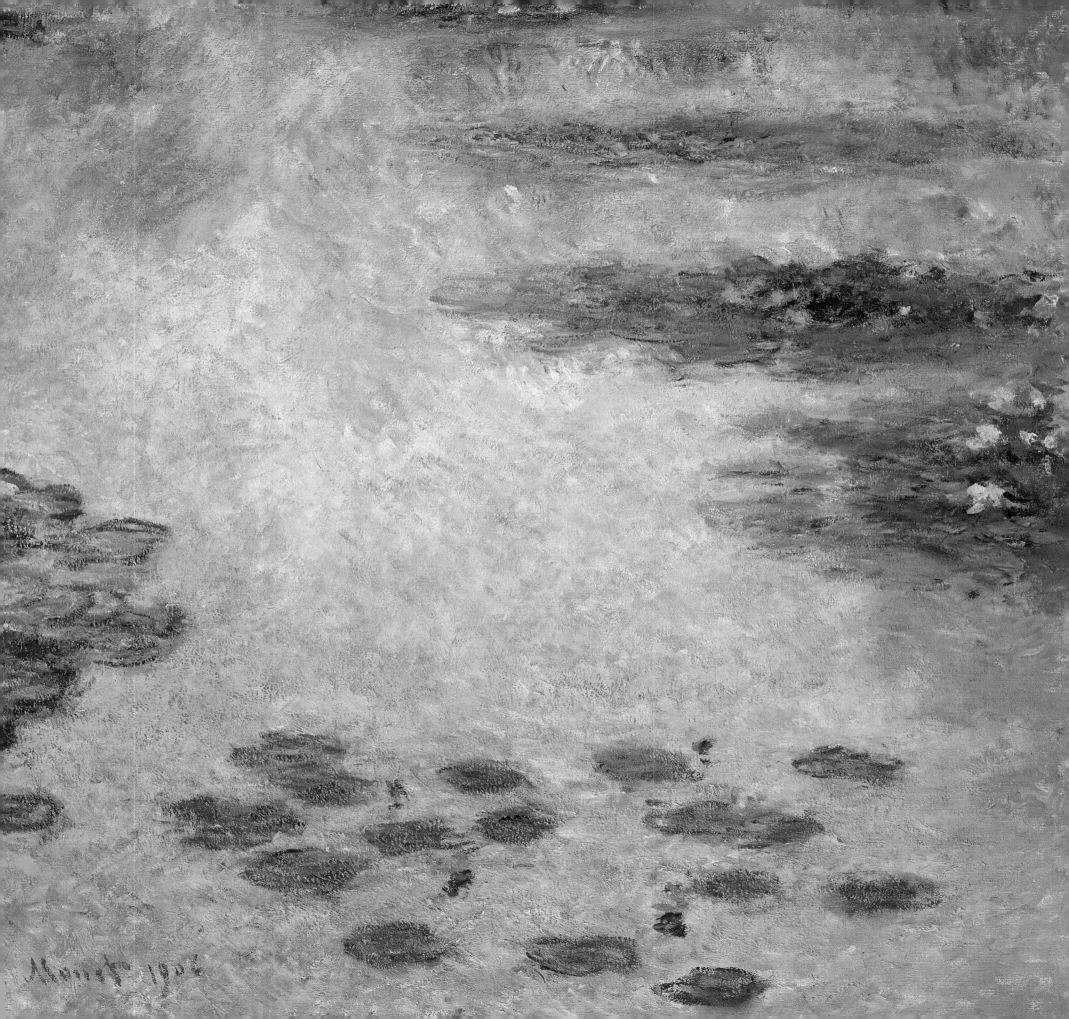

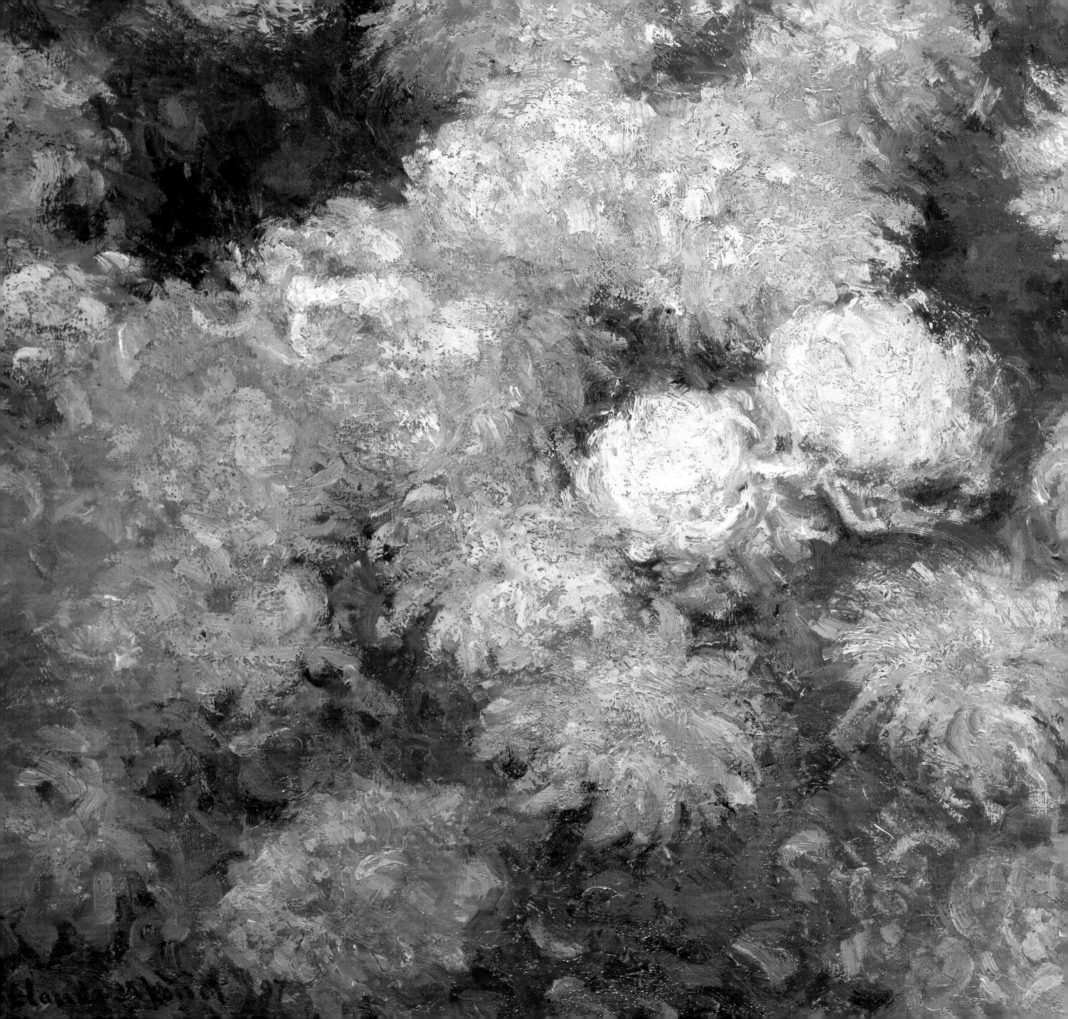

The Growth
of Vision

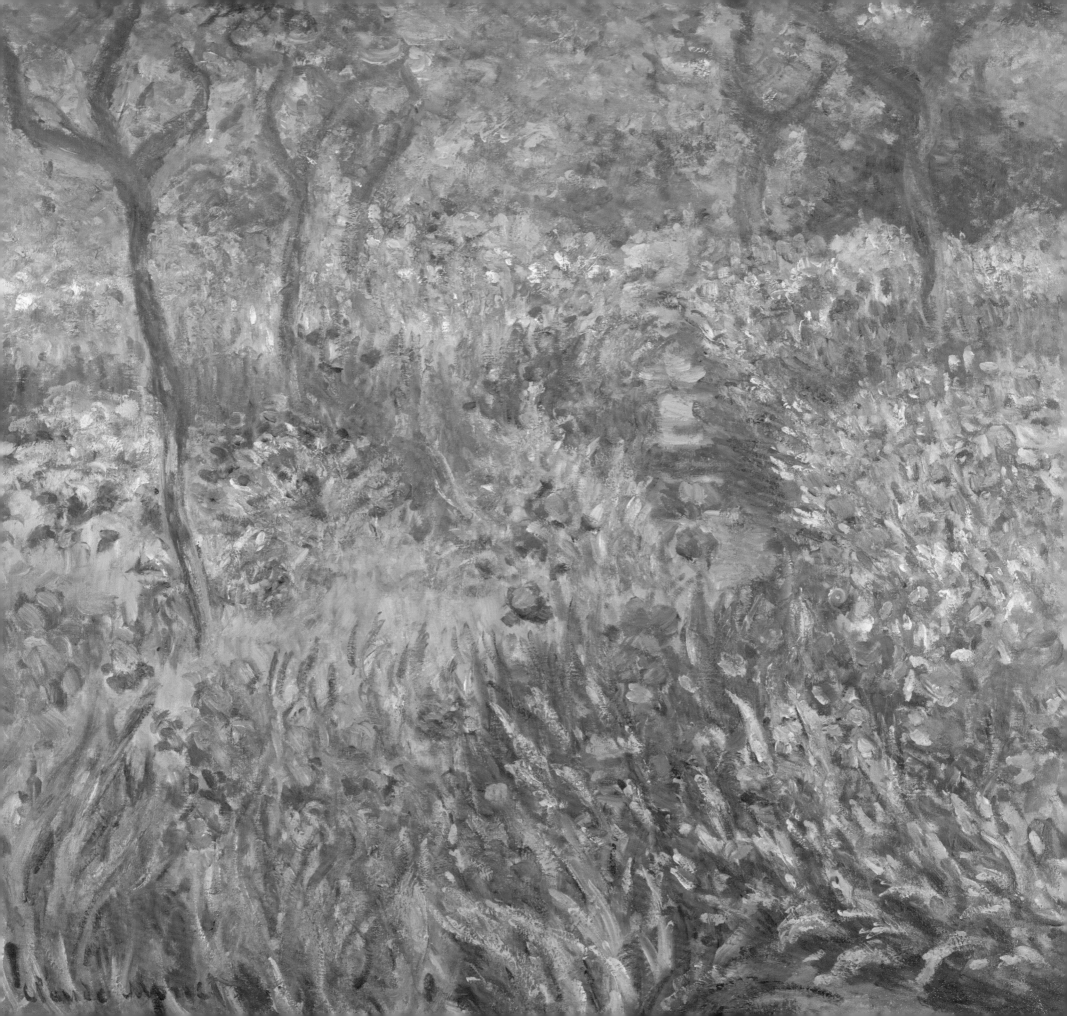

THERE WAS A STORY Monet liked to tell towards the end of his life about the moment of artistic awakening he experienced in the late summer of 1890. He was in a field above the house at Giverny, painting some of the grainstacks erected on the hillside at harvest time, another of the pastoral subjects he had been drawn to that summer. As the story usually went, Monet realized that the light had changed and the canvas he was working on was now redundant to his needs until such time as the illumination it had sought to capture should return. Alice's daughter Suzanne was with him, watching the master at work a little way off. Monet turned to her and asked if she wouldn't mind going to the house to bring him another canvas. She scurried down the hill and within minutes was back, but in a short time was being asked to bring another, then later another, and so on until by the end of the day, the painter was surrounded by more than half a dozen images of the same subject, each compositionally identical but in other ways strikingly different from the others.

The Primacy of Light

This tale of sudden enlightenment is central to the Monet legend, being the moment when the primacy of light became fully apparent to him. In fact, perhaps more than any of the Impressionists, he had always made it a principal goal to try to capture the immediacy of what was in front of him, and for a long time – particularly during the painting campaigns of the previous decade, such as the time he had spent in the Creuse Valley the

The Iris Garden at Giverny (1899–1900)

'To me the motif is an insignificant factor; what I want to reproduce is what lies between the motif and me.'

previous year – he had been increasingly drawn to making multiple images of more or less the same scene. But something new had struck him, which he must have quickly realized was implicit in a key aspect of the Impressionist view of the world: its impulse to capture the reality of an apparently glimpsed moment. It dawned on him that the freshness of vision he had sought from the beginning was in fact the gift of light, which he saw now was continually in flux. What if a series of paintings of a given motif concerned itself not so much with the motif per se – such as a grainstack standing in a field – but with the effects of light as recorded in the changes to that motif depicted at specific moments over the course of a day or season? After all, wasn't light the most fundamental element in perception, without which we wouldn't see anything at all? Wasn't the reality of visual experience wholly conditioned by it?

Business Dealings

Monet's insight, one of the most significant realizations in the whole of art history, would have far-reaching implications for his own painting and arguably as great a significance for much of the art created over the century to come. However, his goals were never much concerned with revolutionizing painting, but with the far more modest and more challenging task of understanding the nature of his own perception, especially if that led him to make work that would sell. By late 1890, sales were indeed rising steadily as a result of Durand-Ruel's two American exhibitions of Impressionist works in the later 1880s and the triumphant show with Rodin of the previous year; this had been organized by Georges Petit, a rival dealer with whom Monet had no qualms about showing his work, despite Durand-Ruel's obvious displeasure.

With growing success, Monet, who already knew the value of what he produced (and, moreover, had fallen out with Durand-Ruel over the American

Grainstacks at Sunset, Frosty Weather (**1891**)

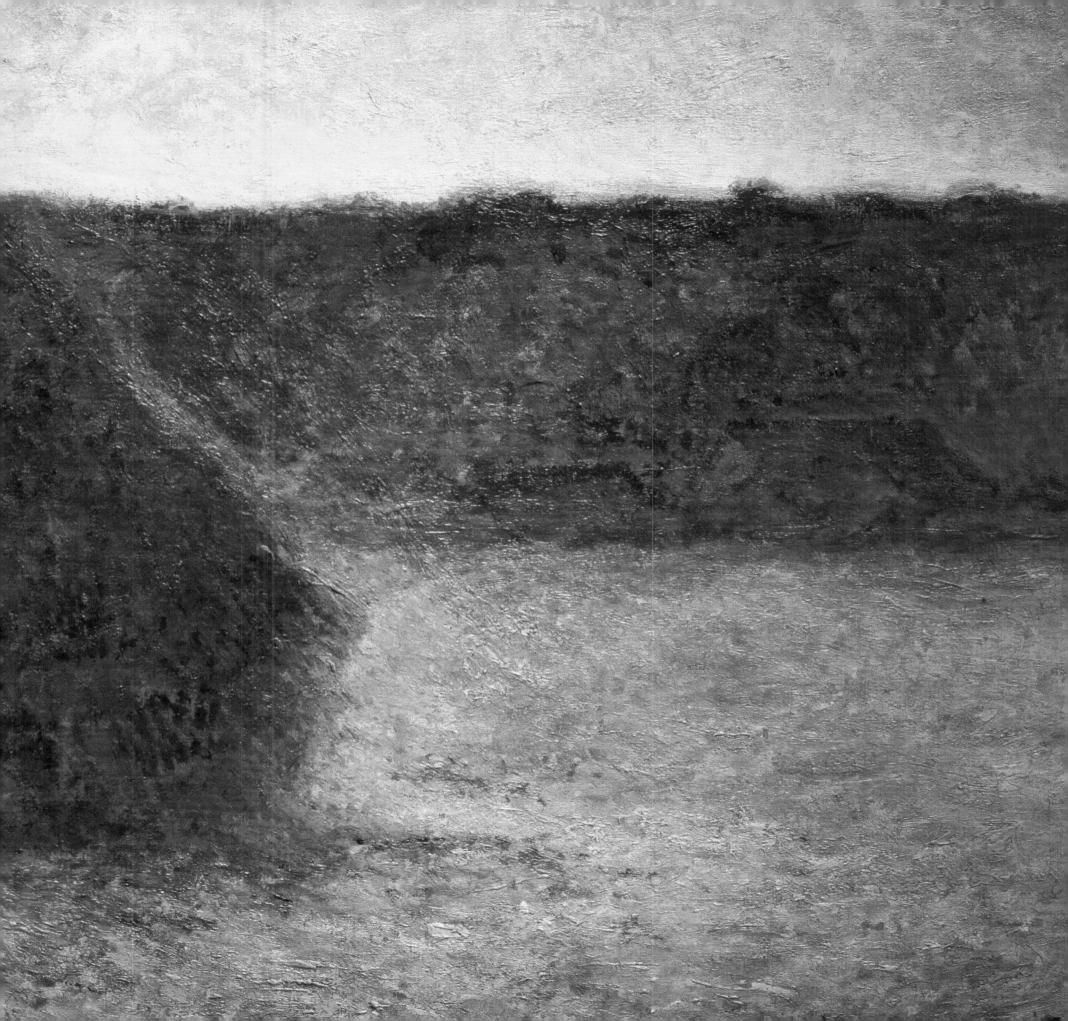

Garden at Giverny (1895), detail

shows), now clearly recognized a turning of the tide in his favour, and for the rest of his life would alternate between various gallerists all eager to show his latest work. Now flush with money, he may have been equally hard-headed that autumn in negotiating the purchase of the farmhouse he had been renting for more than seven years, but he met his match in the Balzacian owner, Père Singeot, who knew how much the house meant to Monet and forced him to settle for the rather exorbitant sum of 22,000 francs.

The Garden Grows

Still, settled it was, and Monet immediately began making plans for the major work on the garden that had been so long delayed. In the new year, he hired a gardener, Felix Breuil, and then several more over the next couple of years, to whom he would issue precise instructions based on his own detailed planning, in particular during the winter and early spring, when major alterations were carried out. Monet and his team began to replace the fruit trees in the orchard with a smaller number of Japanese cherries and apricots, and were soon transforming the rough grass in front of the house into a lawn, planted at judicious intervals with clumps of spring-flowering bulbs, a picturesque arrangement of floral interest that would later be repeated with the water lilies on the pond.

Above all, in accordance with Monet's plans, a continually updated sequence of dramatic planting combinations was introduced to the long borders on either side of the Grande Allée and the rows of shorter beds elsewhere in the garden. These kaleidoscopes of colour and texture, with seasonal changes orchestrated according to natural blooming cycles from early spring until late autumn, were frequently described as a living Impressionist painting of mixed, vibrating colour. In spring, for example, in one part of the garden there were beds of purple aubretias topped by bright red, yellow and pink tulips, while elsewhere poppies, peonies and

columbines would compete for sunlight with massed ranks of purple irises, Monet's favourite flower. With the box hedges gone, the painter also planted low-growing nasturtiums along the edges of the main borders of the Grand Allée, which he deliberately let sprawl across the path, annoying Breuil, who had more traditional ideas about garden maintenance. And the pergolas that were arched at intervals across the pathway, replacing the solemn shade of the former cypresses, spread dappled light filtering through the roses trained along them.

Monet's images of the mature flower garden, such as *The Artist's Garden at Giverny* (1900) and *Pathway in Monet's Garden at Giverny* (1902), clearly show how luxuriant it eventually became. And in future years, as his fame grew, popular gardening magazines like *Jardinage*, which ran pieces on gardens across the country that Monet read avidly and from which he took ideas, began to publish features on his own garden. But through the autumn of 1890 and the winter that followed, what most preoccupied him was the gradually evolving revelation of the series of paintings of grainstacks he had begun in late summer.

The Grainstacks

Monet had used haystacks, that most pastoral of motifs, in picturesque images of the 1880s. And he was not the first to have taken the more architectural grainstack as the main subject of a painting: Jean-François Millet (1814–75), another of the Barbizon painters, had done so in the early 1870s, towards the end of his life. But the Barbizons were still working within a tradition where the main agent of contrast within a picture was variations of tone rather than colour. The Impressionists were the first to recognize the potential of colour to convey not simply how we envisage certain objects or scenes in specific conditions – how they become summarized in the mind – but what the eye actually sees and how that sensory information conditions

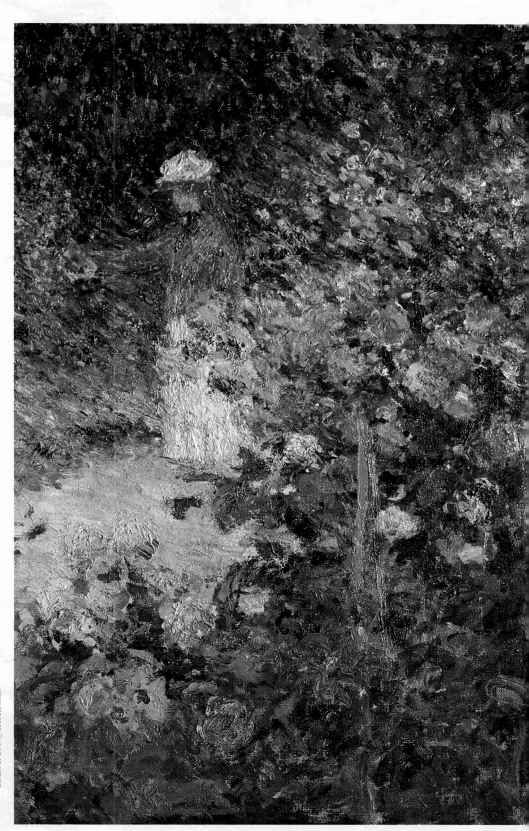

Garden at Giverny (**1895**), *detail*

'... more than ever, I'm disgusted by easy things that come in one go.'

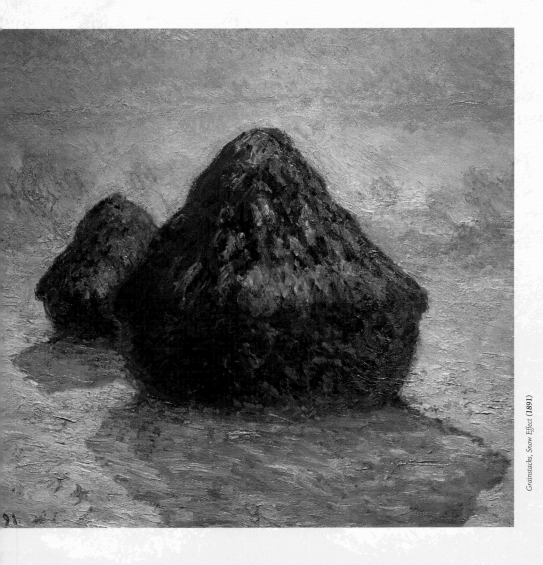

Grainstacks, Snow Effect (1891)

our living experience. The *Grainstacks*, in concentrating so obsessively on a single, almost unvarying motif depicted in a seemingly boundless array of colourings and illuminations, make subjective experience the explicit subject not just of any one picture but of the series as a whole.

Thus, whereas Millet painting the same subject might have included such divertingly picturesque elements as a human presence or a flock of sheep, Monet deliberately simplifies the picture, a strategy that foreshadows much of the Modernist painting that would follow in the coming decades. The background houses and hills are barely discernible in most of the *Grainstacks* series, narrowing our focus of attention to the stacks themselves – the most mundane of subjects – and the natural spectacle of light. To think that, given such limitations, the paintings not only might sustain the viewer's interest across the series but might grow in fascination precisely because of these limitations was not so much a huge gamble as it was a conceptual leap forward. Characteristically, it is one that Monet had been pondering for some time, and one whose implications for art would be huge and whose influence can still be felt today.

Monet and Motif

In some of these images, the sunlight striking a stack from the side models its three dimensions for the viewer; in others, stacks are lit from behind or *contre jour*, assuming the form of opaque, two-dimensional wedges placed enigmatically in a field of winter snow. In another image begun in the autumn, *Grainstack, Pink and Blue Impressions* (1891), the artist positions himself so that the sun is again setting directly behind the stack, whose base has turned a molten red, as if physically ignited by the warm glow of twilight. The snow in many of these paintings is yellow in winter daylight, turning blue in another image as the sun dips toward the distant hills and, in yet another, an extraordinary but wholly believable Mediterranean pink

The Artist's Garden at Giverny (1900)

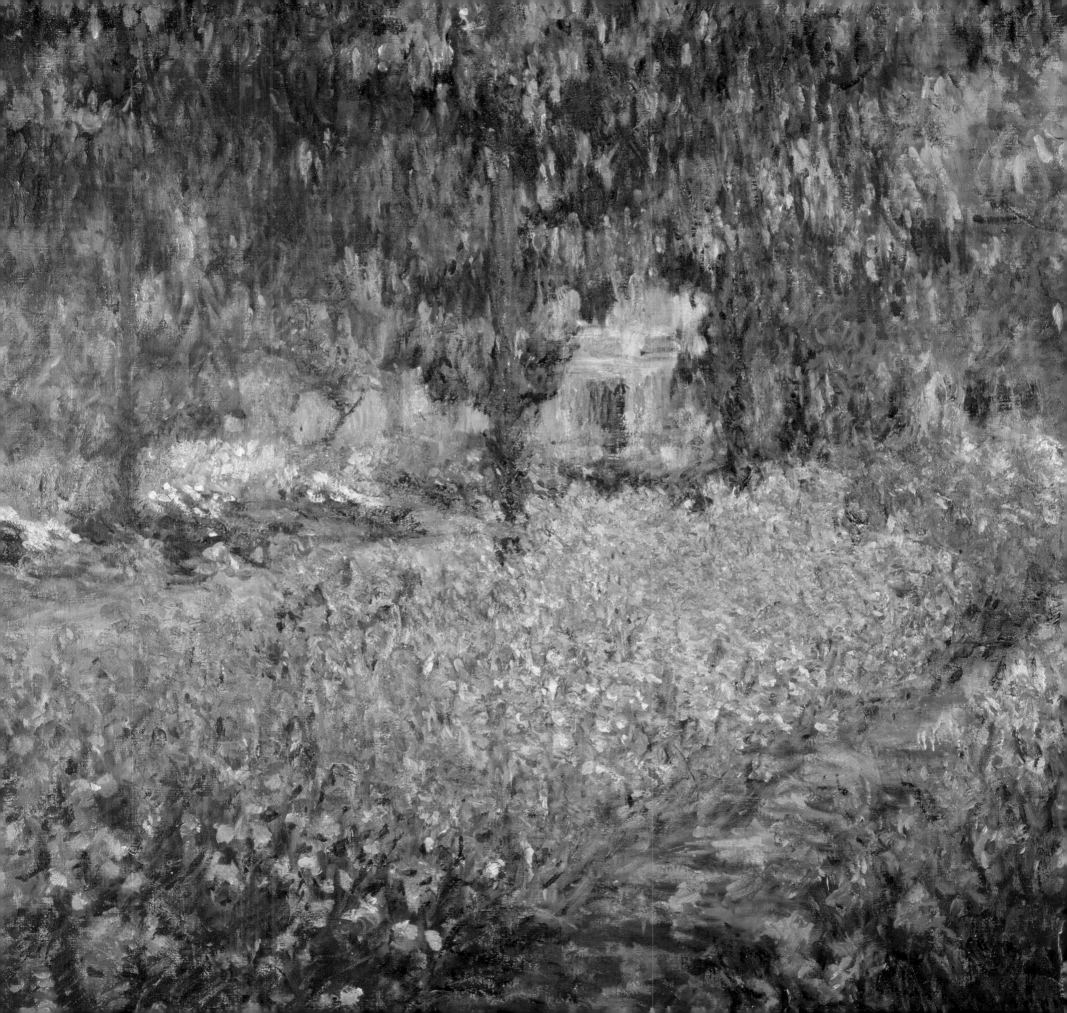

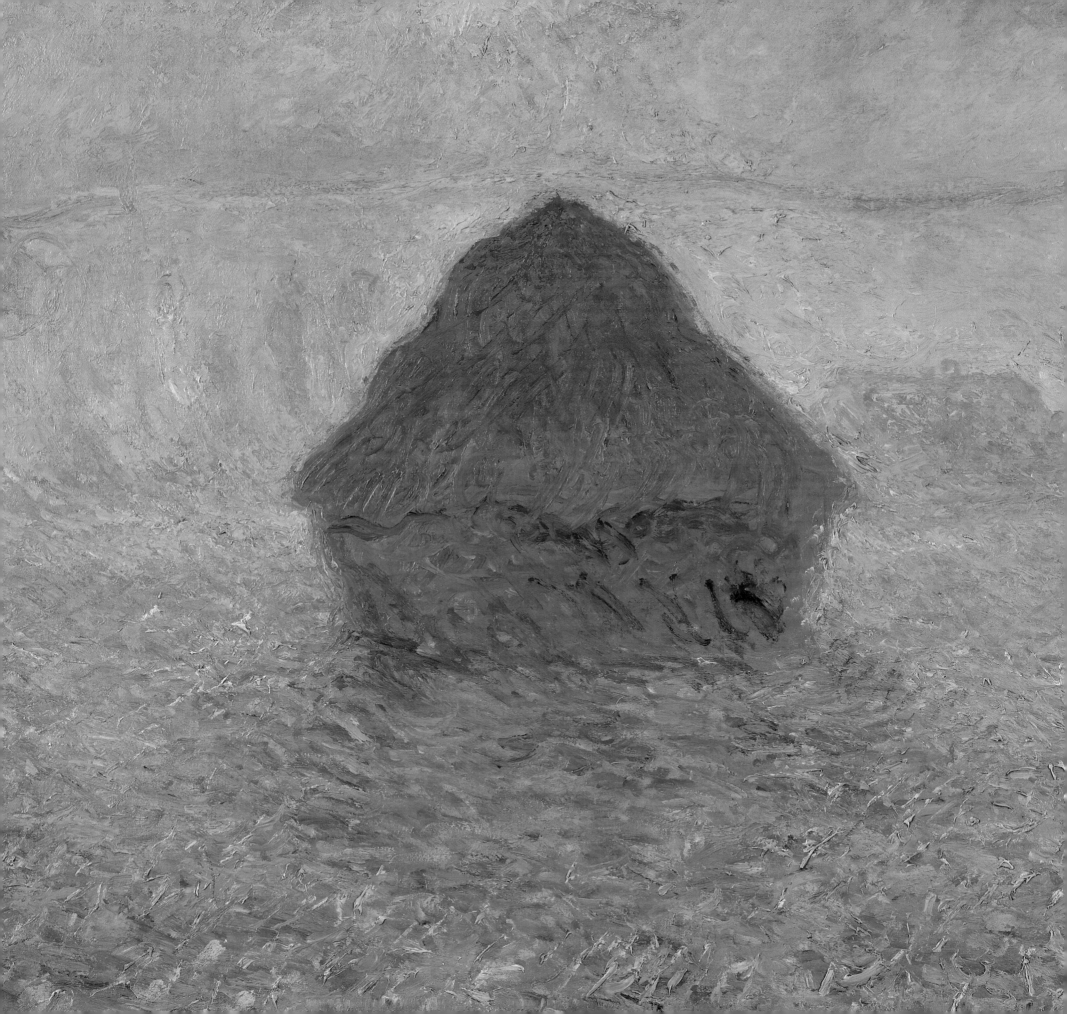

as the dusk draws on. The hills themselves are by turns blue or violet or white or yellow, while shadows are depicted using a panoply of hues, just as they really appear if we care to study them closely. No single element remains stable across the series. Of course, the minutely observed fluctuations in light, though apparently fleeting observations, in fact point to a deeper theme that would underpin Monet's thinking from now on, an idea stated clearly in a letter to his friend Gustave Geffroy on 7 October 1891, just as he was embarking on the series.

Complaining that, 'more than ever easy things which come at one go disgust me', he also identified the remedy, saying, 'The further I get, the more I see that a lot of work has to be done in order to render the thing I'm looking for: "instantaneity", the *enveloppe*, above all, the same light spread over everything.' On a superficial level, instantaneity – the immediacy of an unrepeatable moment – had long been his goal. But Monet now realized that this immediacy resided in specific conditions of atmosphere (the *enveloppe* or envelope) and light that affected everything he saw; these were the fundamentals of his image, to which all other elements were subordinate. He put it quite explicitly a few years later when he said, 'To me the motif is an insignificant factor; what I want to reproduce is what lies between the motif and me.'

The Observer of Light

Given the difficulty of conveying such an intangible, even numinous idea – the air surrounding objects as made manifest by light – to a public used to pictures having clearly defined symbolic or narrative subjects, the notion of a series seems an inevitable development. But no one had ever tried it before, just as no one had observed light with such close attention. Set beside the *Grainstacks* and the series which followed over the next decade, light in much earlier landscape art seems summary and unobserved. Even a

Grainstack, Sun in the Mist (1891)

'What I'm looking for: "instantaneity", the "envelope" above all, the same light spread over everything.'

Grainstacks, Pink and Blue Impressions (1891), detail

work painted only some 30 years earlier, Corot's *The Four Times of Day: Morning, Noon, Evening, Night* (c. 1858), now in the National Gallery in London, seems generic, idealized by comparison. And Monet's recording of apparently randomly chosen moments in his series seems to modern eyes to approach more closely the effect Corot's title suggests he had intended for his series, charting the passage of time through an assortment of moments which, in their apparent arbitrariness, seem all the more likely to be real.

But instantaneity, conveying not the glimpsed impression but the essence of a given moment, was hard to achieve, much harder than similar momentary impressions Monet had striven for earlier in his career. The specific illumination of each scene demanded not only patience as he waited sometimes for several days for the same conditions to return; it also required significant work away from the motif, in the studio, where Monet drew on not only his impressions of the scene, but his memory of it and the conception of it that had formed in his mind over time. His favoured public image of the faithful recorder of natural facts, painting 'directly in front of nature, while trying to render my impressions in the face of the most fugitive effects', was a description of his working methods that was increasingly incomplete as time went by.

A Revelation

This was immediately apparent to all who saw the exhibition at the gallery of Durand-Ruel (with whom Monet was once again on good terms) in May 1891. The reviews were unanimous in their praise, and Monet's peers were equally astonished. Pissarro was at first dismayed at the idea of an apparently repetitive group of paintings he had yet to see, comparing Monet's healthy sales in recent years to his own continuing struggles, and declaring that such repetition was 'the terrible consequence of success'. But having attended the exhibition, he was completely converted. Even

Grainstacks, Pink and Blue Impressions (1891)

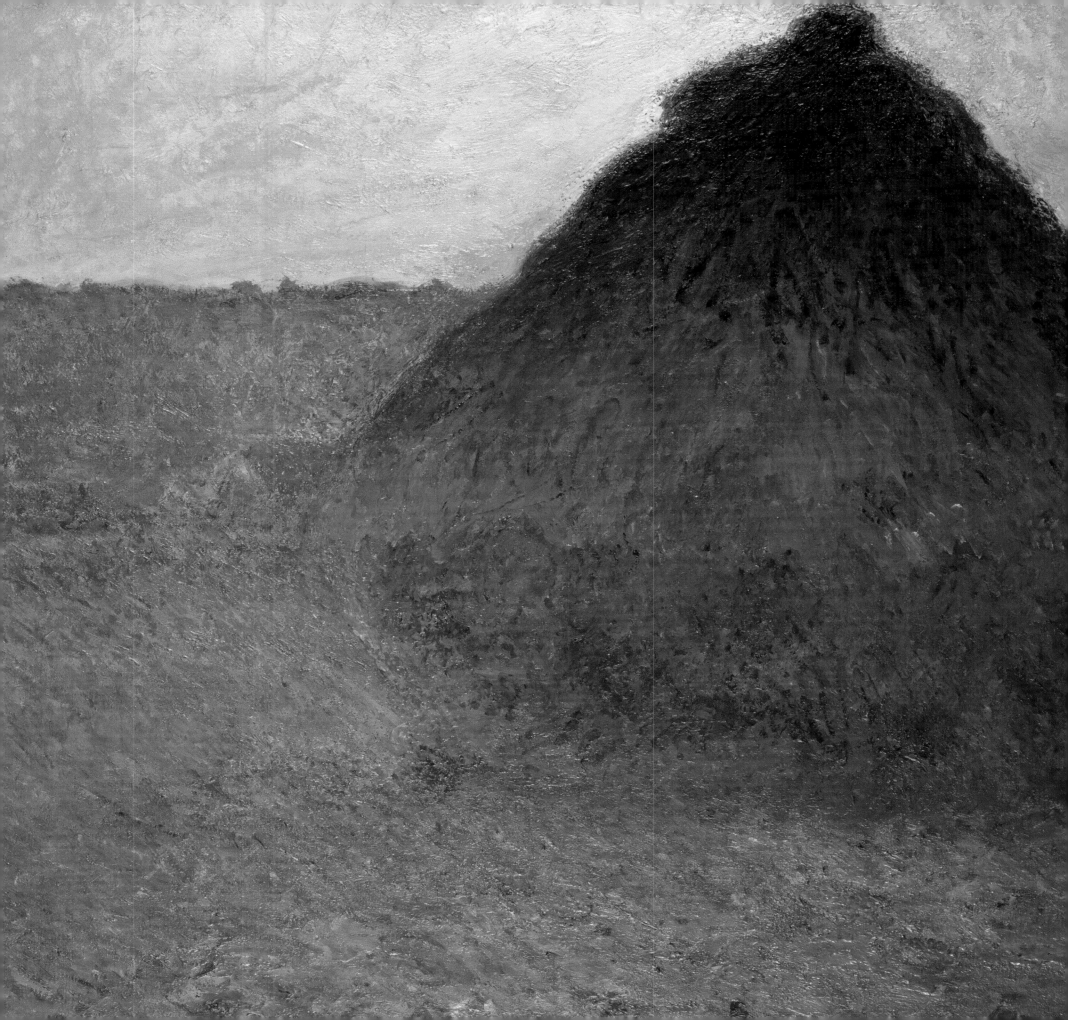

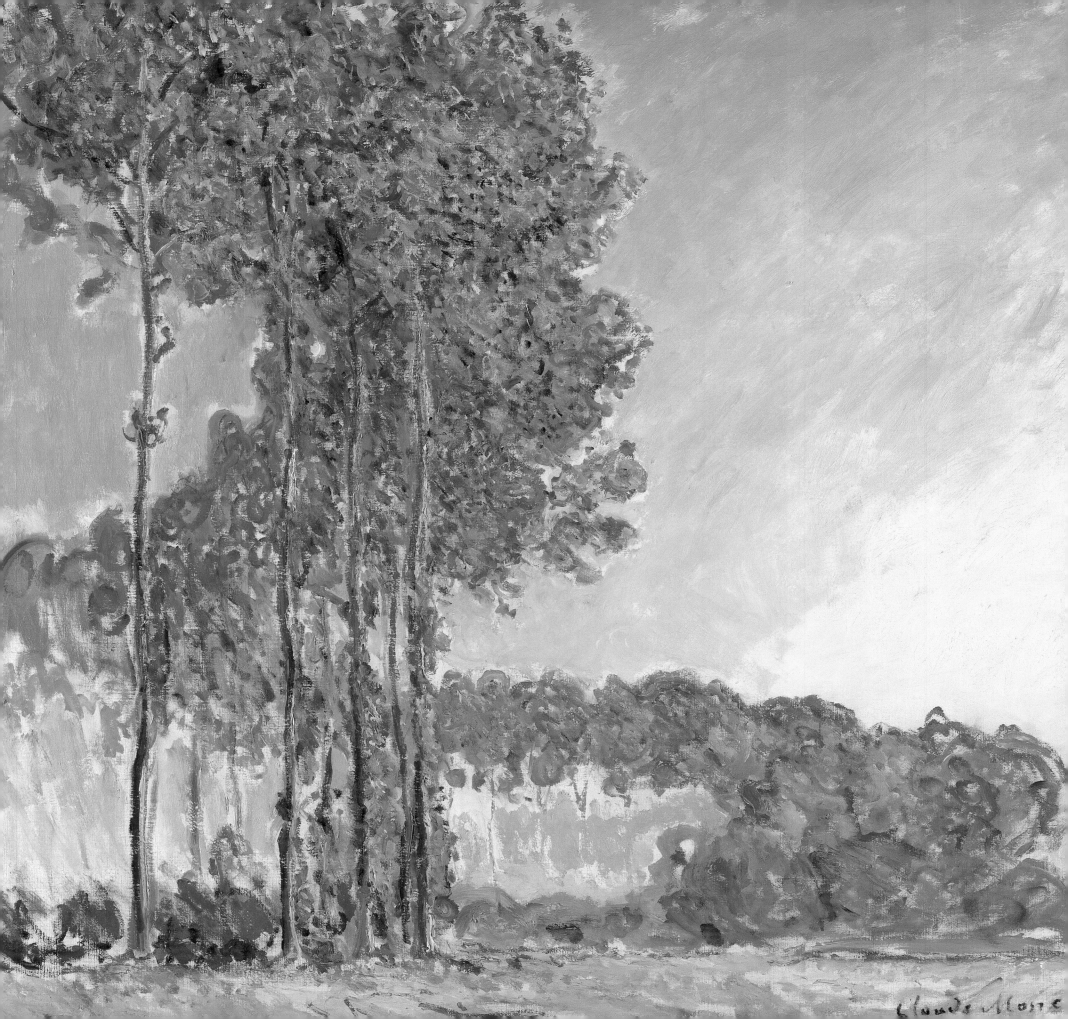

more astounded was Wassily Kandinsky (1866-1944), who at first failed
to recognize the motifs – the grainstacks – which were the nominal
subjects of the series, so unusual was the colouring and so transformative,
too. As he wrote in his memoirs, 'What suddenly became clear to me was
the unsuspected power of the palette, which I had not understood before
and which surpassed my wildest dreams.' Temporarily overshadowed by
the colour experiments of the Neo-Impressionists, Monet was reminding
the public of his achievements as the master of observed colour, in the
process pointing the way to its total liberation by the Modernists of the
coming generation.

But, above all, visitors to this historic show were struck by the effect on
the viewer of the total series, rather than of any individual painting, and of
this cumulative effect on the perception of any one work. Cézanne, on
seeing these paintings, and clearly fooled by the appearance of spontaneity
into the inference that this must have been their mode of execution,
declared that Monet had 'the only eye and the only hand that can follow a
sunset in its every transparency and express its nuances on the canvas at
one go without returning to it'. He seems to have been taken in by the
particularity of these images, projecting their sense of immediacy into a
mistaken idea of how they were created. In this regard, the collective
power of the series, its tendency in depicting so many apparently arbitrary
moments to suggest all the other moments as yet uncaptured, may also
have conditioned his response. As one writer said of the *Grainstacks*,
'they acquire their full value only by comparison and the sequence of
the whole series'.

The Serial Painter

Monet would have concurred, as from now on, this serial method would
come to dominate his output, so that except in a few instances, he would

'For me, a landscape does not exist in its own right, since its appearance changes at every moment.'

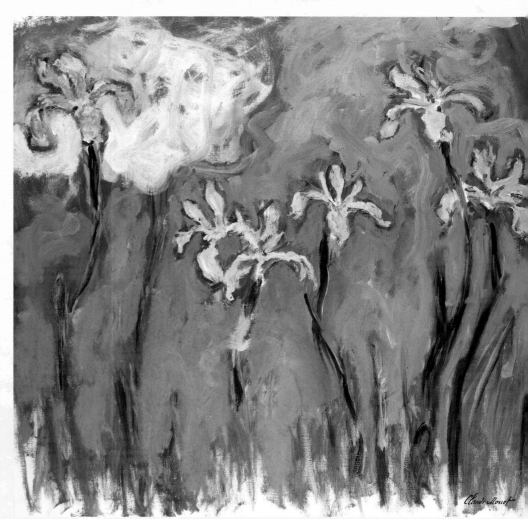

Yellow Irises with Pink Cloud (c. 1918)

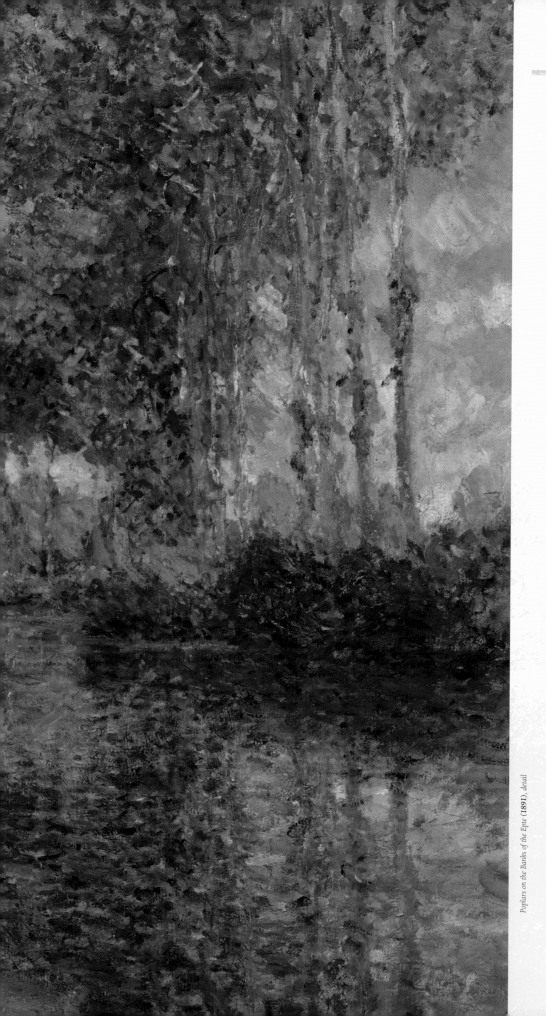

Poplars on the Banks of the Epte (1891), detail

jealously guard every future series in its entirety until he considered the whole ensemble ready to be shown. Indeed, just as he habitually worked on all the parts of a painting at once, so he would work on the images in a series not consecutively but collectively, bringing each to completion in concert with the others. Such a practice was implicit in his working methods in the field, where a given quality of light might last a matter of minutes, forcing him to cease work on the canvas once the conditions had changed and to wait patiently for the light to assume another quality that he recognized in one of the many uncompleted canvases he invariably brought with him. It is here, in an understanding of his unusually holistic method, that we begin to appreciate the continuity of Monet's underlying world view. This concern for the harmony of the whole is as implicit in everything he painted from now on, especially the *Water Lilies* series of his final decades, as it is in the garden from which those last great works emerged.

The success of the *Grainstacks* series and the speed with which buyers came forward to claim them must have confirmed to Monet the rightness of his instincts, and the same summer, he embarked on a new series whose motif was also to be found very close to home. Taking his studio boat on to the River Epte, the artist set himself up on the far bank and began to paint images of the long enfilades of poplar trees that lined the river. But, having originally intended this as a summer series, it was not long before Monet got wind of a potential threat to his plans. The poplars belonged to the local community, who had come to the collective decision to sell the asset to a timber merchant. Monet, obliged to enter into negotiations with the buyer, secured an agreement under which, for a goodly sum, the merchant would delay cutting down the trees until the artist had finished his paintings. Monet literally bought the view for the time that he needed it; luckily, he was now in a position to do so.

Poplars on the Banks of the Epte (1891)

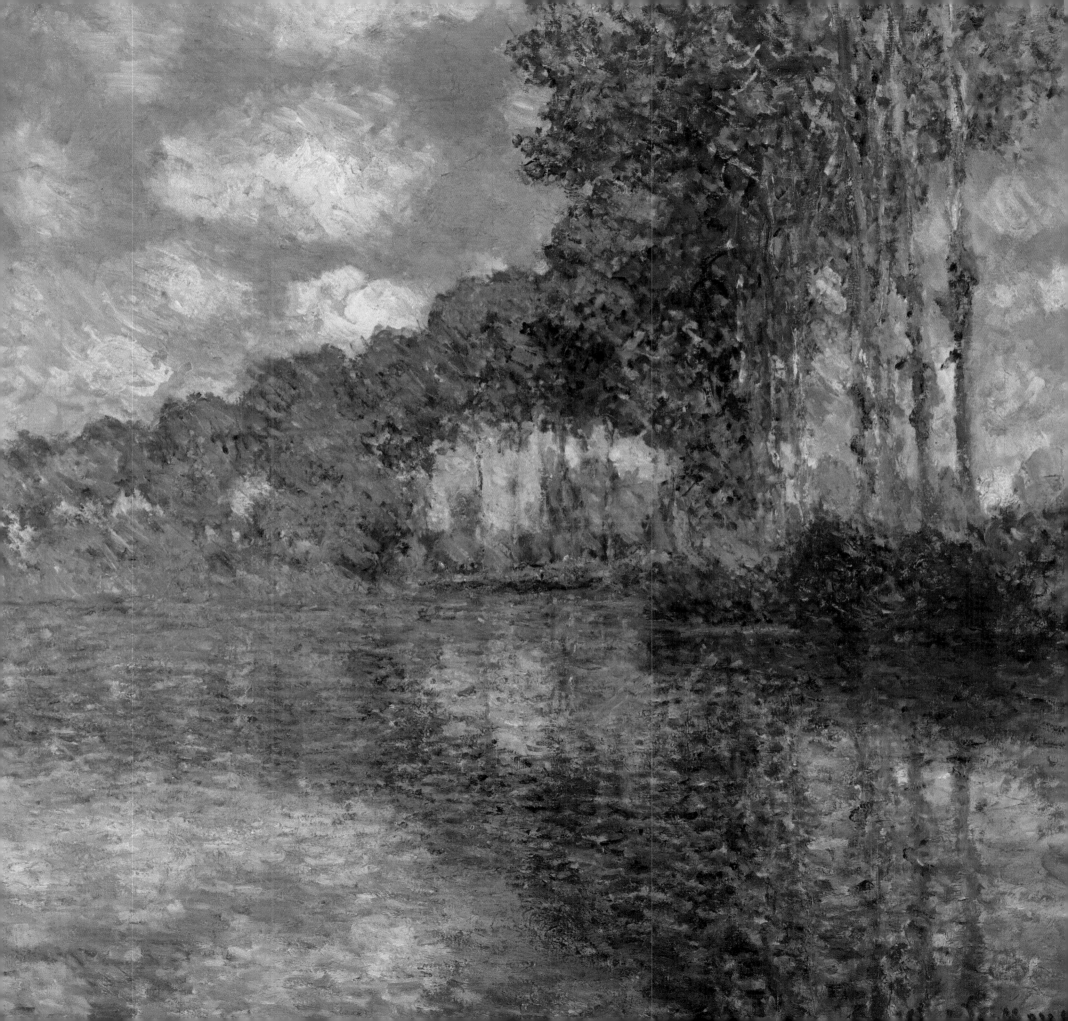

'I'm getting so slow at my work it makes me despair, but the further I get, the more I see that a lot of work has to be done in order to render what I'm looking for...'

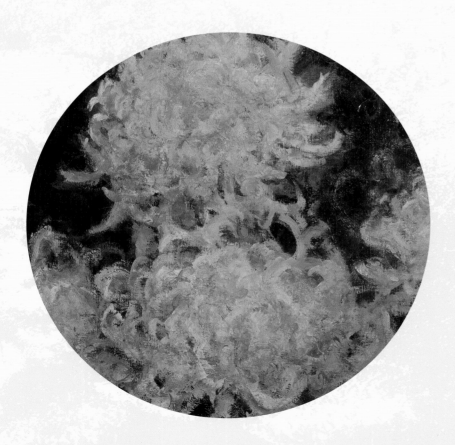

Bridge in Monet's Garden (1895–96)

The Purchase of a Pond

This would not be the last time Monet found his own plans disrupted by the vicissitudes of local opinion. In early 1893, the artist bought a parcel of land which included a tiny pond, very close to his property on the other side of the road and the railway track that ran behind the garden wall. He applied for permission to divert into the existing pond the River Ru – in fact, more of a stream than a river – which flowed just the other side of this piece of land. He intended to create a water garden, a long-cherished dream, filled with aquatic plants similar to those that grew naturally thereabouts, in particular, water lilies such as the small, wild varieties that could already be found in the pond. But the subtlety of Monet's conception, its blurring of the distinction between garden and wilderness, between culture and nature, was rather lost on the villagers, who were worried about the lilies he planned to introduce not only poisoning the little river, and thereby the cattle that drank from it downstream, but also spreading through the river system and choking the flow.

Permission was denied, causing Monet to condemn his neighbours in private with a volley of curses. But having calmed down, he enlisted the help of a prominent local journalist, C.F. Lapierre, who wrote a strongly worded appeal to the local prefect. The new petition was firm but also emollient, offering to limit replenishment of the stagnant waters of the pond to evening hours alone, with the river flow controlled by means of sluice gates. Monet was given the go-ahead and at once his gardeners set to work, adding weeping willows to the poplars and aspens already growing around the small existing pond, as well as Japanese tree peonies and a stand of bamboo. Along the banks, indigenous plants such as heather, hydrangeas, rhododendrons and azaleas were also planted. Water lilies were planted the following year, 1894, at the same time as Breuil was handed the task of looking after them. The water lilies Monet introduced were initially Western

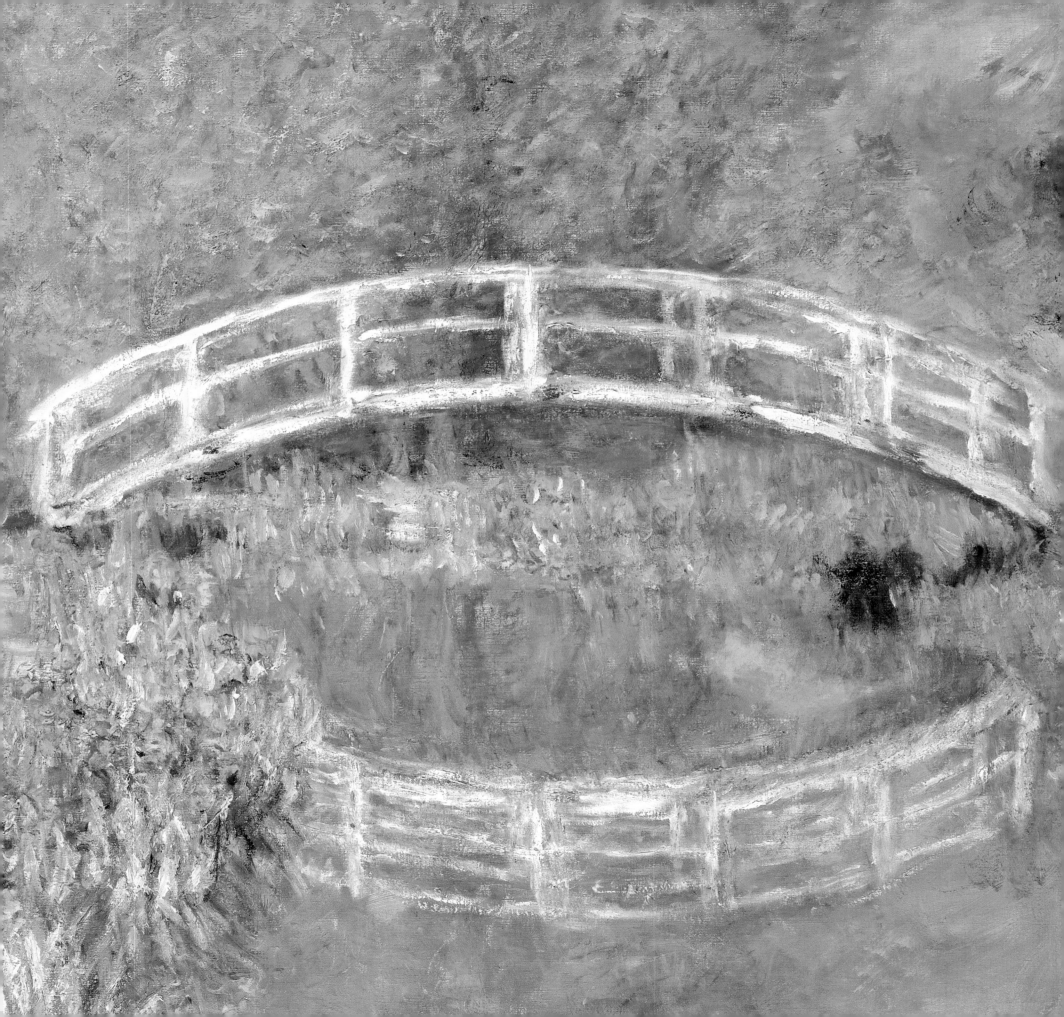

types, but to these he later added exotic varieties, especially those with brightly coloured flowers sent to him by friends in Japan. But despite the bamboo, the Japanese bridge that was added a year later, and the general resemblance of the water garden to those seen in the prints he collected, he denied that the garden imitated Japanese models, saying that the plants were mostly Western and in some cases native to the region around Giverny.

A Man of Flowers

Like any truly creative person, Monet took ideas from wherever he found them. Besides his assiduous reading of the gardening magazines that had grown in popularity in the late nineteenth century as gardening became an affordable pastime for a growing bourgeoisie, Monet also took any opportunity he could to talk to expert horticulturalists or to visit other notable gardens, always keen to learn about new plant varieties and novel ideas in garden design. It was a side of his creativity where nothing was expected of him and everything was an absolute pleasure. Indeed, he was always keen to show guests around his garden before going anywhere near his studio, no matter whether they were garden lovers or not. He liked nothing better than to talk about gardening; his closest friends in the second half of his life – Geffroy, Mirbeau and Clemenceau – were all keen gardeners. And his garden, like his painting, was a way of communicating his love of the natural world, which with the creation of the lily pond was finding a new form. But at the same time as his plans for the water garden were beginning to take physical shape, Monet was also immersed in another series of paintings in which aesthetic experiment reached new levels of subtlety and daring.

Rouen Cathedral

In early 1892, Monet had returned to an urban subject for the first time in over a decade, in this case, the Gothic cathedral of Rouen, one of the great

Chrysanthemums (1897)

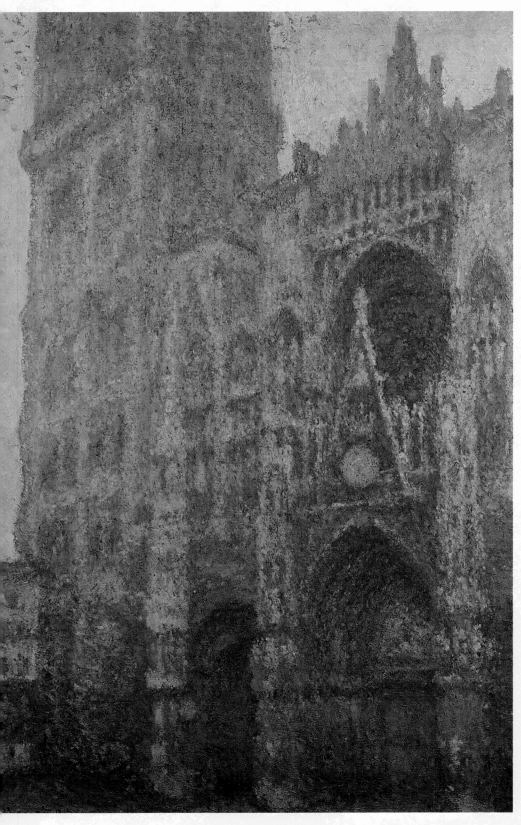

Rouen Cathedral, West Portal, Grey Weather (1894)

monuments of French culture. On the surface it seems a strange choice for this dedicated observer of nature – moreover, a confirmed atheist to boot. But Rouen is where Monet installed himself during the early months of 1892 (and then again in the two succeeding years), renting part of a fitting room above a milliner's shop in the square that faces the west façade. Working conditions, which as ever were less than ideal, were aggravated when the milliner's female clientele reacted with embarrassment to the presence of an artist – a male artist – painting as they were fitted for their latest bonnets. Such were the demure conventions of the day that Monet was obliged to erect a screen to block their view of his activities so that he could continue working undisturbed. Behind the screen, he submitted to an exhausting regime of 12 hours' painting each day, making full use of daylight, working on up to nine canvases at a time, moving from one canvas to the next as the quality of light shifted from one set of conditions to another. In 1889, his friend Octave Mirbeau had written of the painter staying at a particular canvas for half an hour before the light effect he was after had melted into something else, but in fact the time window could be even less than that; in some cases, a matter of a few minutes at most.

Again, it was the demanding acuity of his perception that persuaded Monet to paint so many different times of day and so many different weather conditions. In actual fact, it represented an efficient solution that mitigated the vulnerable position in which he must have felt his artistic programme often placed him – at the mercy of the elements and of his own precise idea of each image. This strategy of multiple canvases meant that he could serve this exacting specificity and not sit around all day waiting for a certain set of conditions to return, if indeed they did. And again it is clear why landscape paintings before Monet can seem somewhat generic compared with his example. How many painters have ever gone to such lengths in pursuit of something so impermanent, so fleeting? This is the decisive moment of Henri Cartier-Bresson (1908–2004) long before the fact

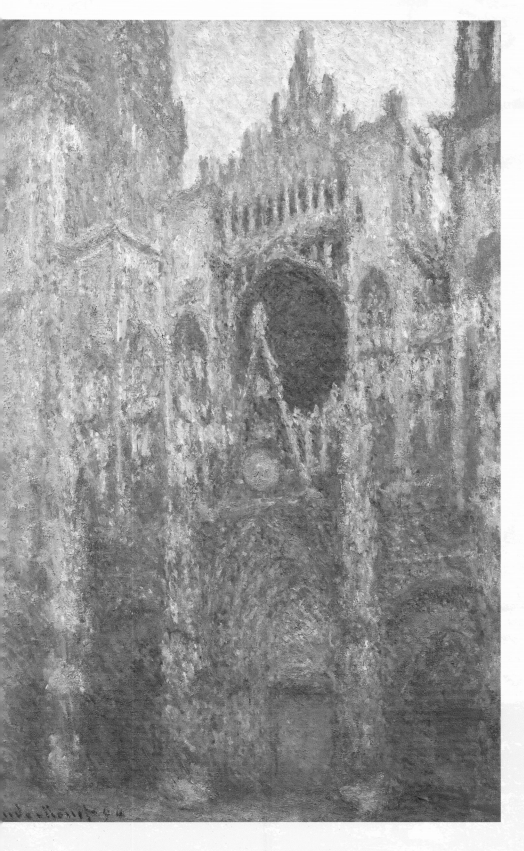

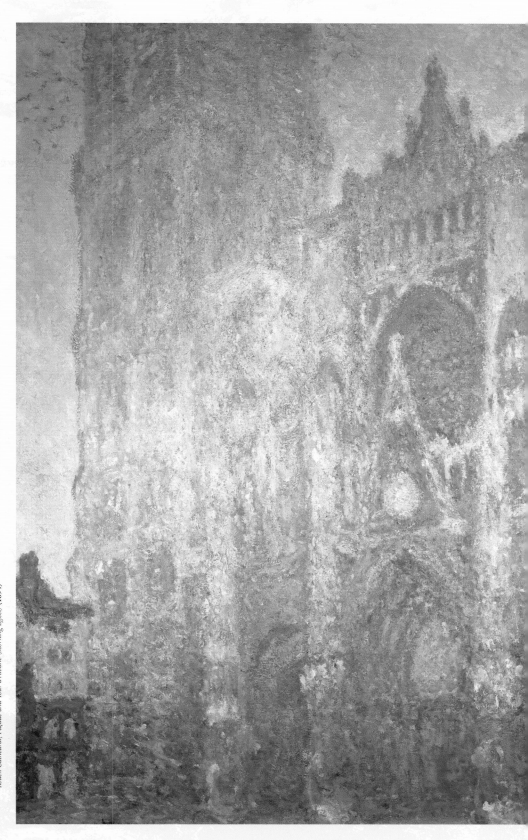

Rouen Cathedral, Façade and Tour d'Albane (Morning Effect) **(1894)**

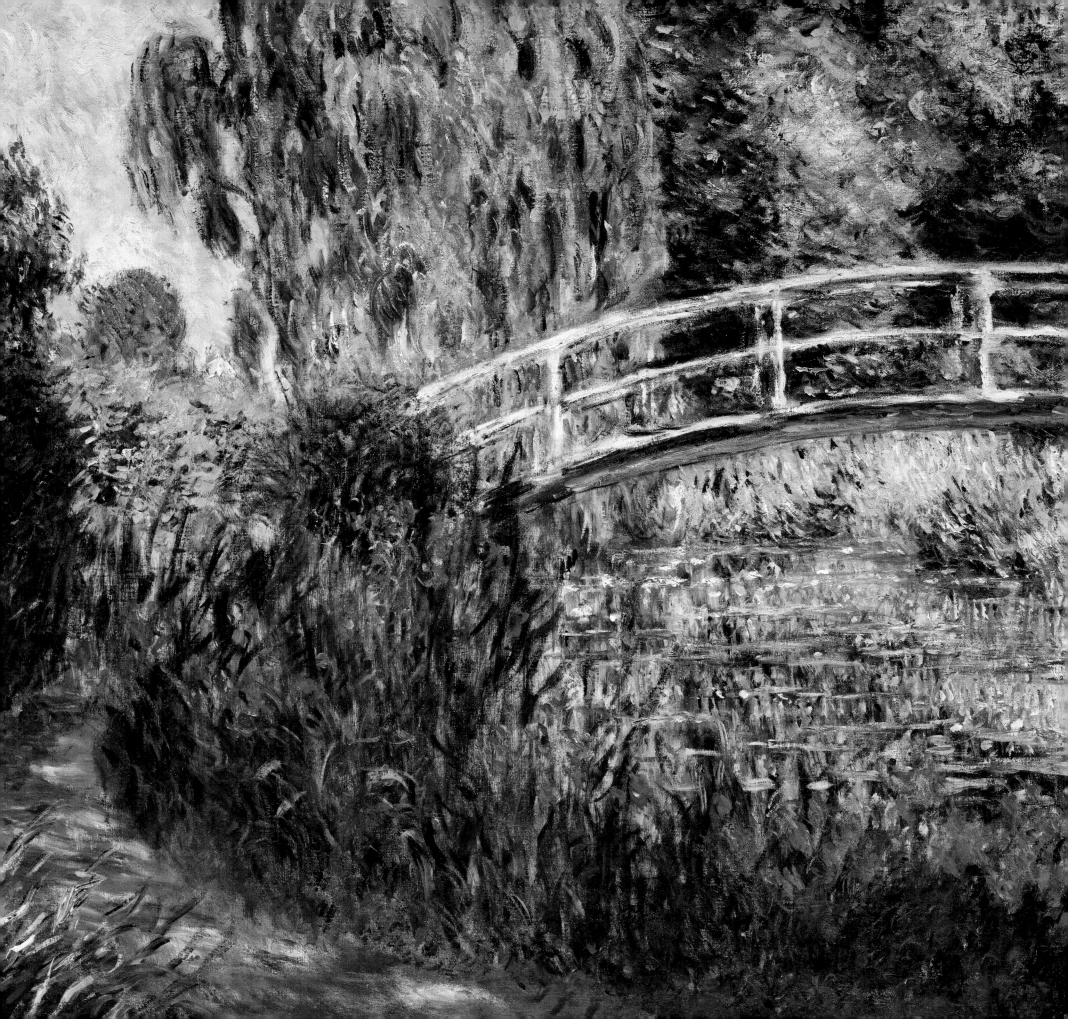

– not accidentally seized but deliberately, patiently revealed through hard work and unflinching observation over a long period. Moreover, in Monet's conception of a world transformed by light over time, every moment is decisive, every instant pregnant with both those that preceded it and those that will follow it. The act of perception is itself the event perceived.

The Light of Impermanence

These qualities were immediately recognized by all who saw the *Rouen Cathedrals* exhibition in 1895. Georges Clemenceau, then a journalist whose friendship would grow in importance as the years went by, dubbed the paintings 'celebrations of immediate experience' and called for the State to purchase them for the nation. Nothing was done at the time, but when Clemenceau himself became prime minister more than a decade later, one of his first acts was to make good on that promise by purchasing one of these images for the national collection using public money.

But there is still the question of why a cathedral would be so compelling to a non-believer. Monet's lifelong interest in the fleeting effects of light had drawn him most often to water, the most palpable transient element and one in which the solid world in being reflected is made to seem equally ephemeral. But even in the great cathedral of steam that was the Gare St-Lazare, the subject of his first informal series and as solid a monument of modernity as he could have chosen, the figures and even the shapes of distant buildings appear as if in danger of dissolving in the steam issuing from the trains; as if the gaseous and solid elements are competing for primacy of being. Now, with these almost identical images of one of the most steadfast cultural monuments he could have selected, light and atmosphere in the form of the envelope combine to transform the age-old building into a dreamlike structure whose material presence may be, after all, nothing more than an illusion. Again, the implication

The Japanese Bridge, Pond with Water Lilies (1900)

'**I am more exacting, and it takes a long time to finish a picture.**'

seems clear: if a structure as apparently permanent as Rouen Cathedral can seem as ephemeral as the briefest garden bloom, is there anything in the world that is not equally subject to change and decay?

Of course, Monet may not have intended such a conclusion to be drawn. The atheist painter was almost certainly not attracted to the supposed timelessness of Rouen Cathedral out of a subversive desire, even unconsciously, to render the eternal as fleeting, impermanent; neither is it likely that these images were meant as a tacit commentary on the claims of eternal life to come, on which the permanent power of the Church was founded. It was probably not the painter's intention either, even implicitly, to remind us of the finite duration of the life we can all agree does exist. Monet always batted away the more extravagant interpretations placed upon his work as his fame grew, feeling that the images should speak for themselves. But there is, nonetheless, an unavoidable sense in these transcendent paintings of matter subservient to light of the deeply held view of life that informs all of Monet's later work, especially the *Water Lilies* and the *Grandes Décorations* of his final years.

A Season of Marriages

Impermanence and change may be a theme of these paintings, but they were not a feature of Monet's life. In 1892, after more than a decade of common-law cohabitation, Monet married Alice in a quiet ceremony, in part to enable him to give away Alice's daughter Suzanne at her wedding the following week to the American painter Theodore Earl Butler (1861–1936). In fact, Butler was one of a number of minor Impressionists, most of them Americans, who gravitated to Giverny during these years, bringing to the village a new prosperity and turning local opinion gradually in favour of this eccentric artist with his unconventional family and his tell-tale urban ways.

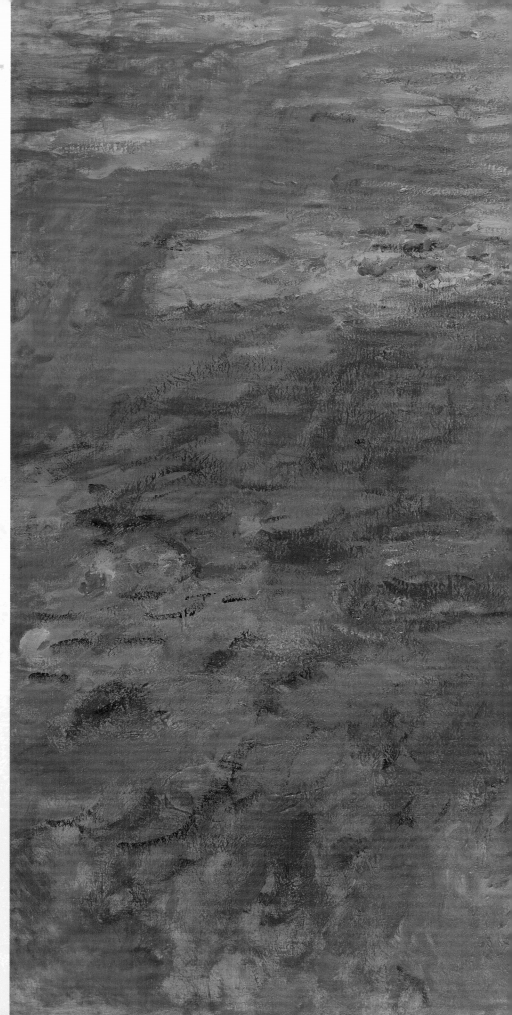

Water Lilies (c. 1919)

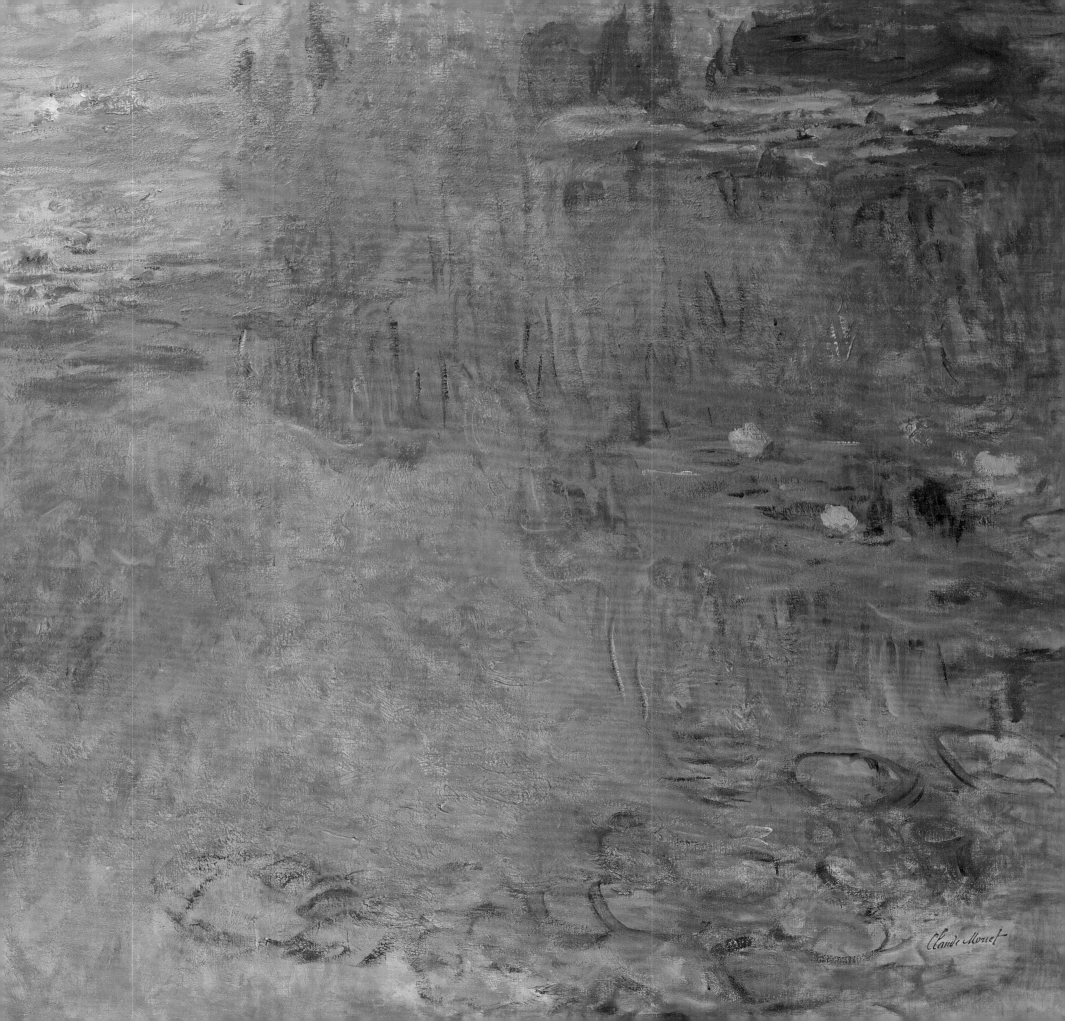

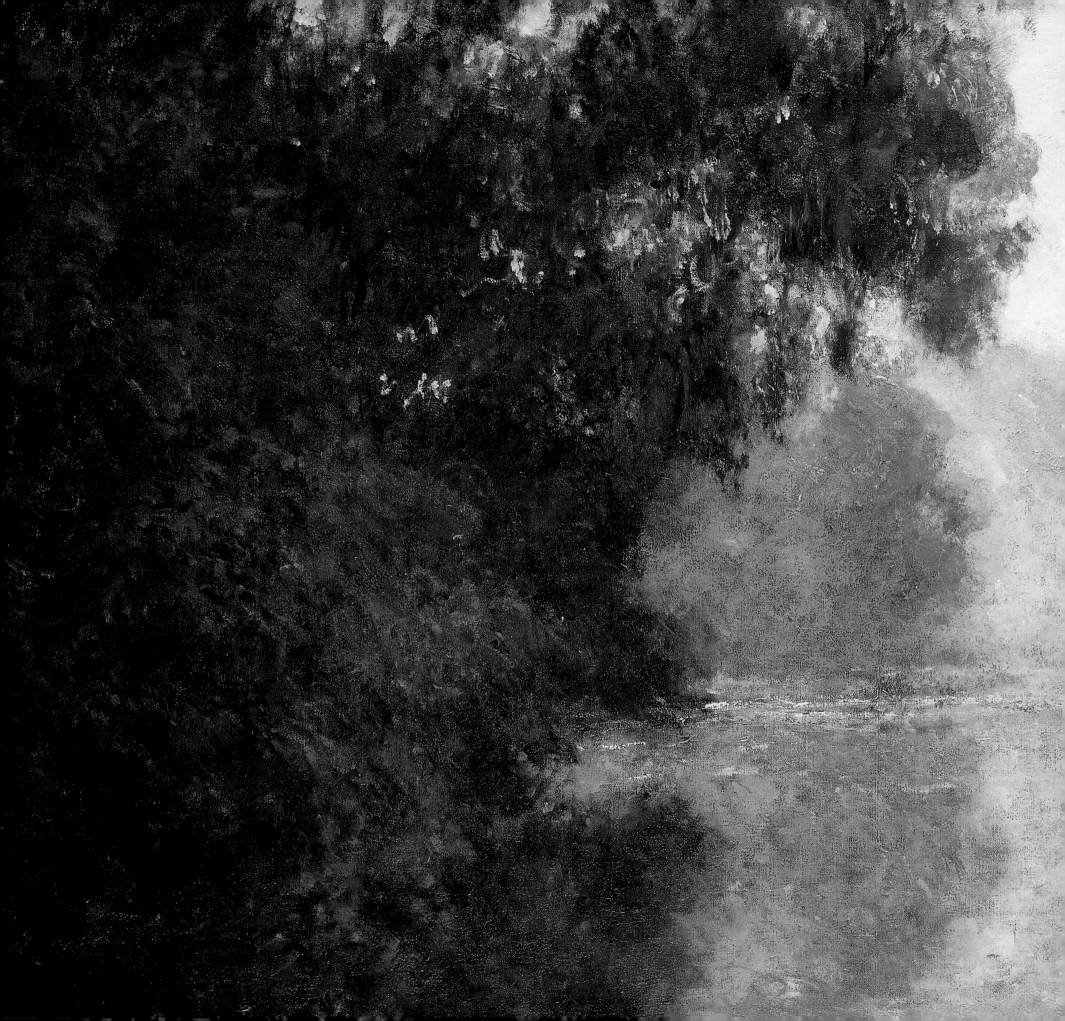

The expatriot community at Giverny had grown steadily after the first exhibitions of Impressionism in America in the mid-1880s, though its growing status as a cultural honeypot brought Monet plenty of attention he would gladly have done without. Not that all of these newcomers were unwelcome: in the late 1880s, John Singer Sargent (1856–1925), an American born in Florence and by all accounts a thoroughly cosmopolitan figure, made regular summer visits to Giverny and had soon become a good friend. A very different painter to Monet, he was nonetheless a virtuoso who on one occasion painted the artist and his wife in the manner of the Impressionist master. By the time the American had taken up residence in England in 1891, the art colony at Giverny had grown to some 40 permanent residents, most of whom Monet chose to ignore. There were just a few to whom he gave occasional access, painters who in some cases – such as his neighbour Lilla Cabot Perry (1848–1933) – happened to be keen gardeners. Perry was among a select few to whom he also gave the pearls of painterly wisdom they all craved; his stepdaughter Blanche, whose own work was good enough to be held today in the collections of various French provincial museums, was the only pupil to whom he consistently gave advice.

Mornings on the Seine

It was never difficult to keep hangers-on at bay. Although often at home throughout the 1890s, Monet was always working, either in the studio or in front of his favourite motifs around the valley. And returning to the environment of the *Poplars*, the river (this time the Seine rather than the Epte) would provide the subject of his next series. Executed over a long sequence of mornings, beginning in 1896 and stretching into the summer of the following year, the *Mornings on the Seine*, as they are collectively known, adopt a single viewpoint, uniformly repeated across the entire set, at a single time of day, the time of mists and quietude in the interval after

Morning on the Seine, Effect of Mist (1897), detail

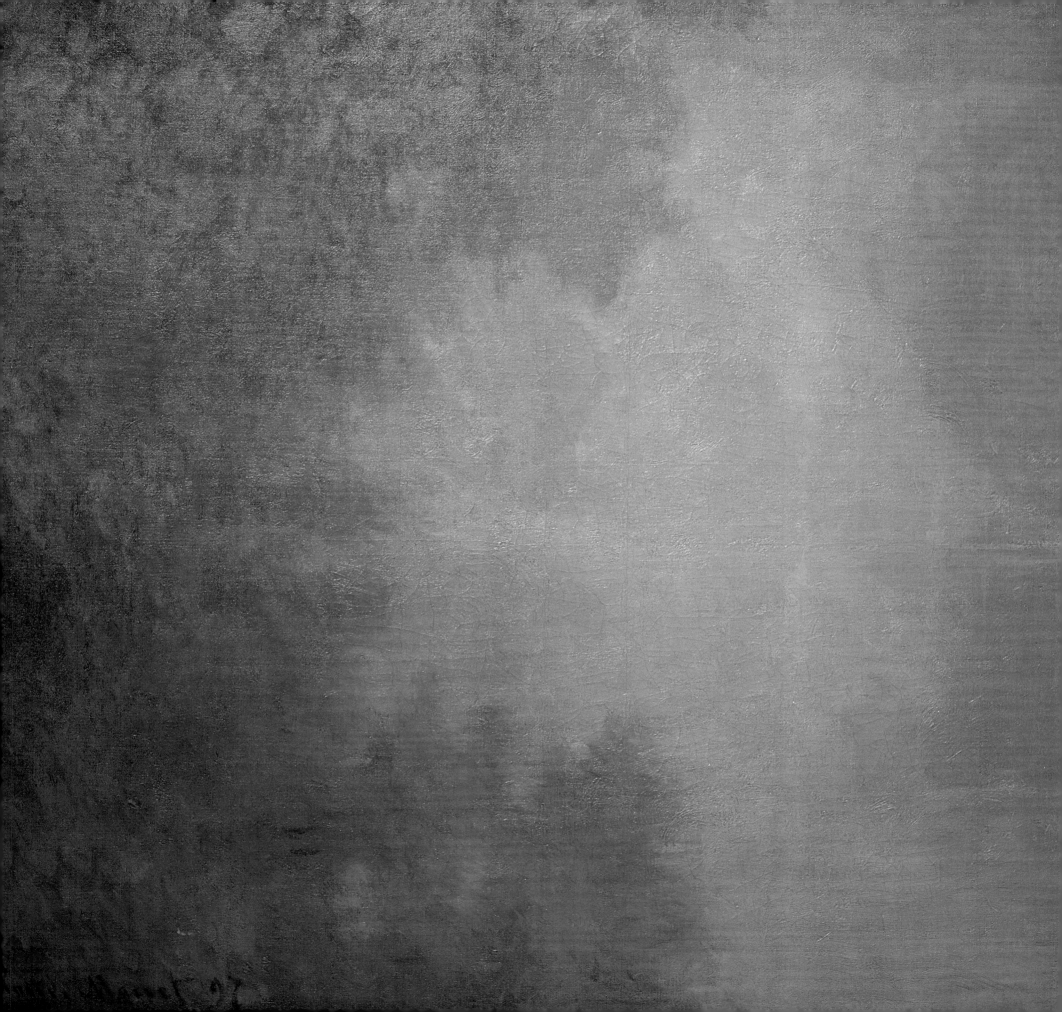

dawn. Monet had always risen with the dawn, but in this case, he was getting up at 3.30 a.m. so as to be out on the river at first light.

Like the *Rouen Cathedral* series, the *Mornings on the Seine* depict an astonishing variety of effects of light and atmosphere gleaned, in this case, from a single liminal time of day. It is as if the painter was deliberately testing his perceptual sensitivity, his ability to depict the tiniest changes in fluvial light 'spread over everything', the envelope which for Monet conditioned our living experience of the world. Unlike the *Cathedral* paintings, which are so impasted with layers of paint that their surfaces have been likened in texture to the masonry the paintings depict, the surfaces of the *Mornings* are smooth, which only adds to the impression that these profoundly still, auroral images – nearly identical in composition, varying only in colour and tone – might even be an edition of artist's prints (the commercial fate, of course, to which so many Monets have succumbed in the intervening century of mechanical reproduction).

An Exacting Eye

As ever, Monet was able to divide his attention between the intense mental activity of this latest series and the developing plans he had for his garden. But top of his list in 1897 was the building of a new studio, in a part of the garden away from the house, whose construction entailed the prior demolition of a small cottage on the site. This being finished, the first studio became a salon where the family often relaxed in the evenings and Monet entertained visitors surrounded by paintings dating from every part of his career. Hung from floor to ceiling, they must have been a source of wonder for the visitor but a constant temptation for Monet, who was always seeing things in apparently finished paintings that he would like to change.

Increasingly dissatisfied with his work as the years went by, it was almost as if Monet had begun to agree with the opinions of the critics of the first Impressionist exhibition, as far back as 1874, some of whom had dismissed his finished canvases as mere 'sketches'. Of course, he had long ago rejected the Salon's idea of what constituted a finished picture, but more and more, his own precise conception of not only an individual image but the impact of that image in the context of a given series led to constant reworking, much to the frustration of his dealers. Early in his career, he had been satisfied with the effect produced after sometimes only a single session in front of a motif; now the number of sessions he expended on a canvas before regarding it as finished might be as many as 60, many of

'I tell myself that anyone who says he has finished a picture is terribly arrogant...'

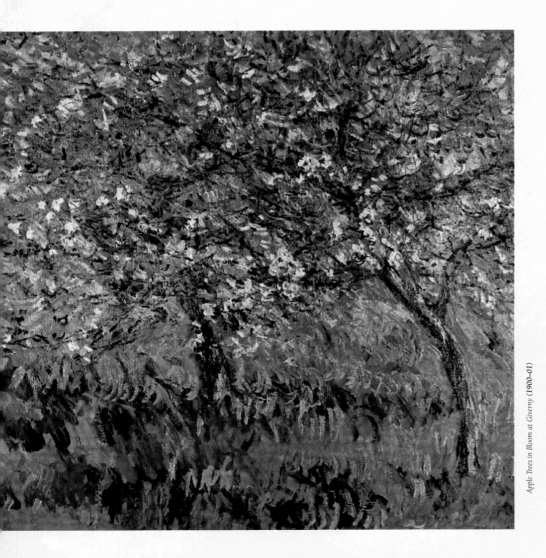

Apple Trees in Bloom at Giverny (1900–01)

them spent in the studio. Where possible, and unlike the case of the far-flung locations he had visited in the 1880s, Monet made repeated trips to certain sites, often in successive years, as with the *Rouen Cathedral* pictures and even the *London* series painted around the turn of the century.

Finishing

Indeed, as Monet became more financially secure, the pressure to finish a series diminished so that, given ever-longer meditations on his chosen motifs, this process of finishing might in theory have taken years. In relation to the heavily worked *Rouen Cathedral* series, which themselves took more than two years to complete, Monet wrote in 1893 that, 'I tell myself that anyone who says he has finished a canvas is terribly arrogant. Finished means complete, perfect, and I toil away without making any progress, searching, fumbling around, without achieving anything much.' It is an extraordinary admission of self-doubt for such an accomplished master; but, of course, such agonized perfectionism was at the heart of Monet's accomplishments. Certainly, as time went on, he slowed down his methods, more uncertain of what he wanted, as he sought the 'more serious qualities' he felt to be an ever-growing need.

A Dreadful Year

The following year, from early 1898 until the end of the next winter, included the *Mornings on the Seine* paintings exhibited in June to the now customary acclaim; but in every other respect, it was an *annus horribilis* for Monet. In February 1899, his stepdaughter Suzanne Hoschedé-Butler, the model for such famous images as *The Woman with a Parasol* (1886), whom he had given away with such pride at her wedding only seven years earlier, finally succumbed to what had been a long, drawn-out illness. It was a devastating blow for Monet, but particularly for Alice, who never

Water Lilies (1914–17)

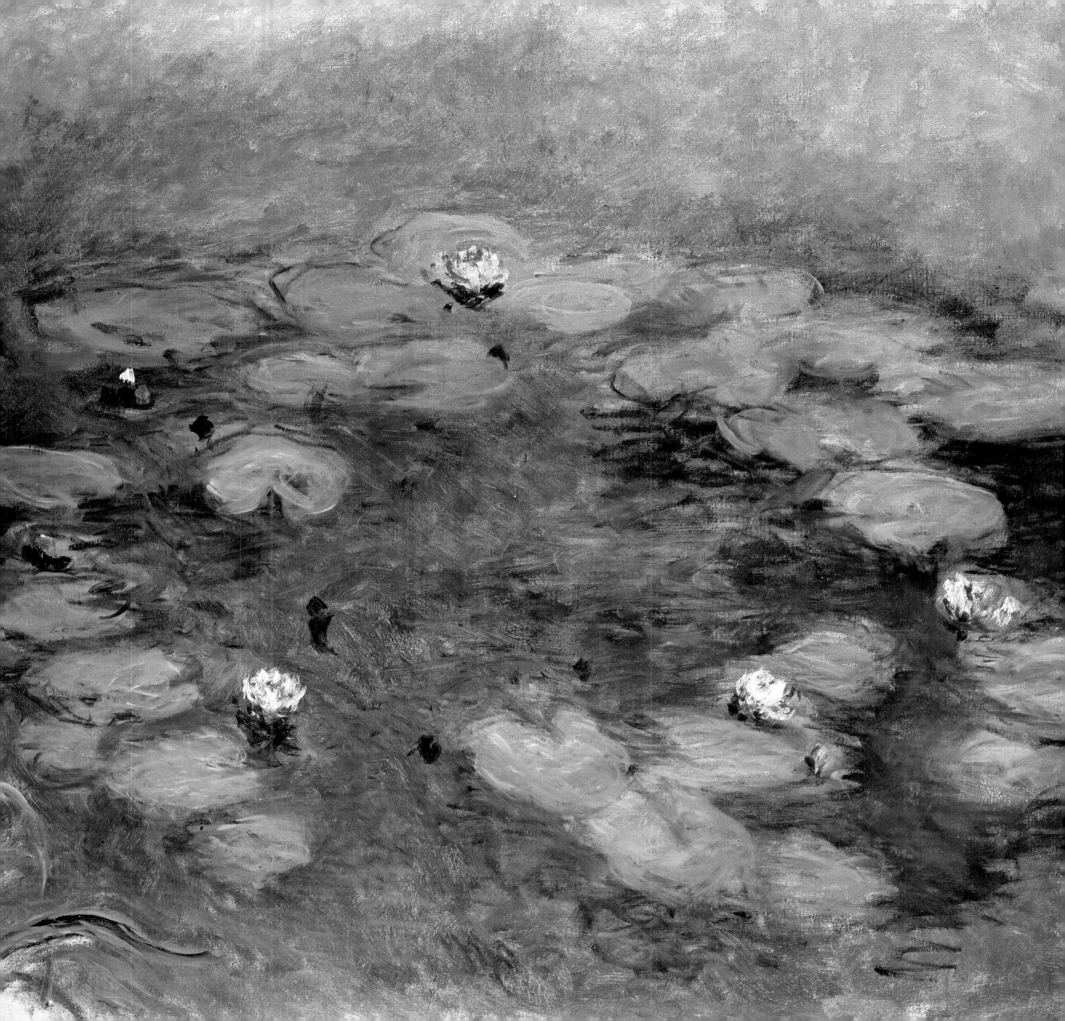

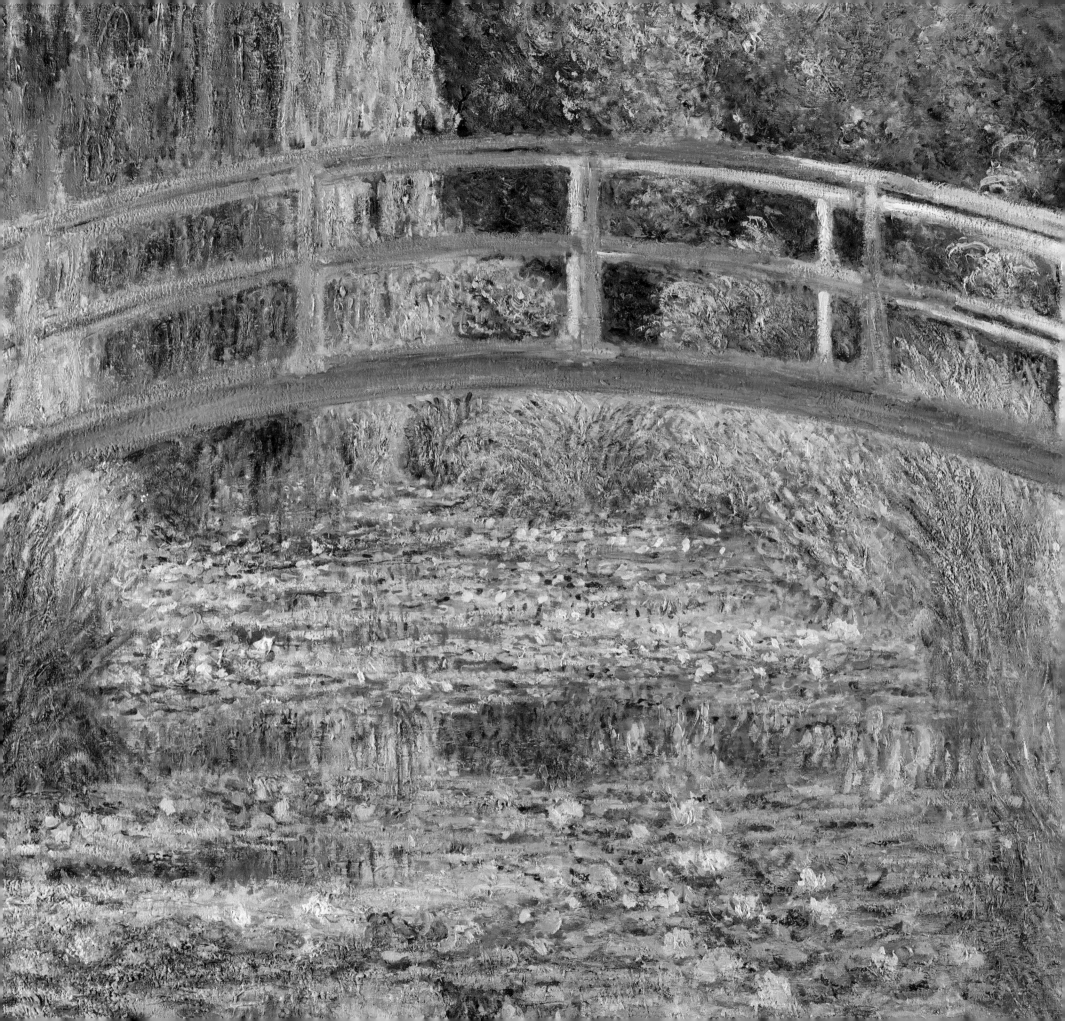

quite got over the loss. This followed a mere month after the death of his old friend and fellow Impressionist pioneer Alfred Sisley, an event which prompted Monet to raise an auction of Sisley's paintings to help his grown-up but impoverished children. But by then, a far greater shadow lay over not only the household at Giverny but the whole of France.

The Dreyfus Affair

A year earlier, what has since become known as the Dreyfus affair had erupted suddenly and was now threatening to tear the nation apart. The case had been agitating the psyche of the French elite since 1894, when Captain Alfred Dreyfus (1859–1935), who was Jewish, had been wrongly convicted of spying against his country on behalf of the arch-enemy, Germany. When in January 1898, the writer Émile Zola (1840–1902), who had once been a strong supporter of the Impressionists, published his famous open letter, 'J'Accuse', in Clemenceau's newspaper *L'Aurore*, Monet immediately declared himself on the same side, in direct opposition to the government of the day and the high-ranking officers in the French army by whom Dreyfus had been framed. Zola's letter inflamed public opinion on both sides, dividing friends and colleagues along lines of fracture whose existence they may not have previously suspected. From the start, Monet had been offended by the obvious injustice meted out to Dreyfus, with its blatant stench of anti-Semitism; colleagues such as Renoir, Cézanne and especially the venomously anti-Semitic Edgar Degas took the opposite view. French society was rent asunder for several years into the new century before the accusations against Dreyfus were shown to be completely untrue.

It is clear that, while Monet avoided political life, he did not want for moral courage, stepping forward with clear commitment when roused to act, whether on behalf of a principle or a friend. But how does that square with the painter of grainstacks or misty river mornings or, from summer 1899,

> ## 'When you go out to paint, try to forget what object you have before you, a tree, a house, a field or whatever.'

the new series he had embarked upon of pictures of the Japanese bridge over a pond replete with water lilies? Is art a realm separate from the ordinary spheres of action and conflict in which human life is conducted? Or can we read into the painter's increasing concern for rendering the truth of his experience a more general commitment to truth in all its forms?

The First Water Lilies Series

Monet began two separate series of paintings following the personal and political convulsions of the awful year that ended in early 1899. One was a huge series of views of London by the Thames, which he continued to work on for several years into the new century; the other, a set of pastoral idylls of his lily pond and the Japanese bridge spanning what was then still a small body of water, a series comprising two quite different groups of paintings executed in two consecutive years.

Monet had painted this bridge shortly after it was first built, when the pond had yet to fill up with lilies. Those earlier images are gentle and delicate, with a colouring and treatment harking back to an earlier way

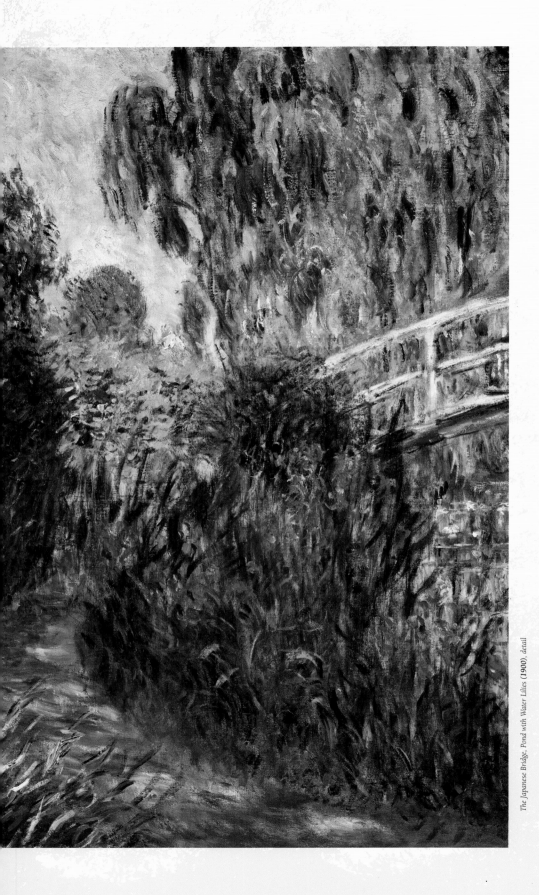

The Japanese Bridge, Pond with Water Lilies (1900), detail

of working, without any sense of the atmospheric concerns of the series paintings in which he had so recently been immersed. Four years later, with the water garden now mature, even luscious, the new paintings were a different proposition altogether. On the one hand, the simplicity of viewpoint is maintained, the paintings frontally composed with the bridge arcing across the picture plane like a low proscenium arch above the cast of water lilies crowding the raked stage of the pond. The sense of copious, indomitable life is further affirmed by the profusion of greenery filling the background and again in the reflections of that life in the surface of the pond. The surface of a painting such as *Water Lily Pond* (1899) is busy, committed, the water lilies loosely scumbled, the foliage of grasses and trees thickly impasted. Moreover, the quality of light across this set is the kind of bright morning or early afternoon light – the time of full wakefulness and vigilance – that features only occasionally in the series of the 1890s. Illumination, atmosphere and the subtleties of perception for the moment are of secondary importance to the unequivocal reality of the natural world, as if the ubiquity of green depicted in the image was simply another kind of envelope, namely the natural environment without which we simply could not survive.

The pictures are clear, straightforward, symmetrical, orderly images of what for Monet were the reliable verities, the strong roots of a just and civilized society: beauty and a natural order shaped by human vision. As he put it in an interview with the journalist François Thiébault-Sisson (1856–1936) in 1900, the 'raison d'être of art [is] truth, nature and life'.

The Master of Giverny

The images of 1900, the second half of this series, are more loosely handled, the viewpoints shifting the bridge off-centre and cropping it at the right-hand side. Even more striking is the pink and even blood-red

colouring with which these images are tinted, as Monet once again turned to the golden hour of twilight when the depth of colour is at its strongest. His old aesthetic preoccupations were reasserting themselves as he entered the new century, but even so, the critics who attended the exhibition of this series of modest size in November that year, having grown used to the breathtaking novelties of the series of the 1890s, did not know quite what to make of these paintings of lilies on a pond. Some could see the continuity with previous work and a tradition of reverence for the natural world which for more than a century had had strong roots in French intellectual life; many others, forgetting the impact of the grainstacks, felt the motif itself was a little mundane. Indeed, perhaps it is, and without doubt, this is just as the artist intended. One eminent writer, Arsène Alexandre (1859–1937), criticized what he felt was a lack of formal inventiveness, writing that the Japanese – in whose obvious aesthetic debt Monet seemed to be – would have made a better job of such scenes.

The following year, when he saw the garden for himself, Alexandre changed his mind, writing that you know a man better when you have seen the environment in which he lives. The garden at Giverny, for so long hallowed ground for young artists infatuated with Monet's art, was now being publicly entwined with that art; it is an image of symbiosis – of man and his environment – which, for reasons that transcend the details of Monet's own story, is still compelling to this day. And in a similar way, it may also have dawned on Monet that in a voluntary submission to the realities of nature lay not only the fulfilment of his vision but the apotheosis of his art.

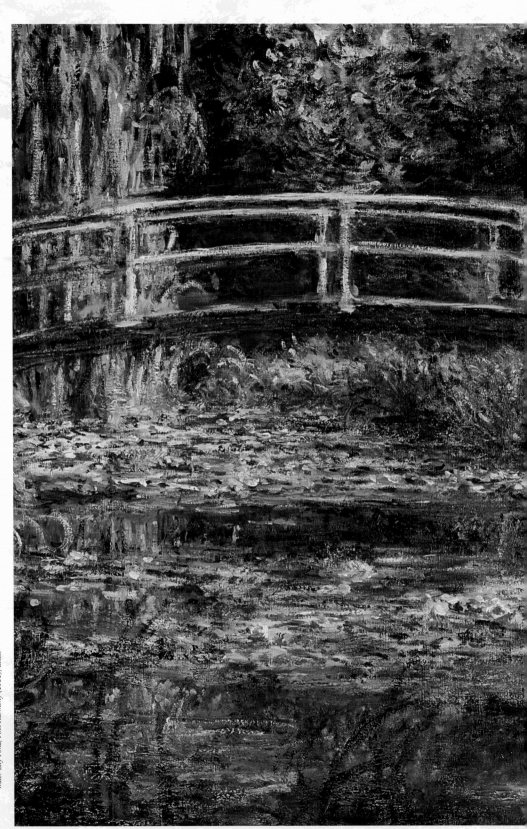

Water Lily Pond, Pink Harmony (**1900**), *detail*

An Artist of
the Floating World

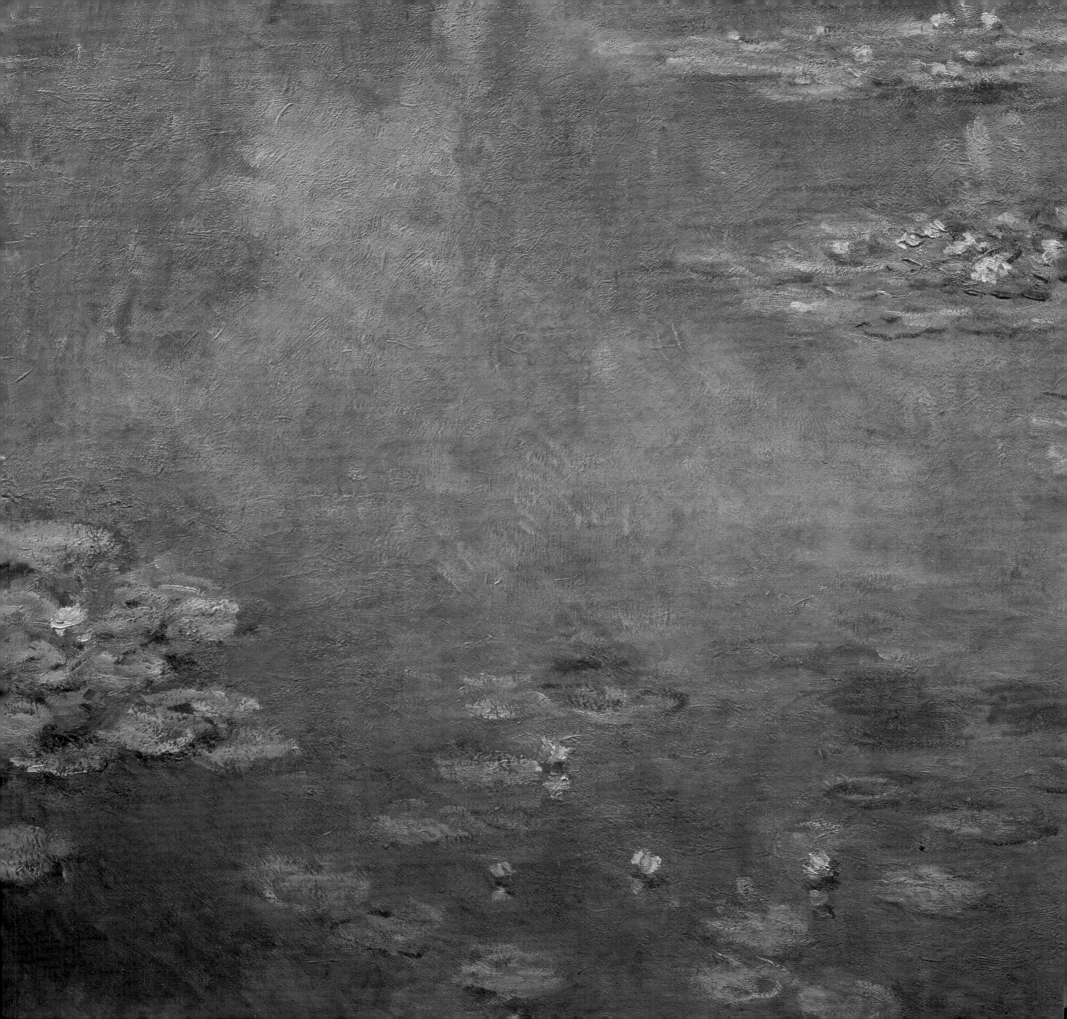

DURING THE SUMMER OF 1902, Monet must have made many circuits of the water garden that had recently undergone such changes, doing what he always did – looking, assessing and perhaps already composing in his mind. A year or so earlier, he had bought another plot of land adjoining the parcel he had acquired in 1893, and in December 1901 had applied for planning permission to greatly expand the pond to some three times its original size, offering the variety of new views around the perimeter that he was now trying to frame. With permission quickly granted to a man who was now regarded as a pillar of the local community, his team of gardeners set to work, digging out the pond and, once this had been achieved, planting new bushes, ferns, stands of bamboo and ornamental trees as well as irises, grasses, agapanthus and still more weeping willows.

The Garden Takes Shape

Four more footbridges were also added to the two Monet had had put in seven years earlier, and a trellis was integrated into the Japanese bridge he had already painted, through the slats of which tendrils of wisteria would entwine themselves in the years to come. Above all, more lilies were sown, both hardy traditional plants and new tropical varieties with colours including red, copper and turquoise – exotics that would invariably be taken out at the end of autumn and overwintered in the greenhouse to protect them from frost before being reinstalled in the spring; these were either chosen almost at random from catalogues or, later on, sent by friends in Japan, such as Madame Kuroki in the 1920s, the wife of one of

'I love water, but I also love flowers. That's why when the pond was filled, I wished to decorate it with plants.'

Water Lilies (1906)

'I have no other wish than to mingle more closely with nature.'

Waterloo Bridge (1900), detail

the earliest Japanese collectors of Monet's work. The railway track that ran between the water garden and the main garden, an unwelcome intrusion of the modern world, was screened off with pergolas on either side of the track, along which climbing roses were trained that in future years would supply yet another painting motif. Under Monet's guidance, the men worked quickly and by early spring, these extensive changes had been completed.

A Trip to London

When he hadn't been out supervising this latest transformation, Monet had been busy in the studio, working on a series he had begun some three years earlier. In 1898, he received word that his youngest son, Michel, who was studying English in London, was gravely ill. Having rushed across the Channel to be with him, Monet found the emergency to be something of a false alarm, but being in London for the first time in almost a decade reminded him of his long fascination with a city whose heavily industrial atmosphere, especially in winter, lent it a uniquely lugubrious charm. It was also somewhere he had painted 30 years earlier, as a refugee from the Franco-Prussian War, a time with happy memories of friendship with Pissarro as well as the birth of his productive business relationship with Durand-Ruel. Monet had had cause to come back in the years since, visiting his good friends John Singer Sargent and James Abbott McNeill Whistler (1834–1903), and now an idea was born to revisit the place the following year to see how he now viewed a city he thought he knew so well.

By the end of the century, Monet's personal wealth had grown substantially, his income often in excess of 200,000 francs per annum as a result not only of burgeoning sales – by then, he had exhibitions taking place all over Europe and as far afield as the USA and Russia – but also his skilful playing of the stock market. Returning to London in early

Waterloo Bridge (1900)

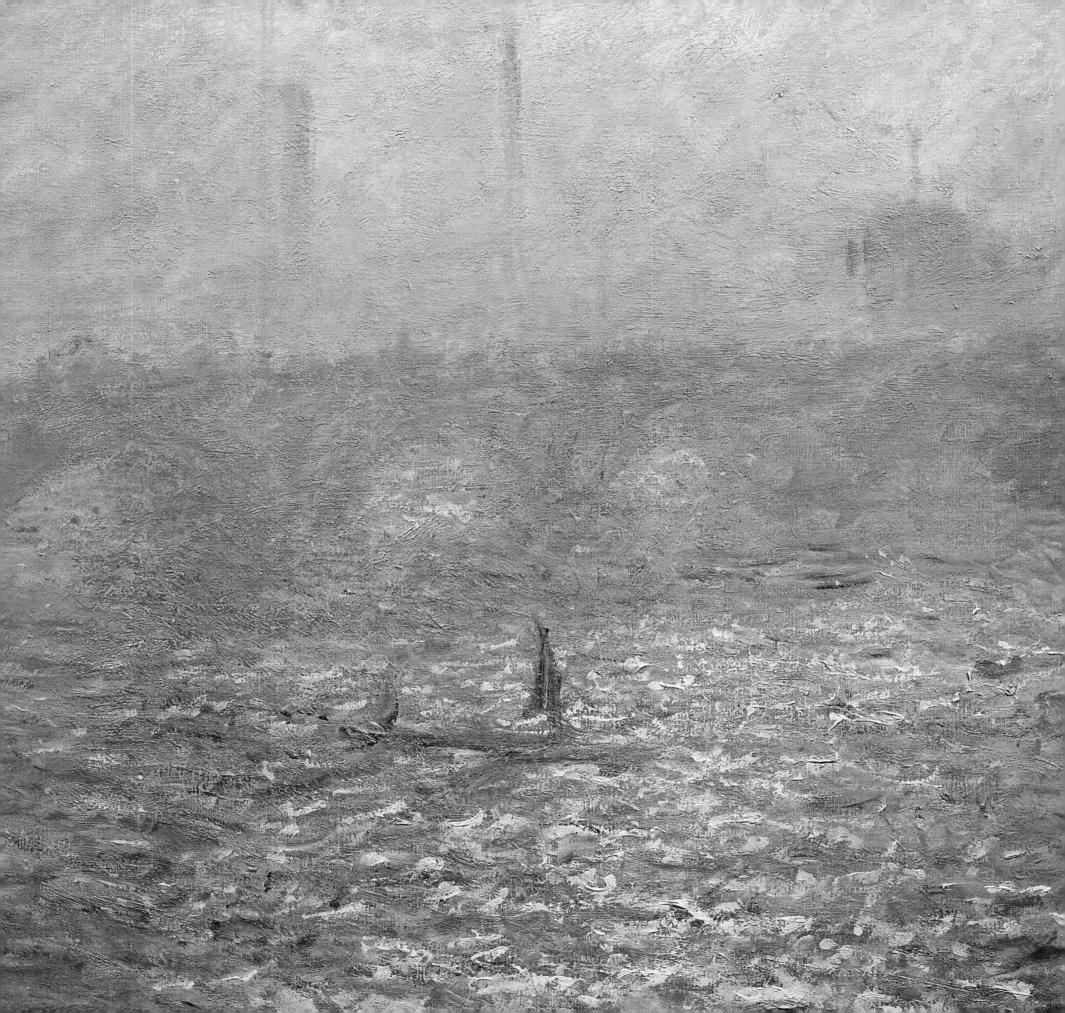

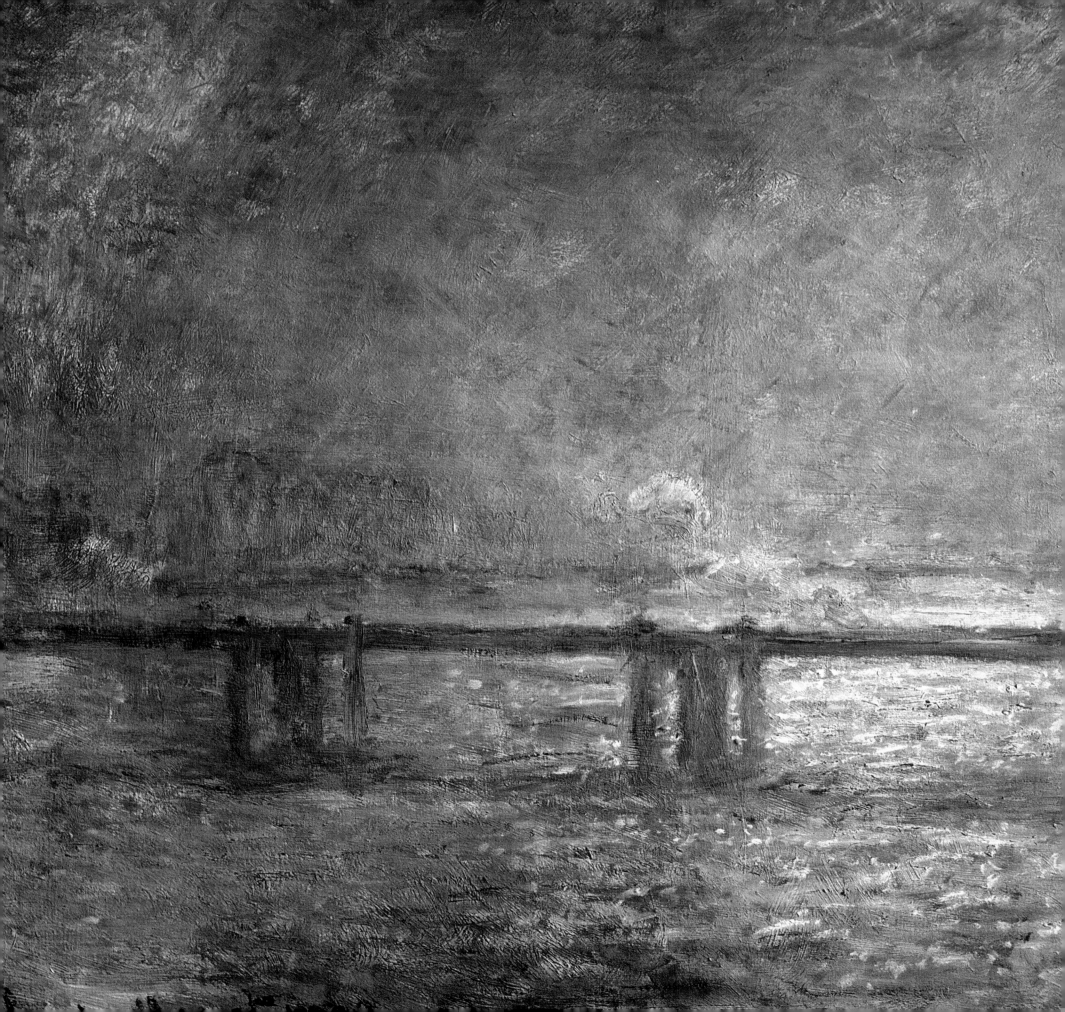

The Thames at Charing Cross (1903)

1899 with Alice and her daughter Germaine (1873–1968), Monet took a suite of rooms at the Savoy Hotel, setting up a studio in one of them which afforded views of Waterloo and Charing Cross Bridges. At the same time (and often on the same day), he would visit another makeshift studio he had managed to organize, an open-air balcony in St Thomas' Hospital a little way across and down the river, from where he could see the Houses of Parliament and Big Ben. This had been a favourite subject during his visit of 1870–71, and one he fully realized was freighted with history. Likewise with the Thames itself he was squaring up to the example of J.M.W. Turner (1775–1851), whose enchanted envelopes of coloured atmosphere had been so important to him throughout the previous decade.

The Londons

Monet was well aware that the difficulties of painting the British capital were inseparable from its charms. It did not help that he had chosen winter, notwithstanding his reasons for doing so. On his third visit, in 1901, working outside at the age of 60 resulted in the painter contracting pleurisy and being confined to bed for a month. Moreover, the constantly changing weather at that time of year, and especially the fog, made the campaign as a whole a continual source of frustration, goading Monet into working on a ludicrous number of canvases (in the end almost 100) as he pursued what had previously been an efficient method to the edge of absurdity. Determined to capture the subtlest nuances of light and atmosphere, he was observed by Sargent at the Savoy in 1901 searching like a frantic filing clerk through the stacks of half-finished pictures piled against the wall of his palatial studio suite. It was partly on account of the sheer number of images he was trying to complete that not only was he still working on these paintings in 1902, but it would be another two years before the series was ready to be shown.

'Nature won't be summoned to order and won't be kept waiting.'

The *Londons*, as he called them, mark a return to Monet's preoccupation with the envelope after the apparent lack of mystery of the first *Water Lilies* series (begun at the same time but finished and exhibited before the last of the London trips had even taken place). As with earlier series, they cover changing conditions of light across every hour of the day and are also perhaps his most disembodied images to that point, with bridges and buildings almost swallowed up by the pervasive envelope of fog, coal smoke and water. The colours are often lurid, the painter's vivid eye almost certainly influenced by the city's notoriously sulphurous air, which was sometimes so thick it could blot out the sun. The forms of the bridges and of Charles Barry's (1795–1860) Neo-Gothic Palace of Westminster, at times almost wholly enshrouded by the fog, are the most spectral Monet ever painted, as if themselves the setting for a tale of Gothic horror in the English style. But in choosing winter, the season in which London's particulated atmosphere – what Monet referred to as its 'mysterious cloak' – was at its worst, he knew what he was doing; it was the only season in which he considered the city to be truly beautiful.

The Motor Car

Alice, noticeably depressed after losing her daughter Suzanne, had accompanied Monet on that first visit with Germaine, but did not return in subsequent years. However, this was Monet's final solo expedition; when the London campaign was over, there would be no more foreign trips without Alice. And in 1900, a new happiness was visited on the family when Suzanne's widower, Theodore Butler, married another Hoschedé, Suzanne's sister Marthe (1864–1925), a union that would last until Marthe herself died a quarter of a century later.

In the summer of 1901, with the London campaign having retreated to the studio, Monet had decided not to paint the water garden, which he knew

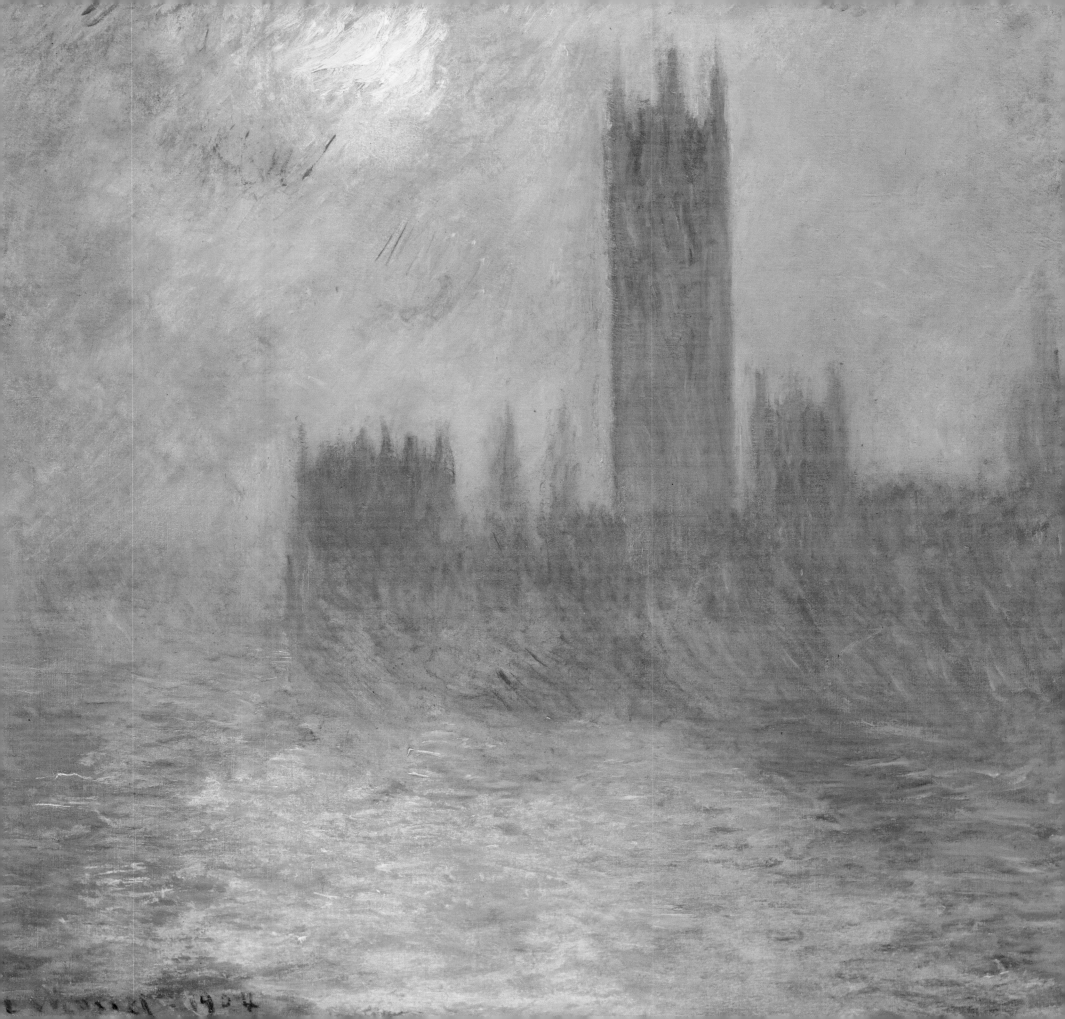

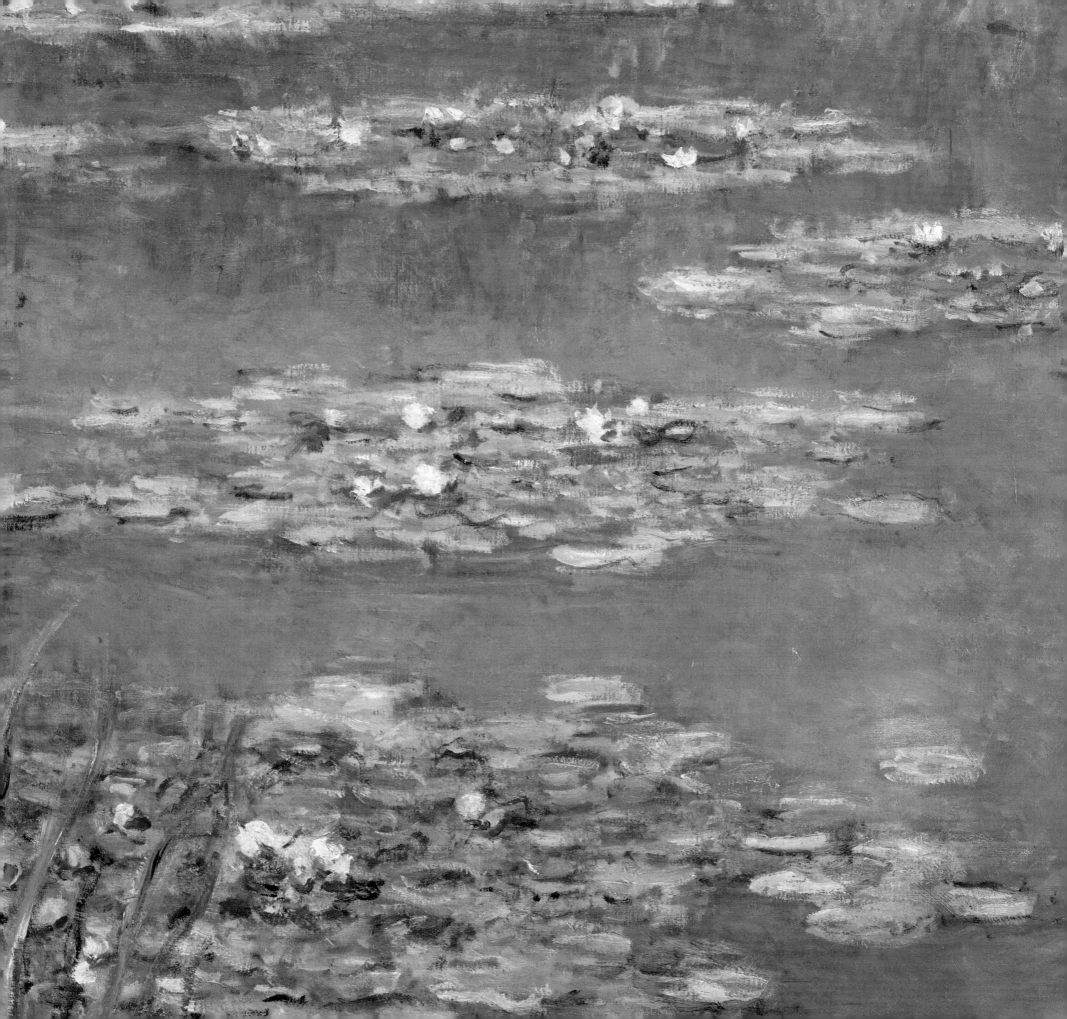

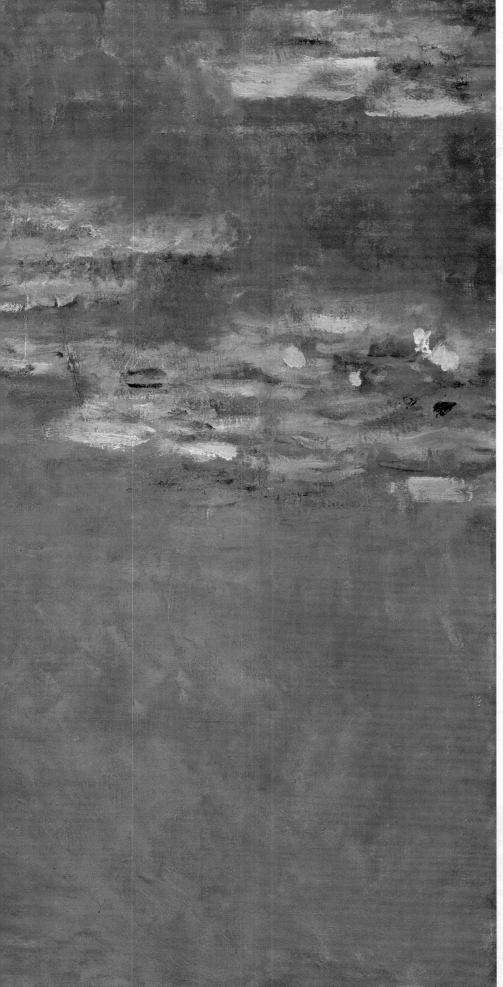

Water Lilies (1905)

was soon to be changed. Perhaps to the surprise of everyone who knew him, this dedicated nature lover whose painting had long since abandoned specifically modern subjects, had recently taken delivery of a Panhard-Levassor, a fine example of a newfangled contraption known as the motor car. The vehicle was housed in what for a few years had been the gardeners' room in the building immediately below the second studio, and in years to come would be joined by several others with names that have long since been confined to history as the Monet-Hoschedés indulged their unexpected passion for speed.

As is usual with technology, it was the children, by then in their twenties and thirties, who had first urged Monet to purchase a car. Motor sport in particular had fired their imaginations since the world's first motor race had taken place in their neighbourhood in 1894, the competitors having passed close to the village on their way from Paris to Rouen. Driven always by a paid chauffeur, in the new century the family would often take trips in their state-of-the-art vehicle north along the River Seine to Gaillon to watch the most desirable cars of the day try to beat the record for the famous hill climb. Then in 1904, Monet and Alice made their longest motoring tour as the painter decided on a whim that he wanted to see the paintings by Velázquez (1599–1660) at the Prado in Madrid. Knowing full well that Alice was even more thrilled by speed than he was, Monet instructed his wife to pack and before long, they were heading south on a three-week round trip that was certainly adventurous for the time.

Old Haunts

Monet's Panhard-Levassor was quite possibly the first car in the village and it may have been the only one on the dirt roads as, later that summer of 1901, he was driven upriver to Lavacourt, just across the Seine from Vétheuil, to paint a group of pictures of a town where the Monet-

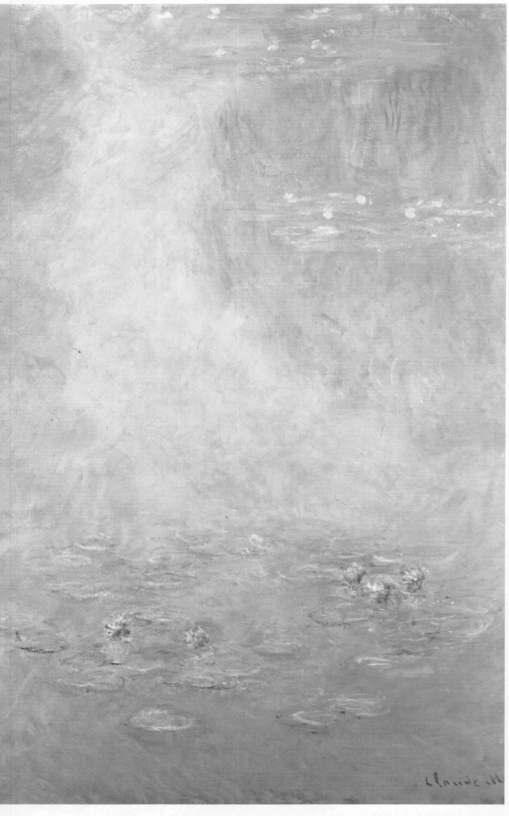

Water Lilies (1908)

Hoschedé family had once lived. Revisiting old haunts had become a habit for the middle-aged artist, now less attracted by new sights than he was by new ways of seeing those with which he was already acquainted. It is as if he was increasingly drawing on not only the motifs in front of him but his memory of those motifs, and in doing so negotiating the differences between the experiences of present and past. There is a pattern to be discerned, if we choose to see it, in Monet's way of thinking about the world through his painting, an attempt similar in intention to his other impulse to depict the envelope, 'to reproduce what lies between the motif and me'. It is as if in this habit of returning, Monet is using his art once again to build a bridge between one reality and another – not in this case between the objective world of the motif and his subjective conception of it, but between an earlier subjective conception and another one experienced, in some cases, many years later. Time, which for more than a decade had been crucial to his method, was now becoming central to his purpose.

The Grand Allée

With the expansion of the water garden completed by the spring of 1902, Monet now had only to wait for his precious water lilies to repopulate the pond. In the meantime, that summer he returned to the flower garden, painting more views of the Grand Allée – especially *Pathway in Monet's Garden in Giverny* – which are loose in handling, reflecting the burgeoning growth evident right across the image, a lush, semi-tropical paradise of boughs and flowers cascading and swooping through all parts of the canvas around the central *allée*, appearing almost to envelop the house. The result is a pageant of colour which brings to mind the human spectacle of the Rue Montorgueil as he had depicted it on a day of national celebration more than 20 years earlier, a painting which had turned out to be one of his final images of modern life. How his priorities had changed!

The New Water Lilies

By the following year, the water lilies had reappeared in abundance and Monet had returned to painting them, sometimes with several easels set up around the banks. This time, he ignored the Japanese footbridge, partly because the greater expanse of water gave him other options. Instead, he concentrated on the pool, in doing so returning to a subject he had first tried to render in a large oil sketch from 1897 of water lilies floating on the surface of the pond, his first known depiction of that motif.

Only a few paintings survive from the set begun in 1903, one of which was sold to a chance American buyer who happened to drop by that summer as Monet was working on these pictures. It is an image which late in life the painter wished he had held on to, but only so that he could have destroyed it; such was his growing impatience with what he considered to be failed images, this is what befell the majority of the other pond images he made that year. What it was about this painting that displeased him is hard to say and must give us pause to wonder what cardinal failings might have caused so many of its sister images to be deemed beyond redemption. It is certainly tempting to attribute Monet's increasing intolerance of his own 'mistakes' not to a failure to render what he saw in the physical world but to some other deficiency: an execution that fell short of the increasingly imperious demands of his imaginative vision.

The One That Got Away

Water Lilies, the Cloud (1903) – the painting secured by the American buyer and the one that, given the chance, Monet would have destroyed – is a clear, easily readable picture of a view across the lily pond to the far bank. The picture surface is almost entirely filled by the pond, which in bright daylight clearly reflects the background foliage in the top half and

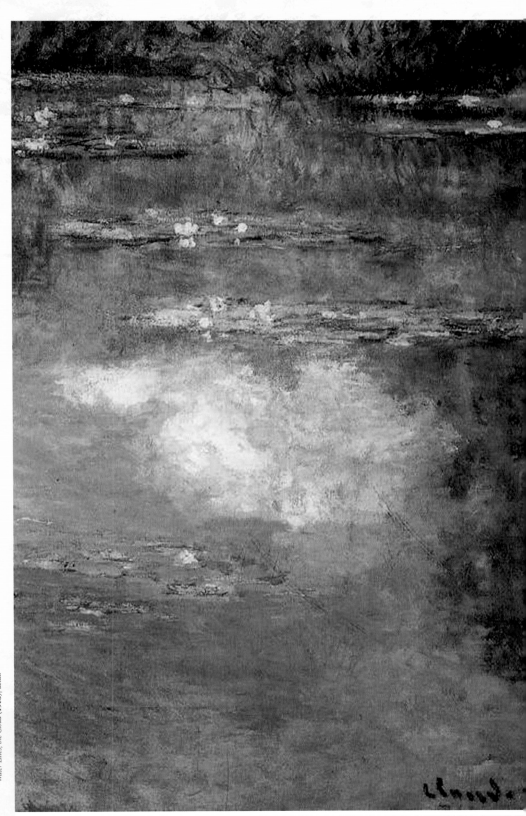

Water Lilies, the Cloud (1903), *detail*

the blue sky and clouds below – an inverted world but a comprehensible one all the same. Perhaps it was simply too conventional for Monet. Certainly, the other images that survive from this first group are less picturesque and so less easy to understand. They pursue a singularity of composition that had characterized Monet's work since the *Grainstacks*, sharing with the 1897 sketch a radical simplification of the motif. For instance, while *Water Lilies* from this year does survey a similar receding expanse of pond, there is no bank to frame the image; the only point of orientation – and a rather confusing one at that – is the willow bough that descends into the picture at the top left. The artist's gaze is tilted more towards the water, still seen in raking perspective, taking in the occasional flotsam of flowering lilies against a water surface highly coloured by ambiguous reflections of the sky and the foliage from trees surrounding the pond; the trees, we surmise, lurk just out of view, as any horizon remains unseen. But, unlike *Water Lilies, the Cloud*, in this image the apparently dull natural light leaves us with little inkling of the water's aqueous surface and thus a sense of what it conceals; only a consternation at the seemingly ambiguous separation of the elements – a vague unease, which Monet would spend the rest of his life exploring, that we cannot be entirely sure where the world of air and earth ends and the world of water begins.

A Template

The lilies themselves are treated in quite a different manner than in the 1899–1900 series. For one thing, after the renovations of 1901–02, Monet had instructed his head gardener, Felix Breuil, to thin out the lilies, leaving fewer, smaller clusters of pads – perhaps envisaged as points of visual repose for an eye weary of scanning the pond's ever-changing reflections – in contrast to the crowded fleets of the earlier images. Unlike that earlier series and unlike *Water Lilies, the Cloud* of

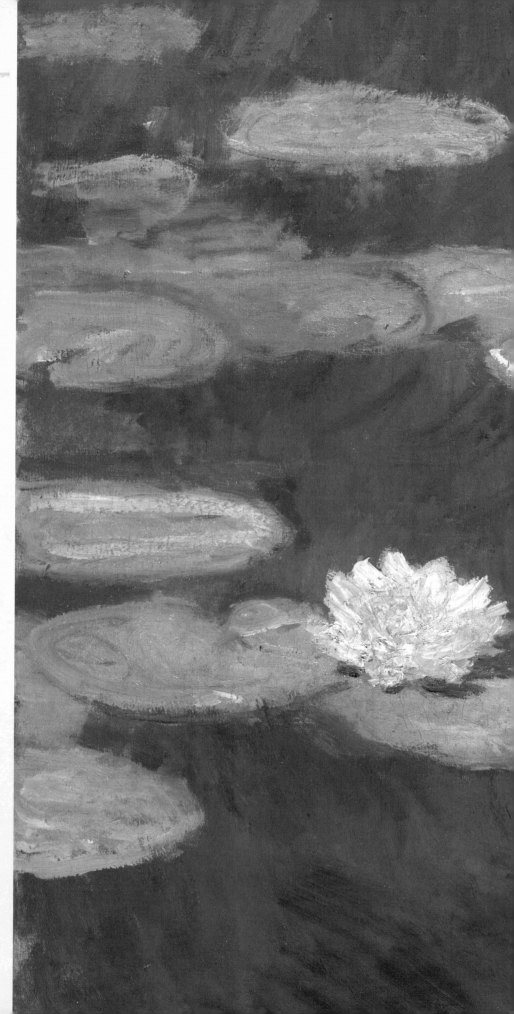

Water Lilies (Nymphéas) (1897/98)

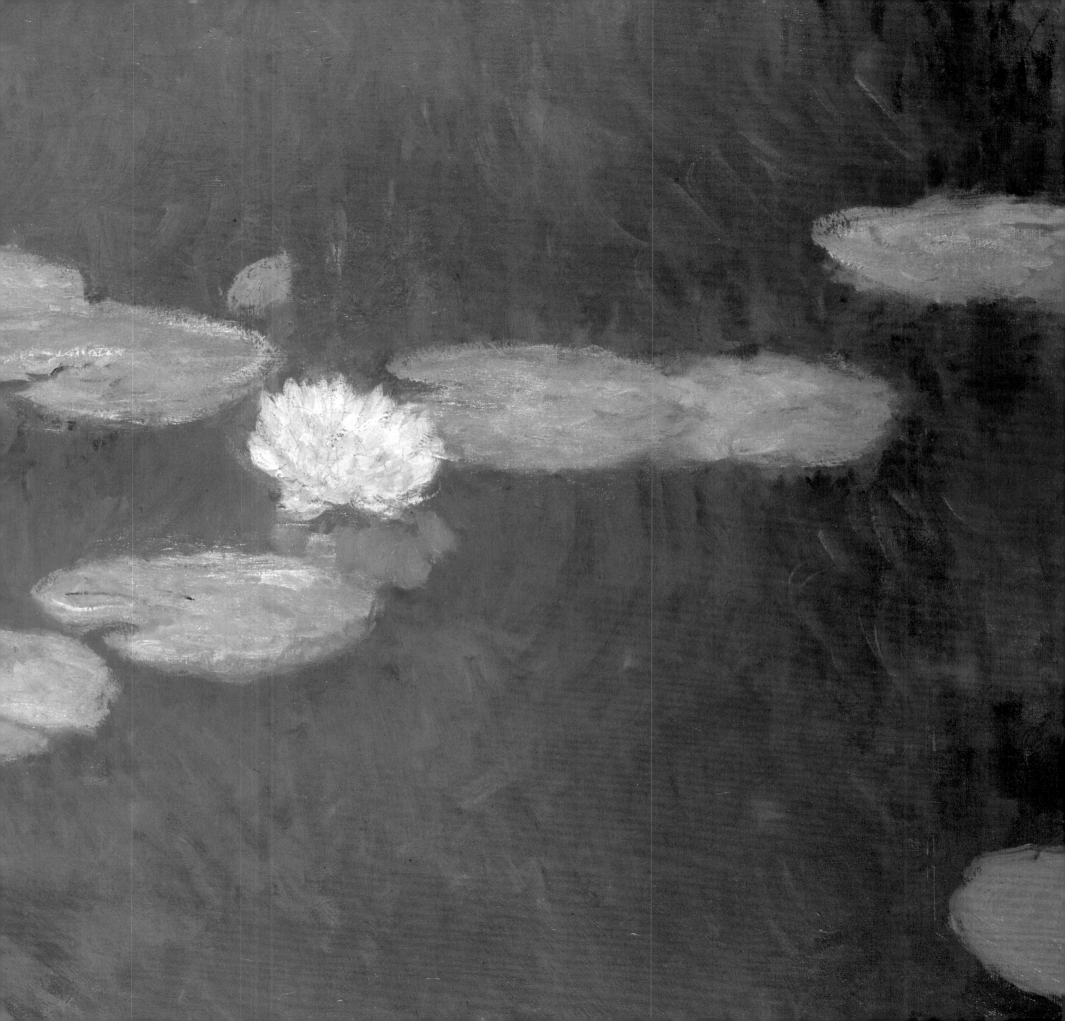

'I have gone back to some things that can't ... be done: water, with weeds waving at the bottom.'

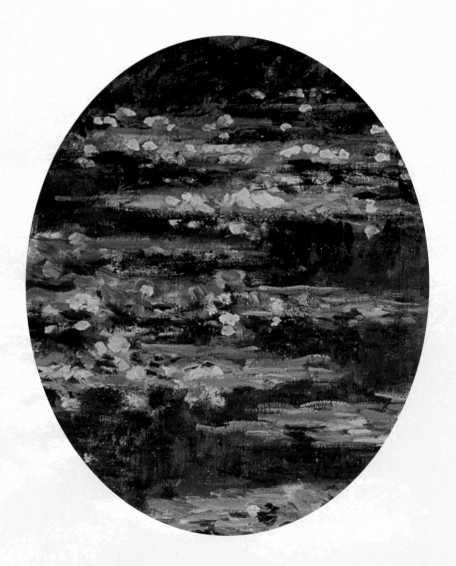

1903, they also seem to float above the impalpable surface of the water and perhaps also above the picture surface, a perceptual phenomenon that Monet would continue to investigate through what for him became an unfathomably absorbing motif. This picture shows how clear his conception was from the start, setting the template for the prolonged ensuing series and indeed for the great project which followed in the final decade of his life.

New Variations

A new set of pictures begun the following year restores both the presence of the far bank as a horizontal plane of orientation and something of the teeming profusion of the 1899–1900 images, though reflections are still a dominant aspect of the picture surface. The illumination is again bright sunlight, which as in *Water Lilies, the Cloud* lends a limpid quality to a water surface in which the details of reflected foliage appear more clearly. The images are again readable and naturalistic in a similar way to the *Water Lilies* of five years earlier, and as such, they represent a detour from what we might characterize as the main direction of Monet's thought about the developing series.

In 1905, Monet again lowered his gaze to the water surface and the flower-spangled flotillas of lily pads, which in some paintings might even be hovering above that surface, like verdant clouds appearing to drift among the foliage and the meandering cumulus reflected in the deep-lying foreground of the pond. In others, lily pads are suspended almost spectrally, their forms in places little more than roughly traced white circles against what might be waterfalls of weeping willow branches reflected in the water surface in a dazzling array of evening colours conveyed with a subtlety that few painters have ever matched.

Water Lilies (1904)

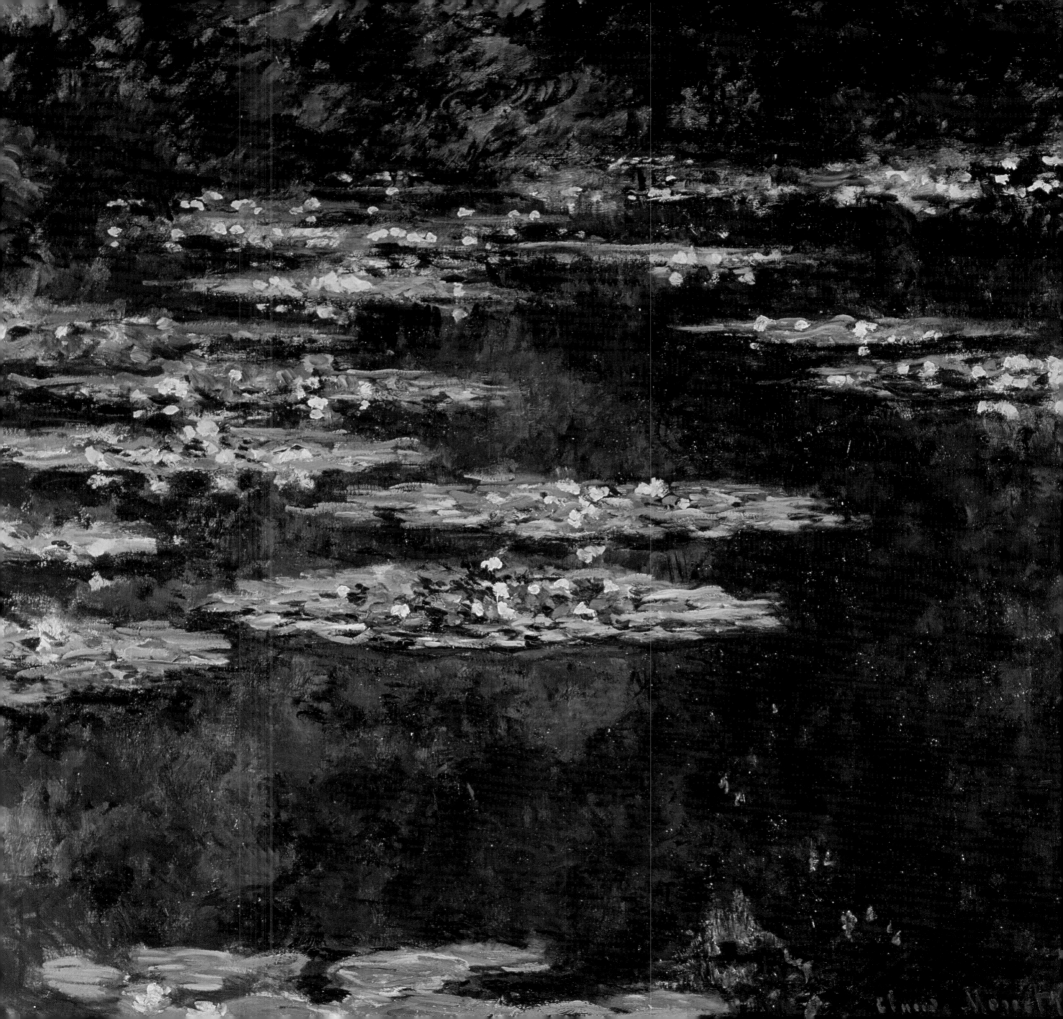

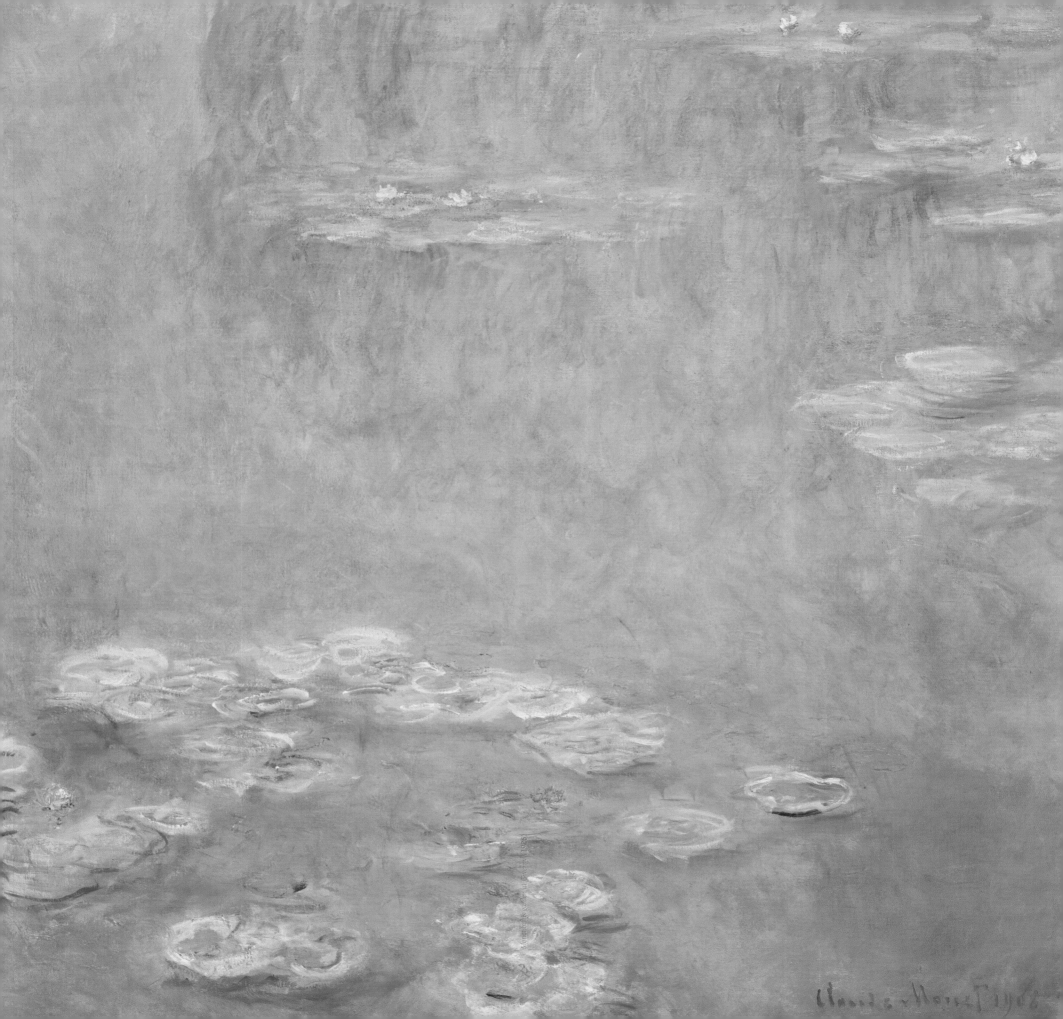

The Developing Series

Thereafter, the variations keep coming as over successive years, Monet found more new approaches to depicting this most mundane but most compelling of all his motifs. What was he investigating now? Is the envelope of importance any longer in images in which the sky is seen only in reflection and the realm of atmosphere is almost coterminous with the picture plane? Certainly, the sheer variety of colourings and textures and even compositional strategies suggest an artist increasingly concerned with the paint surface itself, with a picture as an arrangement of forms and colours – in short, with the decorative qualities of painting.

The 1906 paintings are characterized by the looser handling that had begun to emerge in the previous year's crop. The lily pads seem quickly sketched, their outlines sometimes ringed in white. Their forms appear less distinctive than the year before against a water surface that itself seems diaphanous, as if the flat surface of the painting, increasingly synonymous with the reflecting surface of the water, was in fact a veil drawn across a more tangible world to which we do not have access.

A Bonfire of the Vanities

By the end of the summer, after several months of intense activity, Monet seemed happy with what he had done. An exhibition was planned for the following year, but no sooner had the date been fixed than the painter got cold feet, insisting that only five or six pieces were up to scratch. In fact, as he informed Durand-Ruel, who was pressing him all the time for new work, he had already destroyed 'at least 30' of the new series, 'to my great satisfaction', and certainly would not countenance showing the few that remained until a complete series had been assembled, claiming that he needed 'to have the few finished ones before my eyes in order to compare

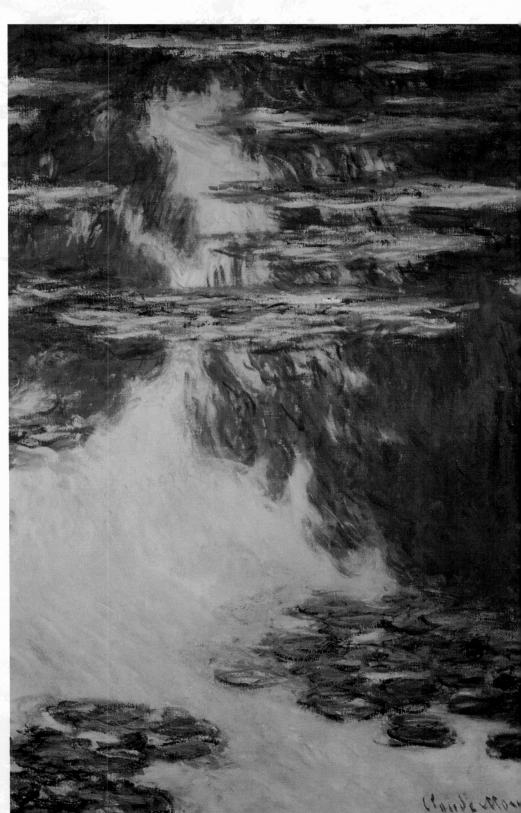

Water Lilies (1906)

Water Lilies with Weeping Willows (1907)

[them] to the ones I am going to make'. Here, again, we see Monet the holistic thinker, concerned with the integrity of the whole series as much as he was with the cohesiveness of any single image. He could also afford the luxury of time now that sales of previous work as well as his own canny investments were providing him with an annual six-figure income even when no new work was sold.

So in 1907 (the year in which Clemenceau became Prime Minister of France and immediately made good his earlier intention by arranging for the purchase of the French State's first Monet, which of course was one of the *Rouen Cathedral* series), the painter set to work again with renewed focus, following a punishing schedule: up before dawn, working from first light till early afternoon; then a brief lunch and back to work until about 3.00 p.m., when the light became most unpredictable and the lilies began to close; then a longer break of two to three hours before returning to the pond in the early evening to examine the conditions and to paint the pool as the light closed in.

Bold New Pictures

Monet may have felt he was making headway, but many of the new paintings shocked Durand-Ruel when he saw them. For a start, the series as a whole is mostly square in format, though, intriguingly, there are also a few circular canvases or tondos, a rare format for any painter and the only examples in Monet's career. But a good number of the pictures from 1907 were vertical, a format that could be difficult for collectors to find space for on their walls. More alarming still for the ever-patient dealer were the, at times, violent contrasts of colour in some of these paintings: vertical, wraith-like columns of often garish reflected light jarring against dark green clouds of reflected foliage – fields of strongly opposing colour striated horizontally by skeins of roughly sketched lily pads whose contact with the

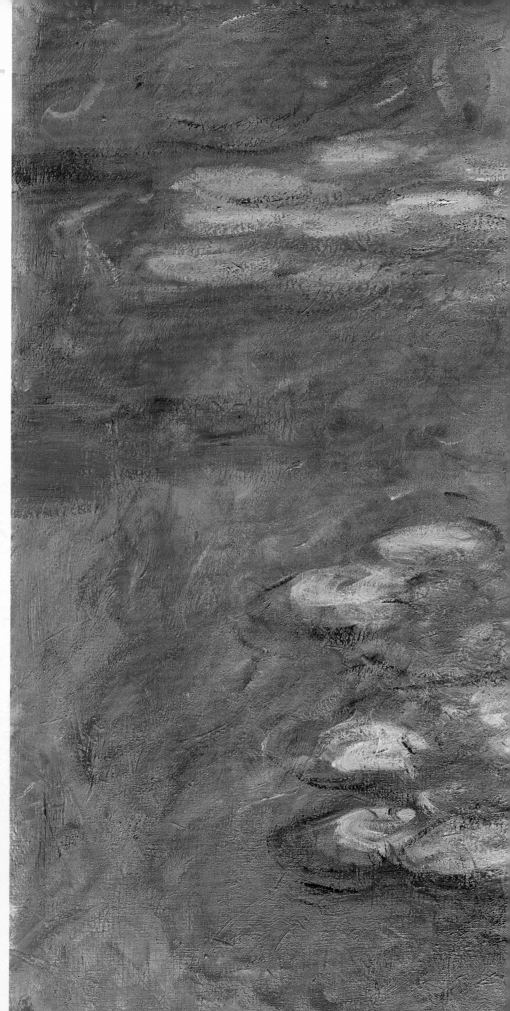

Water Lilies (1907)

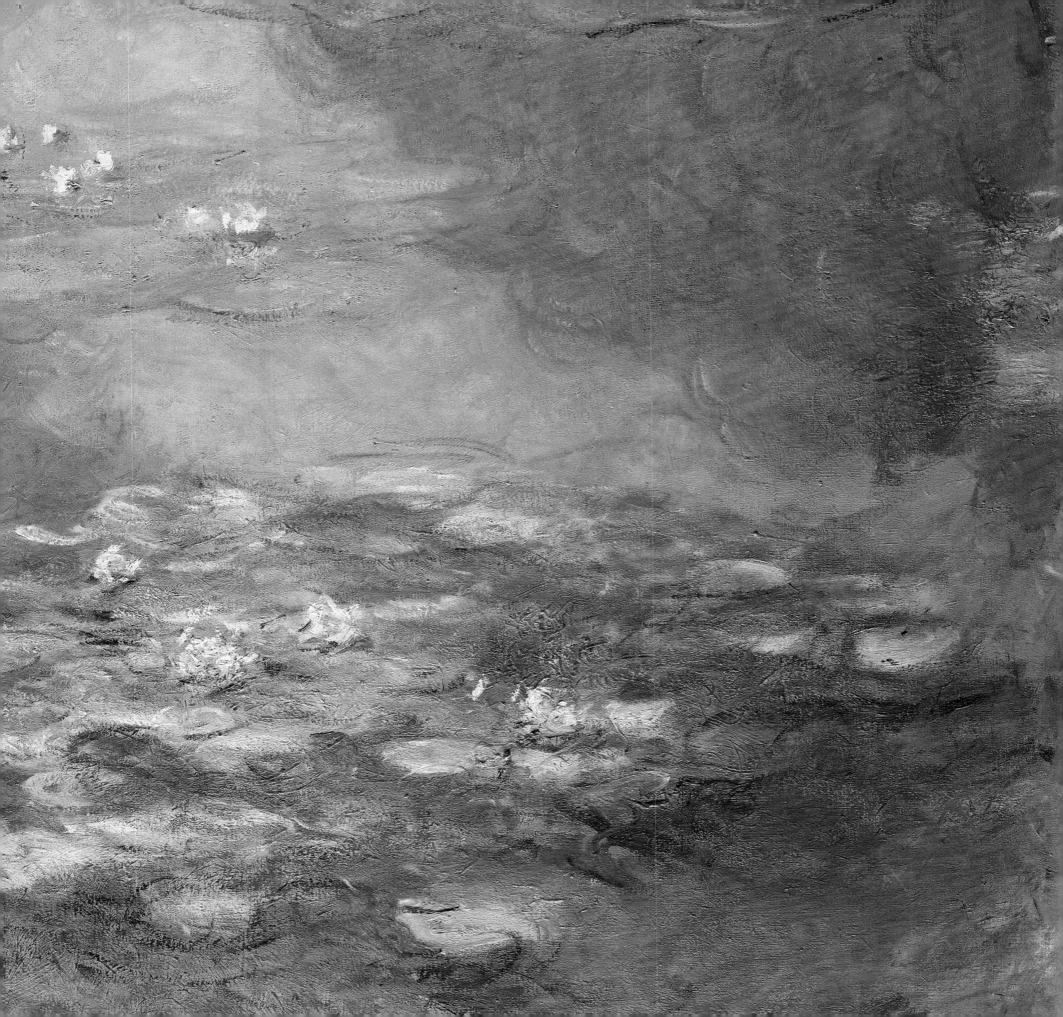

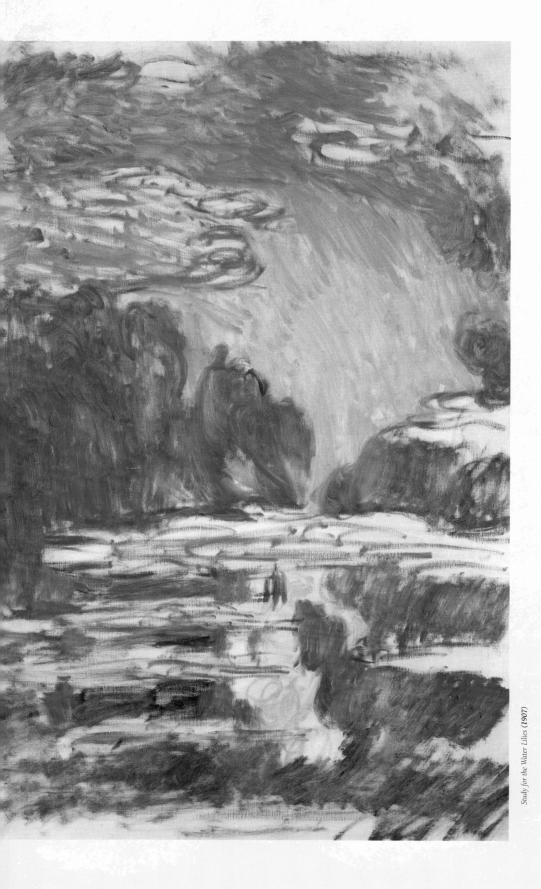

Study for the Water Lilies (1907)

water surface seems more tenuous than ever. Monet's desire to explore the possibilities of his motif had led him into territory he had never entered before, areas of inquiry to which his devoted collectors may not have felt inclined to go. but in doing so he had also opened up fields of gesture and formal invention that in future years would reward him for such risks.

A Crisis of Confidence

By spring 1908, Monet was pretty glum – disenchanted with what he had done – and was also experiencing dizzy spells and blurred vision from the exhaustion brought on by such a huge effort. Then in May 1908, the USA having lionized him for the past two decades, *The Washington Post* ran a report that Monet had ruined his revolutionary new pictures – said to be paintings of clouds on water – cutting some of the canvases to shreds after first postponing and then cancelling the planned exhibition. It was certainly a sensational piece, reflecting the intense interest the American public continued to take in his work; sensational, but not without foundation.

In June, after a period of rest and reflection, Monet began again with renewed intensity on yet another set of pictures that are both more radical and in many cases more decorative than all that preceded them. Returning to a squarer format, he retained the loose handling of the two previous years but channelled now through a more harmonious palette, at times greatly subdued to a range of pastel yellows and blues administered with a calmer brushwork that makes these images among the most liminal of the entire extended series, with lily pads, flowers and reflections, all apparently suspended in the miasmal world that fills the picture surface and brings to mind the barely fathomable images of the ageing Turner. They also foreshadow the dreamlike visions, still some years in the future, of what would become Monet's great final series.

Monet in Piazza San Marco, Venice (1908)

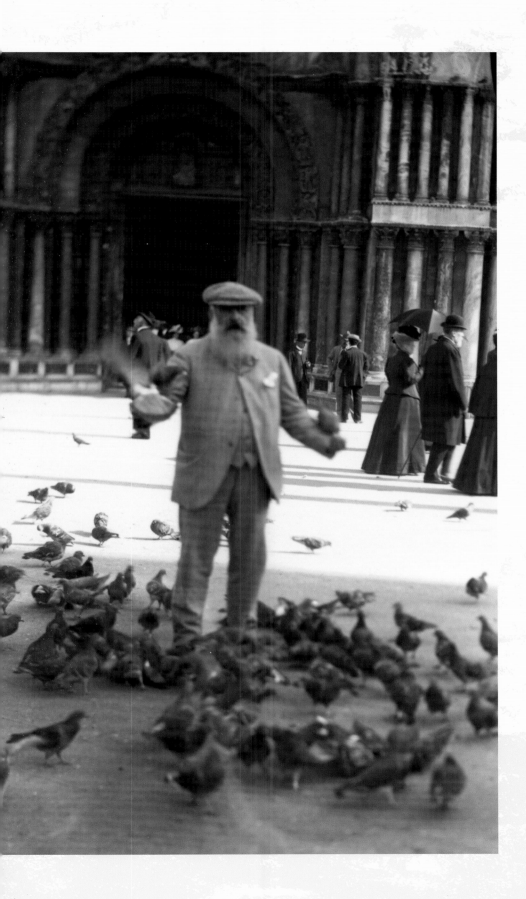

Venice

At last, Monet was happy with the results, writing to Geffroy in August that, 'These landscapes of water and reflections have become an obsession. It is beyond my old man's powers and I want nonetheless to succeed in rendering what I feel.' Indeed, he was getting older and was less and less inclined to leave Giverny. So when the following month Monet and his wife were invited to go to Venice, the oneiric city of water and reflections that he had never yet seen, his acceptance came only after Alice for once had put her foot down and insisted they go. In the end, the trip was prolonged to ten weeks, far longer than intended for what was ostensibly a holiday. Initially, they stayed with their host, a rich American heiress, in the Palazzo Barbaro on the Grand Canal. But after three weeks, they felt it was time to move to a hotel along the canal, having already extended their original plans at a time when she wanted to return home to America.

This last trip of Monet's life was a very happy affair and, in fact, for the first week or so, Monet the tourist thoroughly enjoyed himself. Incongruous photographs show Monet and Alice in St Mark's Square with their arms extended to allow the pestilential pigeons a temporary perch. But, of course, this could only ever have been a busman's holiday, and soon the artist became as engrossed in the city's many famous motifs as he had with London's landmarks nearly a decade earlier, keeping up as punishing a schedule now, at the age of nearly 68, as at any time in his career. Having waited so long to see the city of Bellini (*c.* 1430–1516), Titian (*c.* 1488–1576) and Veronese (1528–88) – even at this time of year, its lagoon and buildings still richly tinted with the southern light he had previously found such a tantalizing challenge – he knew that another opportunity might never arise. Soon he had begun work on a new series, painting famous landmarks such as the Church of San Giorgio Maggiore and the Doge's Palace, as well as palazzos across the Grand Canal from where they were

staying. But by now, this series, which followed the more relaxed treatment of motifs that had characterized the *Londons*, was perhaps more a diversion from his main preoccupation: the *Water Lilies*.

The Venice paintings were eventually finished in the studio, from memory, and may have suffered from his inability to return to the city. But the pictures were a huge success when exhibited in 1912, the critics again unanimous in their praise; however, Monet, who remained his own harshest critic, was never quite convinced by them.

Landscapes of Water and Reflections

Monet returned from Venice refreshed and with such confidence in his ability to finish the *Water Lilies* that he agreed a date for the exhibition with Durand-Ruel. His first in five years, the show opened as planned on 5 May 1909, with the paintings being shown in chronological order to demonstrate the growth of the basic idea over time. Durand-Ruel wanted the series to carry the title *Reflections*, but Monet, anchored as ever in the real world, preferred *The Water Lilies: Landscapes of Water*. Even so, it is clear that he was equally well aware of the disorientating effect such decontextualized images might have on the viewer, claiming that he had sought 'the illusion of an endless whole, of water without horizon or shore'.

'The illusion of an endless whole': whatever could he have meant by that phrase and what might have driven him to conceive of a picture in those terms? Why was such a faithful recorder of 'impressions in front of the most fugitive effects' suddenly so interested in illusion? Had he recognized something about the nature of painting itself? If so, does this phrase indicate not only an acceptance of its illusionism but an embrace of that inescapable fact? Can painting, no matter how faithfully it seeks to represent the world we inhabit, ever be anything other than its two-

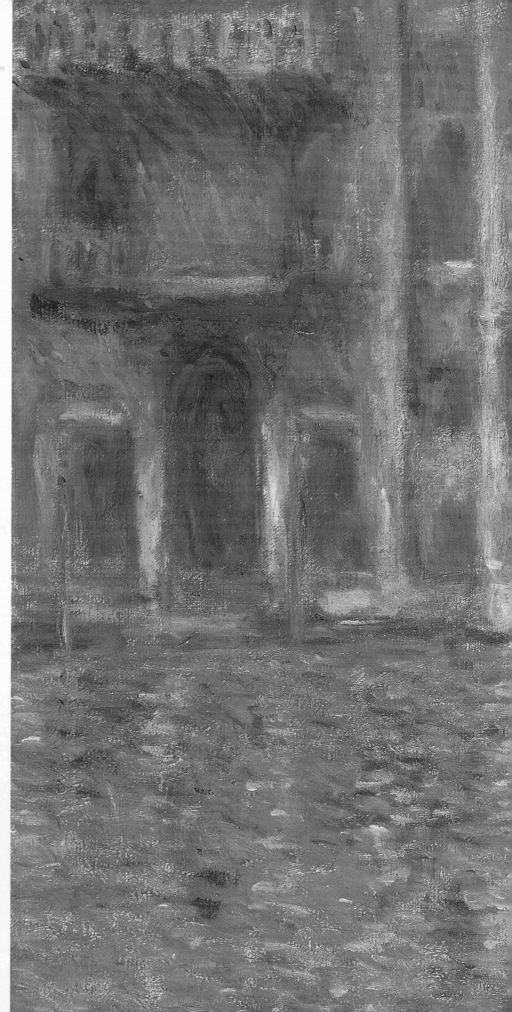

Palazzo da Mula (1908)

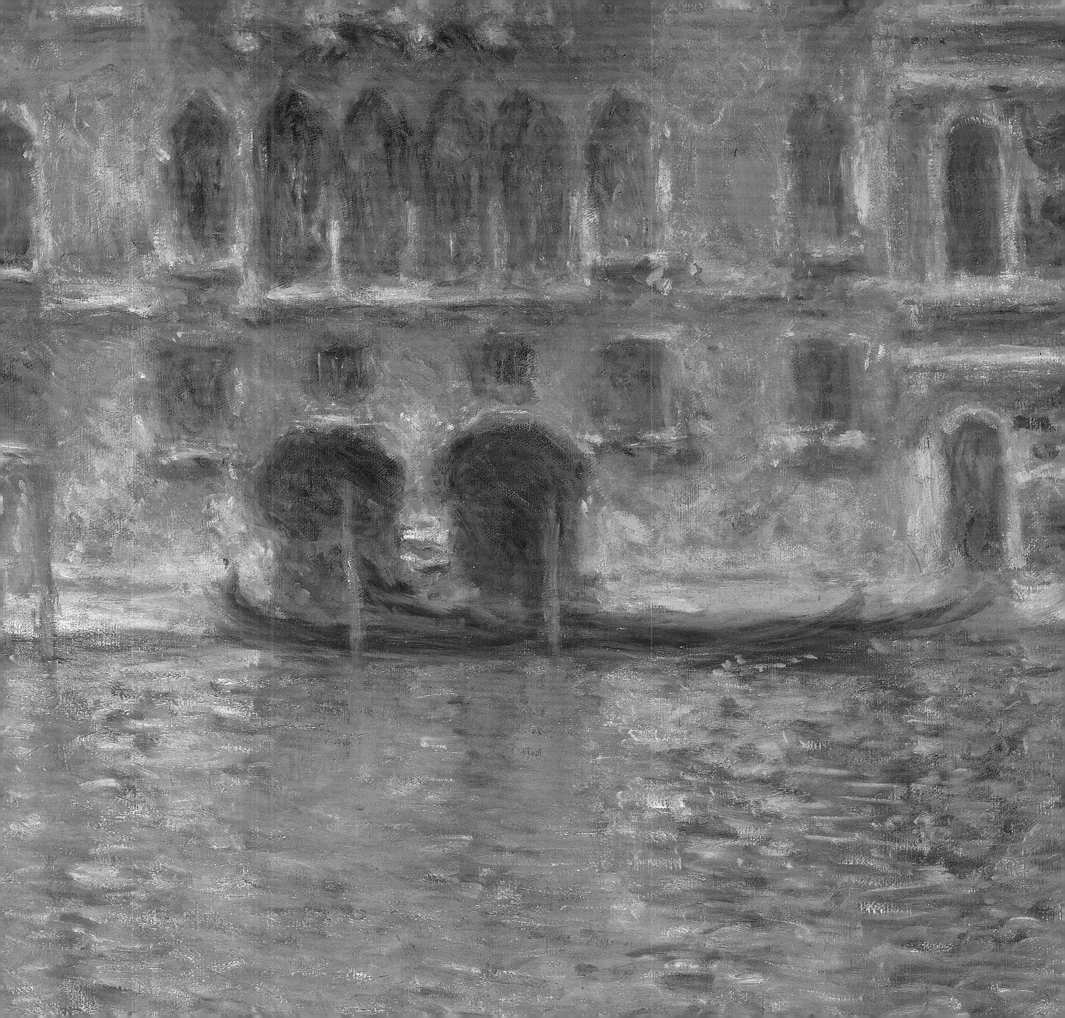

I felt it would not be trivial to study a single motif... and to note the effects of light.'

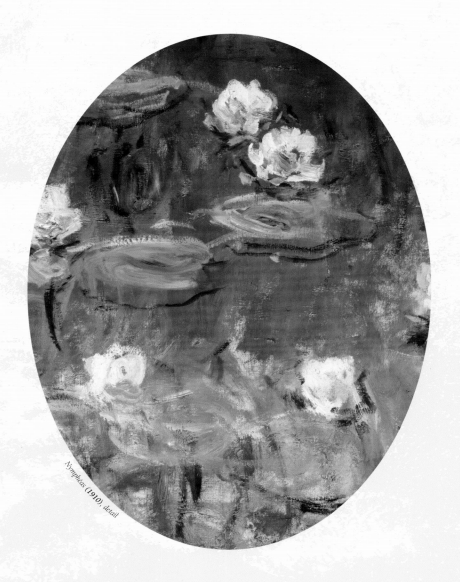

Nymphéas (1910), detail

dimensional reflection, the creation of an alternative world that, by definition, will always be a fantasy? These are unavoidable questions in the light of what followed – indeed, questions that became central to artists in the twentieth century – but they also suggested themselves to critics who saw the long-awaited exhibition of 1909.

An Ecstatic Response

In contrast to the mixed reactions to the series of 1899–1900, these new *Water Lilies*, 48 images in total, most of them stripped of the strong visual anchors of the previous series, were greeted with rapturous acclaim by a critical fraternity used to Fauvism and cognizant of the Cubist upheavals that were just beginning. One review, by Henry Eon, stated: 'Monet has reached the final degree of abstraction and imagination allied to the real that his art of the landscapist allows' – a wonderful and understandable encomium, given that these paintings must have seemed like the end of a process whose stages were indeed iterated in the chronological progression of pictures around which the show was structured. Another writer declared that Monet had liberated landscape from its terrestrial moorings, the water being now the entire ground – indeed, the landscape – of the territory depicted. But Monet made light of their more extravagant claims, saying, 'You mustn't assume that I have labyrinthine, visionary plans. The truth is simpler; the only virtue in me is my submission to instinct; it is because I have rediscovered and allowed intuitive and secret forces to predominate that I was able to identify with creation and become absorbed in it.'

In Harmony with her Laws

Rediscovering 'intuitive and secret forces' is another phrase worth pondering. Had Monet lost these powers only now to rediscover them,

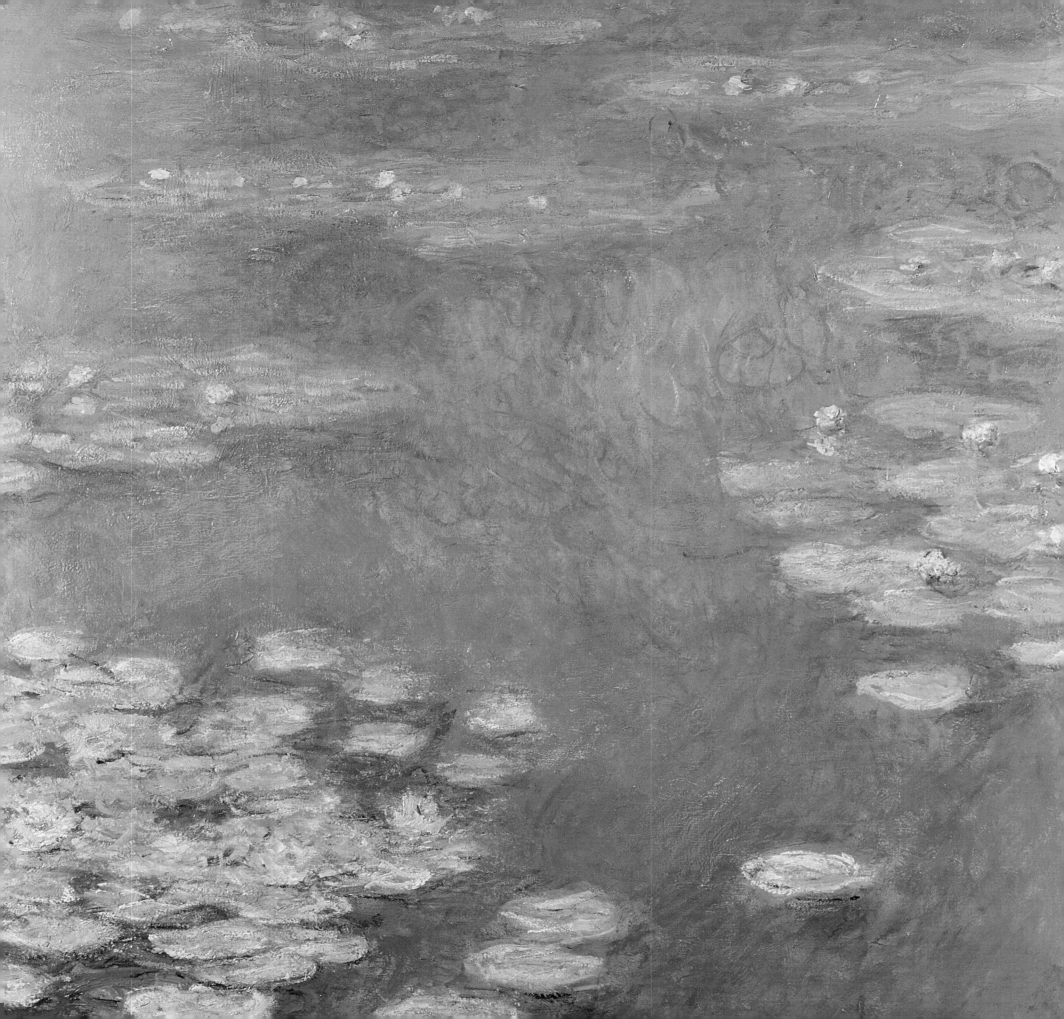

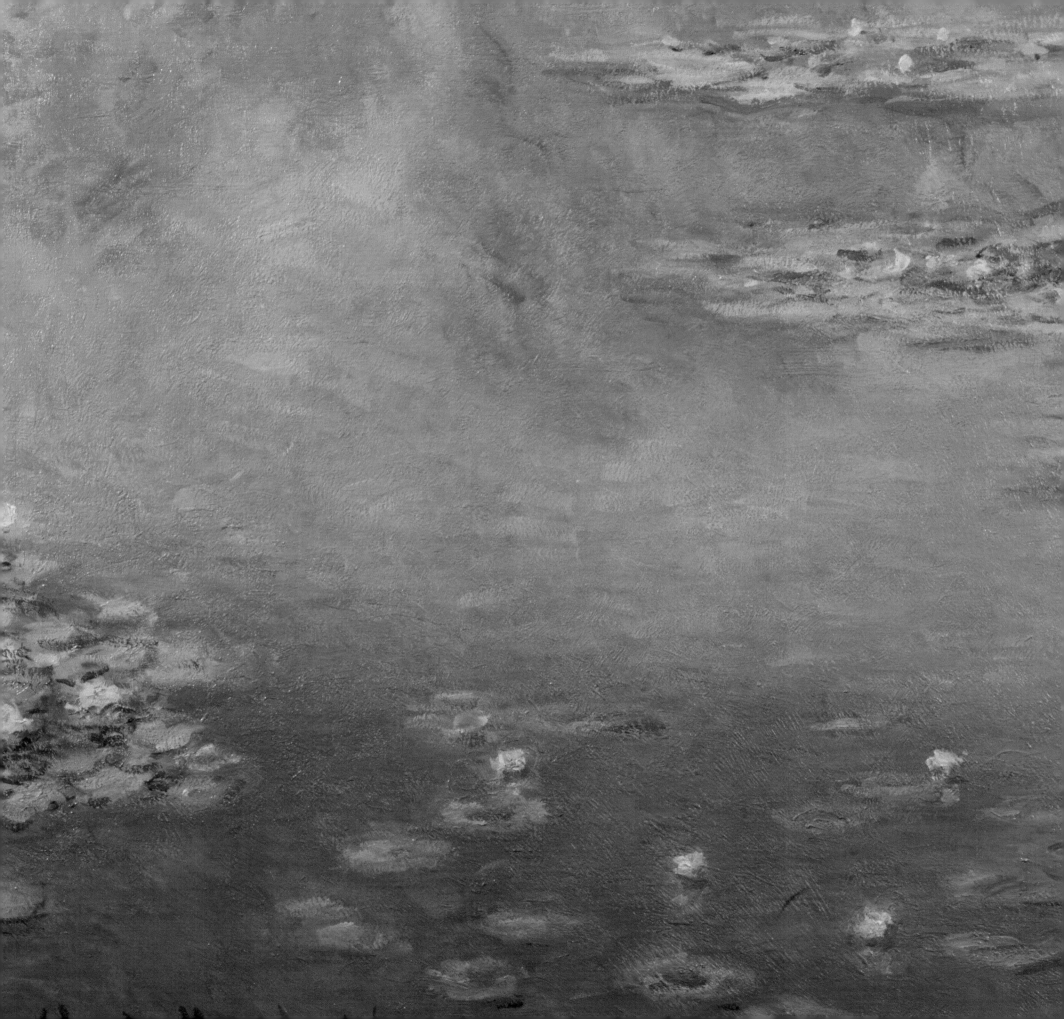

or was he implying that Western culture as a whole had lost them? If the latter, wouldn't their rediscovery and renewed employment constitute at least a visionary attitude to the business of making art and the act of seeing which is its primary tool and function? Though he may have feigned modesty, Monet knew very well just how revolutionary, how visionary, these paintings were, notwithstanding the howling mob of artistic revolutions that rampaged through the galleries of Paris in those final years of the *belle époque*. Indeed, his declared aims – 'I have no other wish than to mingle more closely with nature, and I aspire to no other destiny than to work and live in harmony with her laws' – were revolutionary in their simplicity and their reorientation of human subjectivity: not just painting nature, nor even co-opting her forms as an alternative visual grammar, as Art Nouveau had done, but mingling with her, living 'in harmony with her laws'. Here is painting not as career or aesthetic programme but as way of life and world-view. The painter who had had the leaves stripped from the oak at Fresselines was now a man whose sole ambition was to take in humility only what nature offered him, albeit a nature he had selected and husbanded according to his own needs.

The Debt to Japan

Monet's needs by this point in his life were simple enough, but perhaps had been implicit from the start. Indeed, the intense focus on a single obsessive motif only deepened the attitude to composition he had taken throughout his career, inspired initially by the cropped, informal style of the Japanese artists of Ukiyo-e ('pictures of the floating world'), whose prints he avidly amassed his whole life, even when, as a young father, he couldn't afford them. (Many of the Impressionists had assembled such collections but Monet's is the only one that remains intact; it can still be seen at Giverny today.) And having absorbed these lessons, his obsession with light in the series of the 1890s had led him to radical compositional gambits such as

Nymphéas (1906), detail

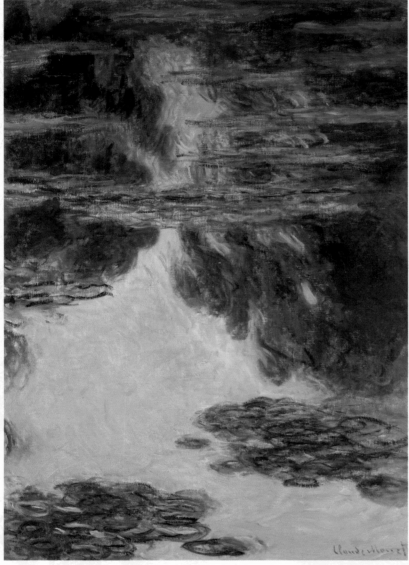

Water Lilies (1907)

picture, an approach to composition that had underpinned Western art for centuries. In Japanese art and in Impressionist paintings, especially Monet's paintings going right back to the images from La Grenouillère, the hierarchy is suppressed, the viewer's focus diffused across the picture, alighting first on one patch of coloured light, then on another, like a butterfly flitting between coloured flowers. Diffused light, diffused focus, the eye's attention directed not to specific objects but, increasingly, to the environment as a whole, of which objects are only constituent parts, any of which may be of no more significance than the space which surrounds them.

The Fragment and the Whole

In the case of the *Water Lilies*, the objects in question, a few clumps of lily pads, are wholly inconsequential, resting places for a dragonfly gaze zooming this way and that across a waterscape shimmering with reflected life. For Monet, Japanese art was an 'aesthetic code that evokes presence by means of a shadow, the whole by means of a fragment', to which we could add, the world by means of a reflection. The appeal of the *Water Lilies* lies in just this power of suggestion and implication, an aesthetic attitude which has since become commonplace in a cultural climate in which artists, along with everyone else, have come to recognize how little we know or can ever hope to know.

the cropping-out of almost everything but the stone façades from his *Rouen Cathedral* pictures; compressing the interest of an image into a stretch of water and a few clusters of lilies was simply an intensification of such motivic simplification.

But cropping also has another function, namely, to undermine the acquired tendency to create a hierarchy of visual interest in a given

Monet's series paintings had taught him that radically simplifying the 'natural' content of his pictures, in some cases to little more than motif and envelope, intensified their visual meaning. Emboldened by these achievements, and having further condensed his vision to a small area of the surface of his own lily pond, he realized that the fragment could indeed suggest not merely the whole pond but the wider world extending beyond it and, fundamentally it seems, his ever-deepening vision of the wholeness of life.

A Gathering Darkness

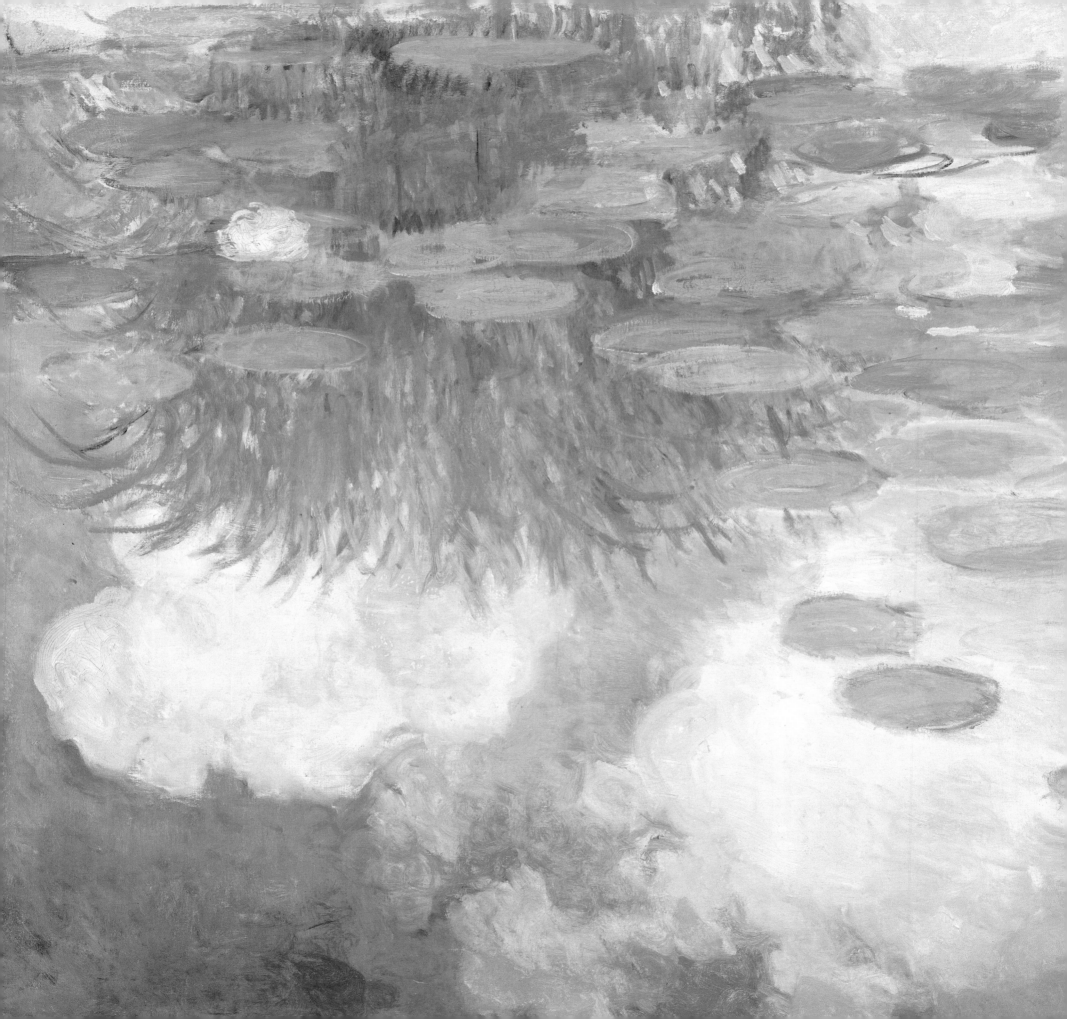

IN THE SUMMER OF 1911, Monet would spend hour upon hour in his garden, thoroughly disinclined to paint for almost the first time in his life. His wife Alice had recently died and, as he admitted in a letter to his friend Gustave Geffroy, his thoughts turned to her again and again, 'going back over most of our life together', the flicker of memories affirming the persistent sense that some vital part of the world had gone missing, without which nothing made any sense.

His stepdaughter Blanche was living again at Giverny with her husband, Monet's eldest son Jean, who was mentally unwell. Also in mourning for her mother's death, she had slipped quietly into the role of household manager which Alice had previously assumed, caring unobtrusively for a man quite obviously stupefied by grief as, in the numbed spaces of his mind, he attempted to come to terms with the worst loss of his life.

A Deluge of Sadness

The previous 18 months had been among the most difficult Monet had ever known. A year earlier, in January 1910, the Seine had flooded badly, overwhelming the low-lying parts of the village of Giverny and submerging with ominous ease both the water garden and everything across the railway track as far as halfway up the Grande Allée to the house. The deluge destroyed countless bulbs and perennials even if the trees and shrubs mostly survived; at the time, it seemed like a devastating blow. In 1896, Monet had painted a less severe flood when the river had burst its banks, but in this far more serious inundation, this stalwart

'Now, more than ever, I realize just how illusory my undeserved success has been.'

supporter of his community had been too busy lending assistance to households affected in the village, as well as working out how to restore his beloved garden, to have the equilibrium for painting. But, after the initial despair, the ever-resourceful gardener-artist seized what he recognized as an opportunity to enlarge the pond still further, altering its contours to give him a greater variety of views he might want to paint. Nature, with Monet's help, would bounce back.

Then, in the spring, with the replanting of the flower garden and the more drastic renovation needed in the water garden well underway, Alice had been diagnosed with myelogenous leukaemia. It was the worst possible news and, although she rallied through the summer, her condition worsened through the early months of 1911 until in May she died. Monet, as his letter to Geffroy the following September shows, was despondent for many months. He may have even abandoned the habit of observing the shapes and colours of nature that was so automatic he had once told a cautionary story about where this could lead: he described himself sitting by the deathbed of an unnamed woman when he realized that he was abstractedly analysing the changing hues of her skin as the pallor of death replaced the last flush of life. The woman is now assumed to have been his first wife Camille, whom he did indeed paint in death, but if his reaction to that loss seems to have been ambivalent, Monet had changed in the years since; moreover, Alice had been his companion for far longer and his source of strength through so many difficult years.

Gathering Clouds

As tough as this was, Monet's troubles were far from over. As the garden came back to life the following spring, he was back in his studio finishing the *Venice* paintings whose public unveiling had been delayed by the sadness of the previous year but which were now due to be shown at the

The Artist's House at Giverny (1912)

'As you doubtless already know, my wife is seriously ill and I'm still not in my right mind with such worries.'

Water Lilies (1914–17)

gallery of yet another dealer, the Galerie Bernheim-Jeune run by brothers Josse (1870–1941) and Gaston (1870–1953) Bernheim-Jeune, in June. These pictures at least would have brought back fond memories of that last happy trip with Alice, but Monet was now beginning to look past the consoling shadows of memory and take an interest again in what was in front of him, the colours and shapes and shadows cast by his loyal legions of flowers and trees. It was only in trying to look more closely at these details that he began to acknowledge persistent shadows which had nothing to do with the sun – milk-white clouds that seemed to envelop the world of forms in their sticky mist. Now realizing that the problem had been getting worse for several years, in July 1912, he consulted an oculist to see what could be done to resolve it. The physician diagnosed cataracts and recommended an operation. But Monet was appalled at the thought that his eyesight might be irrevocably changed, opting instead for a course of treatment which did lead to some improvement but was only ever intended as a postponement of further decline. Now fully apprised of his condition, in the course of that summer, he produced his first new paintings in almost three years, two scumbled images of his house painted from the rose garden directly in front of it. As yet, these were small steps.

The Death of Jean

With the treatment at an end, things appeared hopeless when, in spring 1913, he found he was unable to tolerate bright outdoor light. He may have been resigning himself to further intervention, but by summer things had improved enough that he was able to execute three paintings of the rose pergola painted from across the pond, serene images that recalled the *Water Lilies* series of 1899–1900.

But for every improvement in those awful years, a setback would inevitably follow. In the summer of 1912, just as Monet was coming to

The Rose Arch (1913)

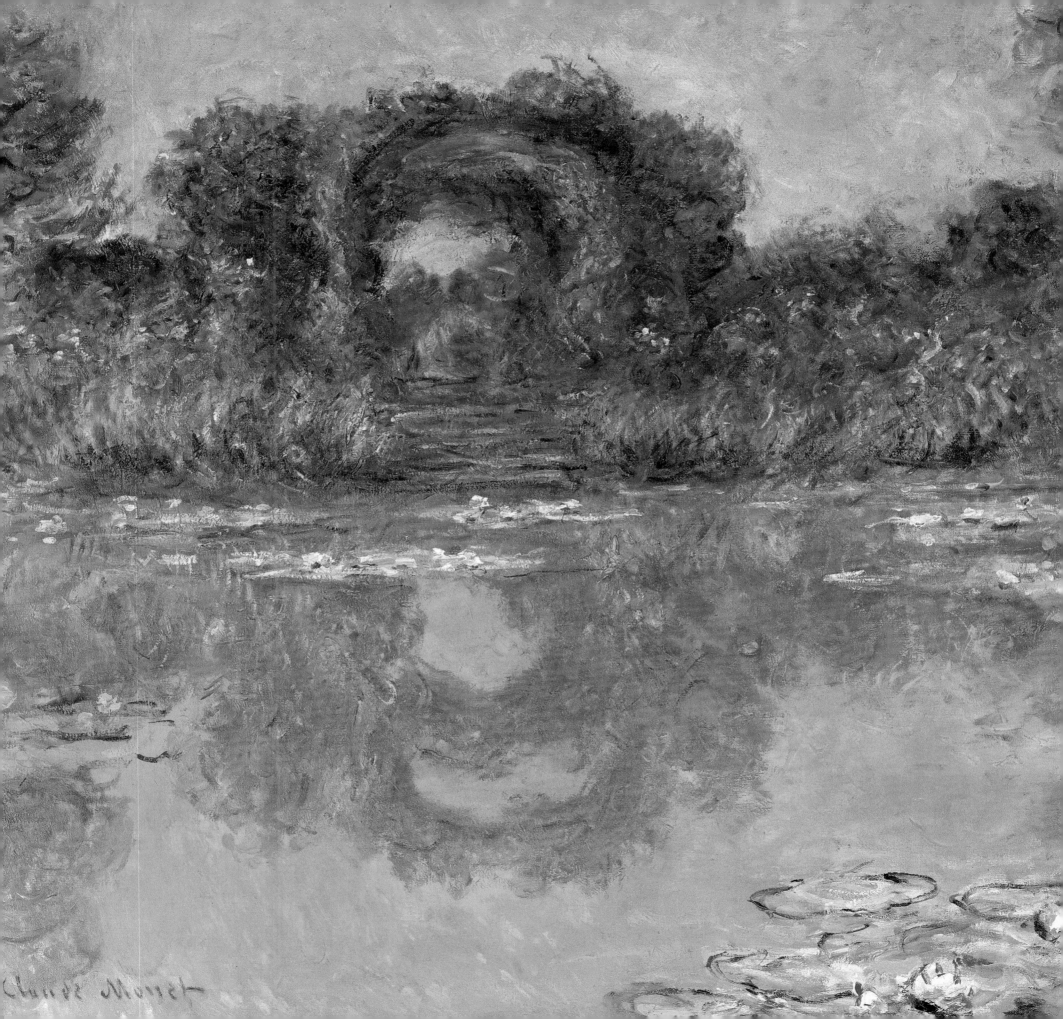

terms with the impairment to his eyesight, his son Jean suffered a stroke from which he would never recover. In February 1914, just a few months after the new rose pergola paintings had been completed, Jean died, leaving the newly widowed Blanche with the responsibility she had already assumed: that of looking after her ageing stepfather, no matter how long that might mean.

A Final Endeavour

Again, Monet absorbed the blow by getting back to work. In April, encouraged by his friend Georges Clemenceau to believe he had one last great effort to make, he declared his intention to start work on a plan that had been in his mind for almost 20 years and perhaps even longer than that. In fact, he may first have conceived of the possibility of a scheme of large decorations back in the 1880s, possibly as a result of the series of door panels he had decorated for his dealer Paul Durand-Ruel during the early years at Giverny. And during the following decade, occasional suggestions seem to have been made in the press for Monet to decorate a 'vast hall', his fitness for such a task being obvious to many. Then in 1892, he was nominated by his friend Auguste Rodin to be one of the muralists contracted to paint the interior of Paris's Hôtel de Ville. But Monet, the self-declared independent, was not selected, once again slighted by the powers-that-be despite the considerable success and acclaim of the previous few years.

Even then, the idea had continued to germinate, so that in 1897 – the same year in which he painted the first close-up images of his beloved water lilies and clearly demonstrating an appetite for such a project while also perhaps realizing the logistical difficulties involved – Monet spelled out a vision of such a work for an interviewer who came to visit him that summer: 'One imagines a circular room, the walls of which above the

The Two Willows (1914–26), centre-left section

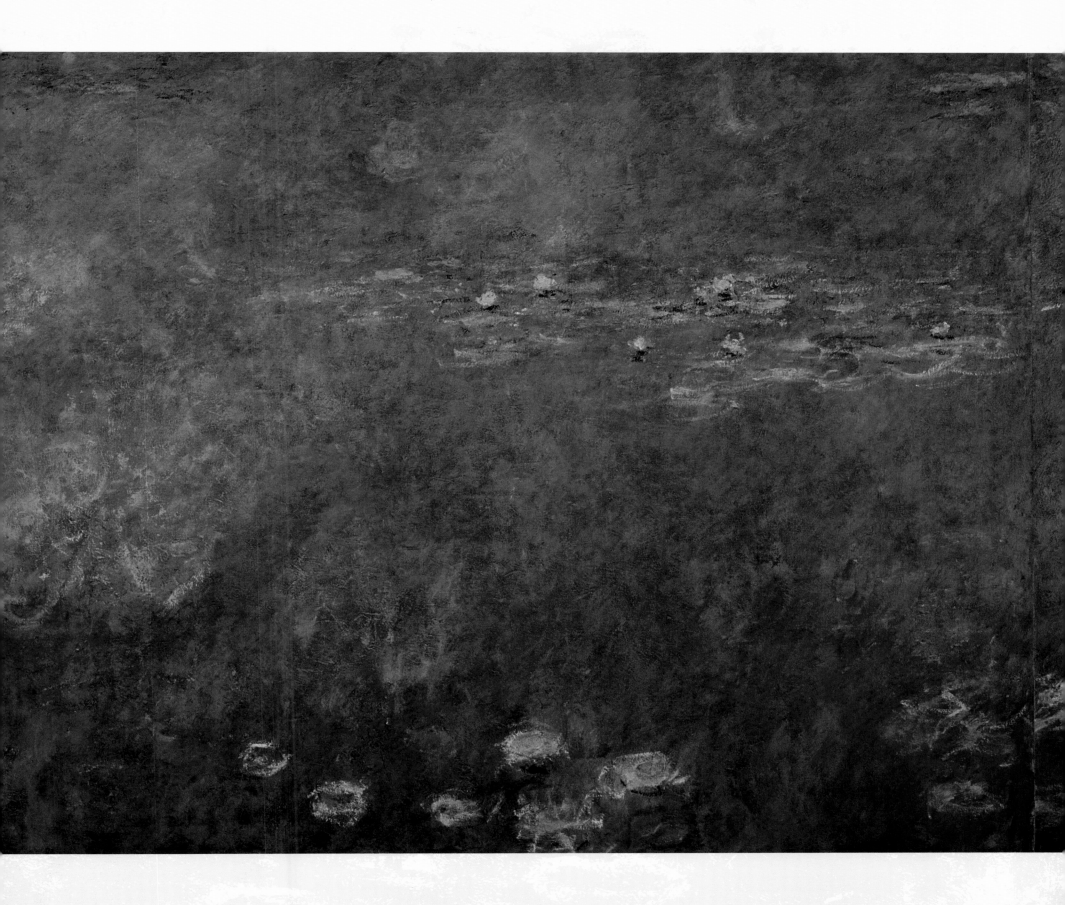

skirting board would be entirely filled by water dotted with these plants to the very horizon, walls of transparency by turns toned green and mauve, the still water's calm and silence reflecting the opened blossoms; the tones are vague, lovingly nuanced, as delicate as a dream.'

An Enveloping Vision

It seems clear from this statement that Monet's appetite for a work of this magnitude was already strong, but what is more significant is the shift it shows in the focus of his vision. The description seems accurately to evoke the suite of panels known as the *Grandes Décorations* – which are now in the Musée de l'Orangerie in Paris – in colour, subject matter and format, but above all in poetic texture. Monet was no longer simply the recorder of fugitive effects, but a translator of a pre-existing vision that may well have arisen from encounters with motifs – the envelope of nature – and may also have needed constant re-observation and fresh experience of those same motifs, but whose sources of inspiration were now more or less internalized.

The following year, 1898, the report on the *Mornings on the Seine* show by Maurice Guillemot (1859–1931) included the first public mention of the scheme that would eventually become the *Grandes Décorations*. Then, more than a decade later, in 1909, Monet described to an interviewer at the *Water Lilies* exhibition his idea of decorating 'a circular room of modest dimensions' with a painting that encircled the room 'up to half a man's height'. The idea sounds pleasant and unassuming, with no hint of the imposing intimacy of the final scheme. But to another writer around the same time, Monet outlined a much more ambitious vision, very much like the one he had spelled out in 1897: 'At one point I was visited by the temptation to use the theme of *nymphéas* [water lilies] for a decoration. Carried the length of the walls, enveloping the entire interior with its unity, it would attain the illusion of a whole without end, of a watery

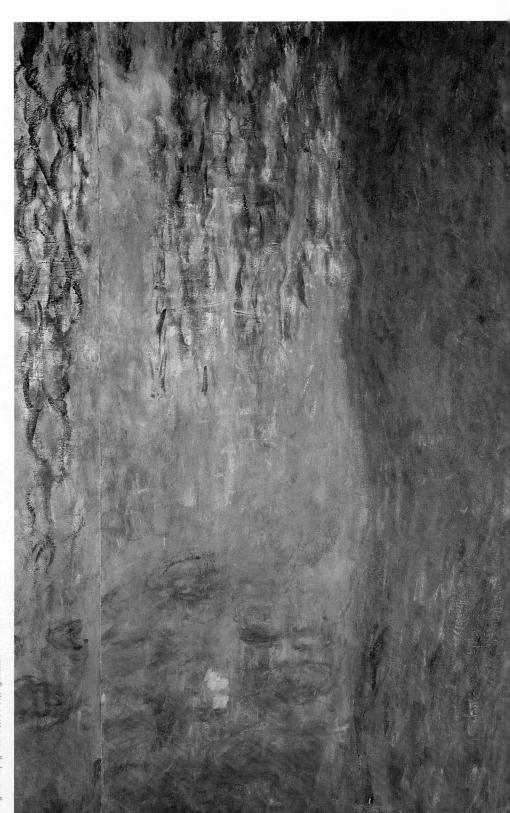

Morning with Weeping Willows **(1914–26)**, *right section*

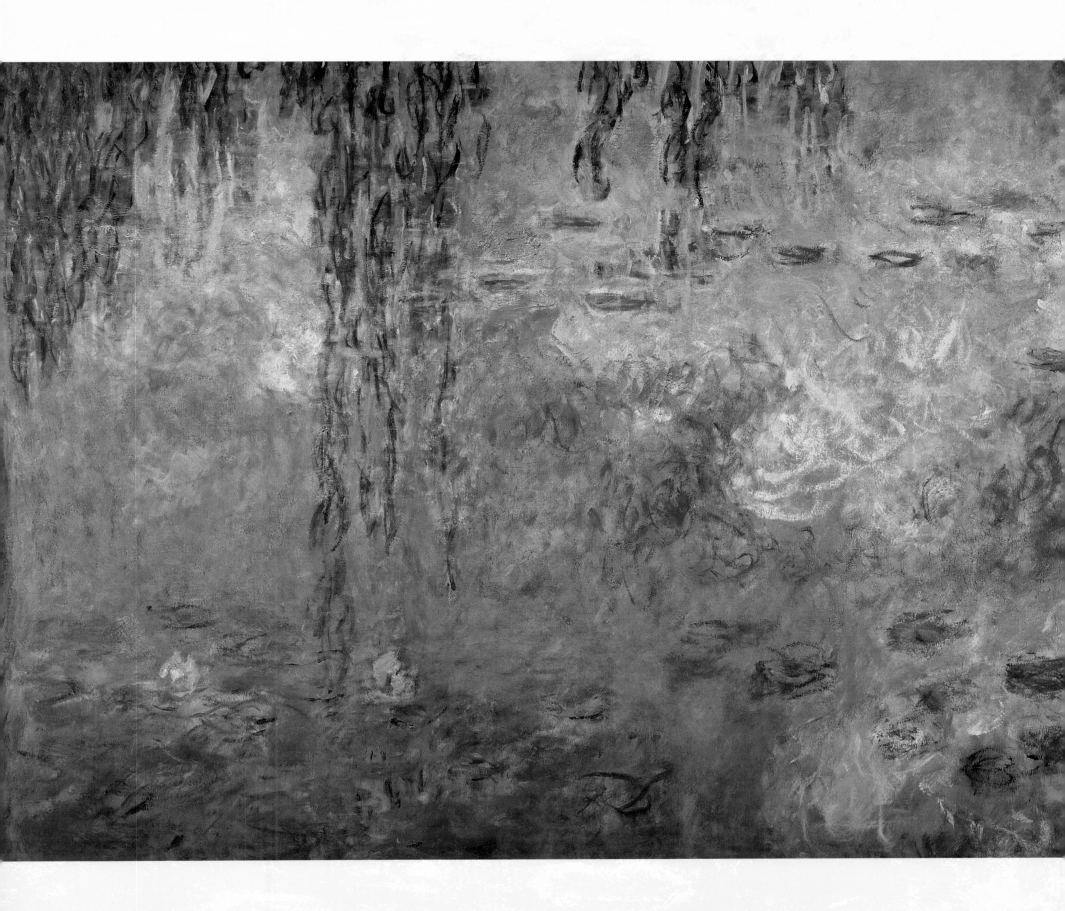

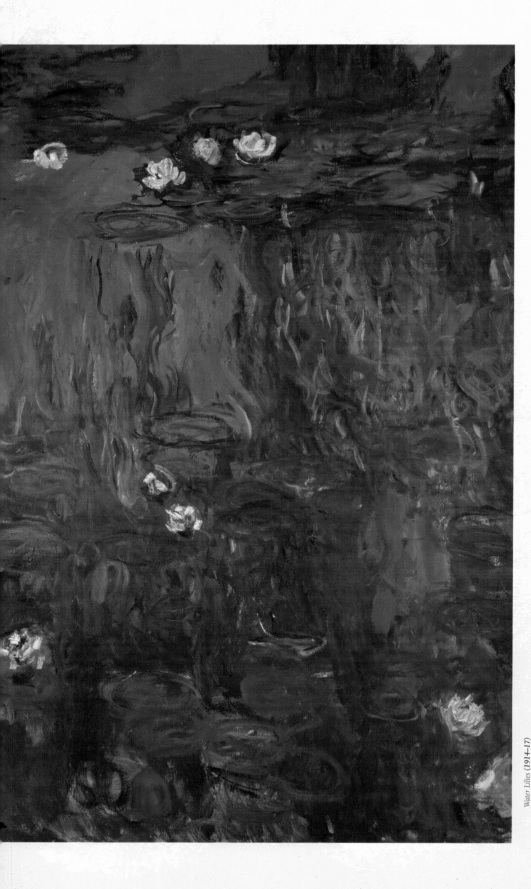

Water Lilies (1914–17)

Nymphéas (1914–17)

surface without horizon and without banks; nerves overstrained by work would be relaxed there, following the restful example of the still waters, and to whomsoever lived there, it would offer an asylum of peaceful meditation at the centre of a flowery aquarium.'

A Sea of Griefs

This was only a few years earlier, when Monet was at the height of his public success; but even then, did he really imagine that such a vision might ever come to pass? Would the *Grandes Décorations* have happened at all without the sea of troubles which had assailed him in the few years since he had so publicly speculated on the project? It is possible Monet himself could not have answered these questions. But for so many people, these late works hold a power that seems to emanate from some deep well of thought and feeling far removed from the aesthetic environs of any of his earlier work.

In late spring of 1914, he began again and had so soon recovered his enthusiasm for painting that by midsummer, at the age of 73, he was getting up at 4.00 a.m. every day and painting until sundown. But if his personal losses in this decade had been huge, at the end of June, just as he was once again getting into his stride, Monet must have intuited a coming tragedy, on a scale that would dwarf all private griefs, just then beginning its ridiculous manoeuvres in a faraway Bosnian city.

War

In early August, war broke out with the old enemy, Germany, for a time plunging Monet into a confused depression that afflicted the national mood in much the same way. But with so much recent experience of adversity, he was not about to give up. As he put it defiantly in a letter to Geffroy, 'As for me, I will stay here all the same, and if these savages must

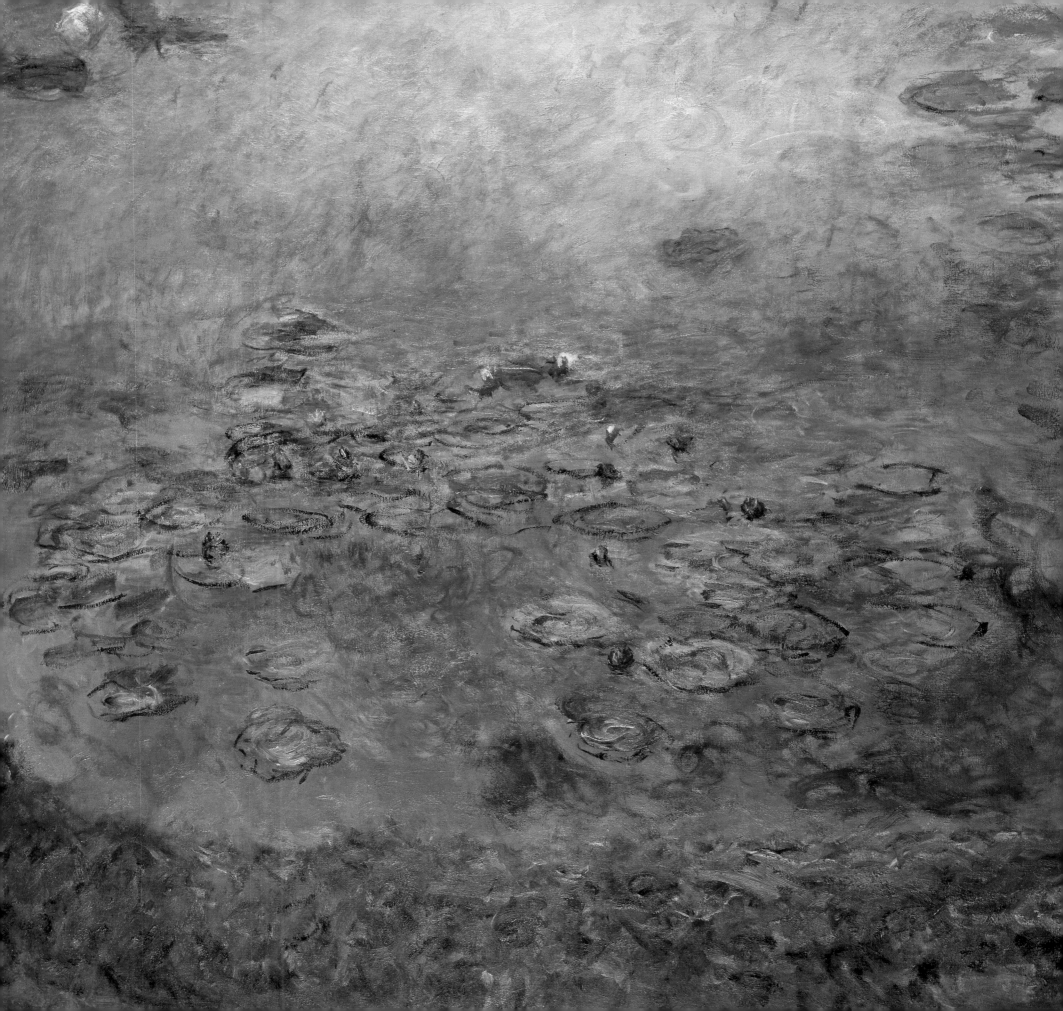

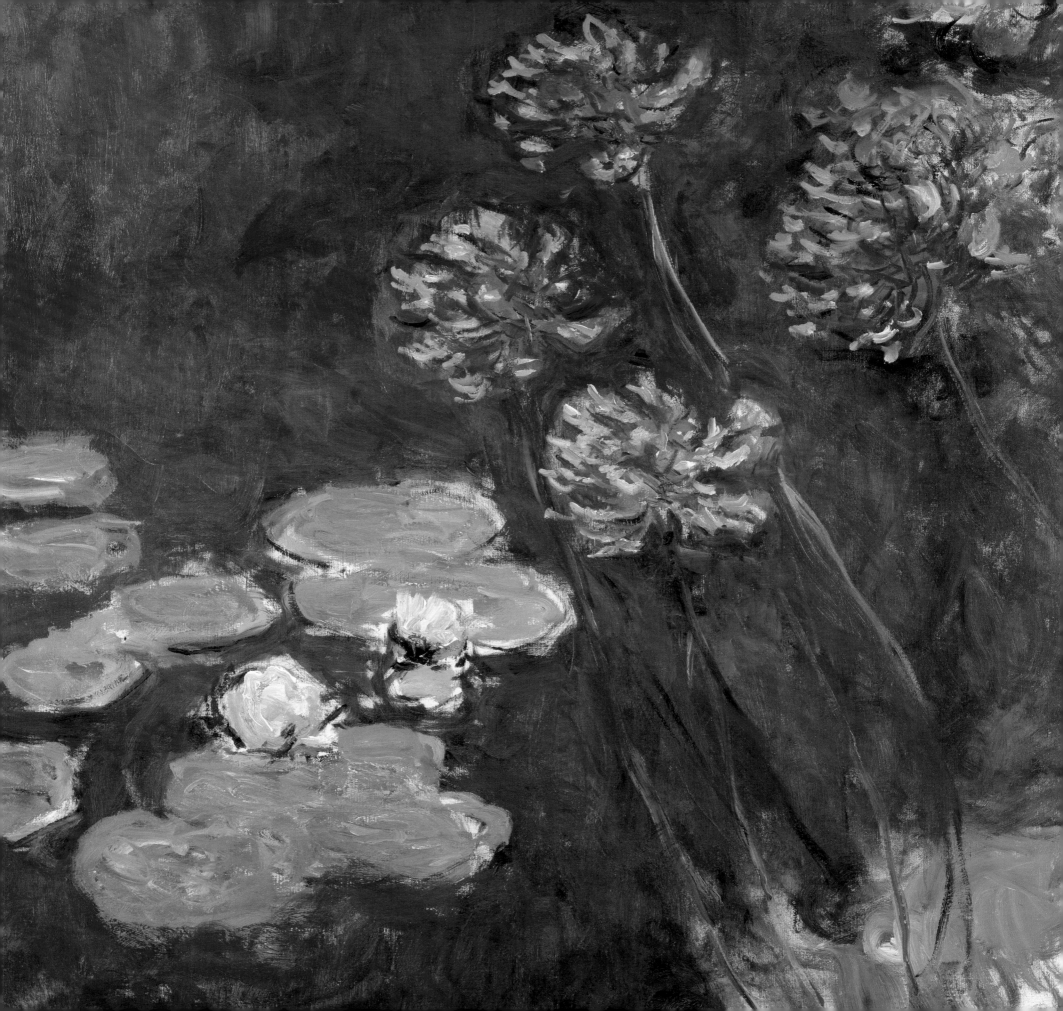

kill me, it will be in the midst of my canvases, in front of all my life's work.' His stepdaughter Germaine fled for the relative safety of the Loire, but Blanche remained staunchly by his side, organizing the household to accommodate Monet's often demanding needs. This time, he was staying put. In 1870–71, he had fled to London, a decision that may now have troubled him, especially in the light of what had then transpired: he had fled and prospered while his friend, Frédéric Bazille, had remained behind, fought and died for his country. To Monet, now the principled patriot and artistic father to the nation, staying and fighting, if only with brush in hand, may have represented a chance to redeem that error.

The conscription of his stepson Jean-Pierre Hoschedé in August 1914, sent to the front in the first week of the war, and then his son Michel, dispatched to the same fate the following year, only made him work harder. What were they fighting to defend if it wasn't the cultural patrimony of France? It was inconceivable that Monet should do anything but give their own ordeals the greatest possible meaning. Hardly a day went by that he was not reminded of the grim character of those ordeals: whether by the wounded soldiers who passed along the Chemin du Roy which bisected Monet's property between the flower garden and the water garden, and were a common sight in every community as close to the front as Giverny; or by the grave reports he heard of those injuries affecting people he knew, such as Clemenceau, whose own son was wounded in the conflict, and both of Renoir's boys, who were also casualties.

Helping the War Effort

Indeed, it was Clemenceau, in his position as president of the Senate's armed forces committee, who kept him abreast of how the conflict was progressing during the fairly regular visits to Giverny he continued to make throughout the early years of the war. Monet wrote to his friend of feeling

I'm using up a lot of paint, but it's absorbing me sufficiently not to dwell too much on this terrible, unbearable war.'

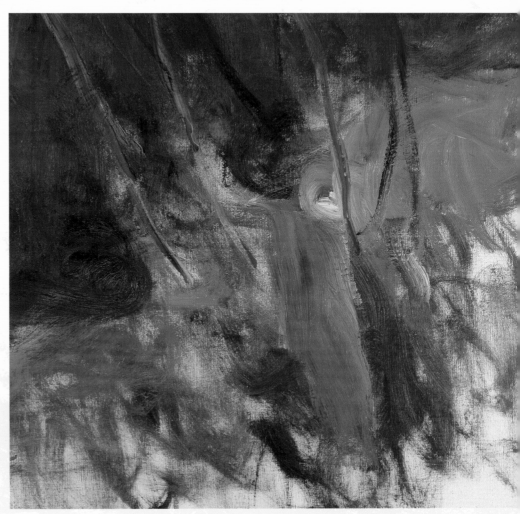

Water Lilies and Agapanthus (1914–17), detail

ashamed still to be preoccupied with forms and colours when so many were dying, but he also reacted with typical practicality, turning over his kitchen garden to the war effort, supplying vegetables to the local field hospital set up in an old monastery that had once belonged to a couple of rich American artists who had since gone home. It was to this makeshift hospital that wounded soldiers were brought by exhausted stretcher-bearers trudging right past the Monet house along the Chemin du Roy.

Monet also did whatever else he could, offering paintings for auction to fund the war effort and allowing himself to be filmed at work for a patriotic documentary on the nation's culture. In fact, this footage offers a fascinating glimpse into the master at work. Shot in the summer of 1915, the film shows Monet in a Panama hat and a white linen suit and waistcoat that may not have been his usual painter's garb at this point in his life. With a cigarette apparently drooping from his mouth, he works with considerable vigour at a large square canvas, most likely one of the many sketch-like panels that functioned as studies for the *Grandes Décorations* on which he had already started work.

A Patriotic Duty

The film shows the artist and his work sheltering from the sun beneath two white parasols. Monet turns and glances at the pond in his brisk and customary way of painting, turns quickly to his canvas to make a mark or two, then back again to the pond and so on. Everything is executed with the sureness and speed his peers so admired, a facility he learned from Boudin, who had impressed upon him the importance to a *plein-air* painter of working swiftly to capture fleeting atmospheric effects. And, of course, as the camera pulls back to the other side of the pond to show the painter put down his brush and amble back to the house, the garden of Giverny looks immaculate.

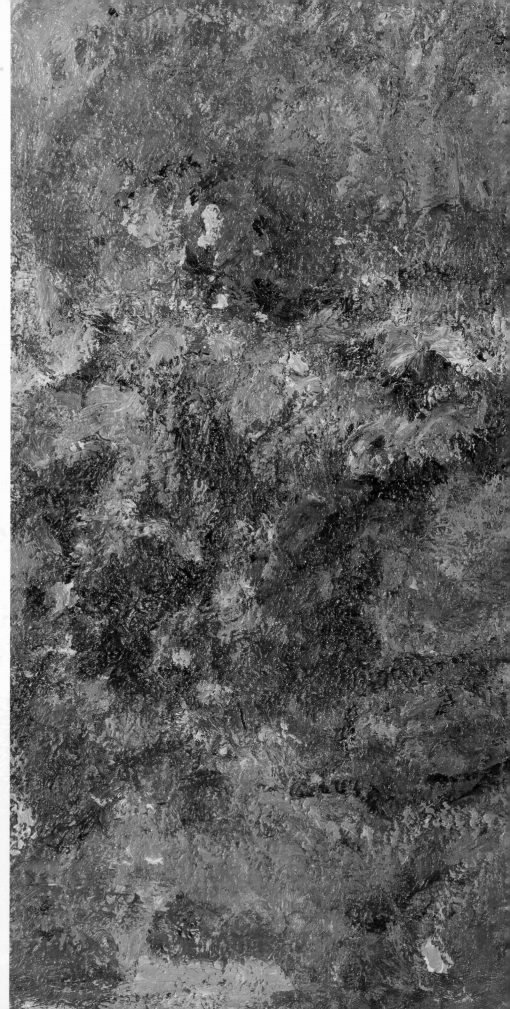

The Bridge across the Lily Pond (1919)

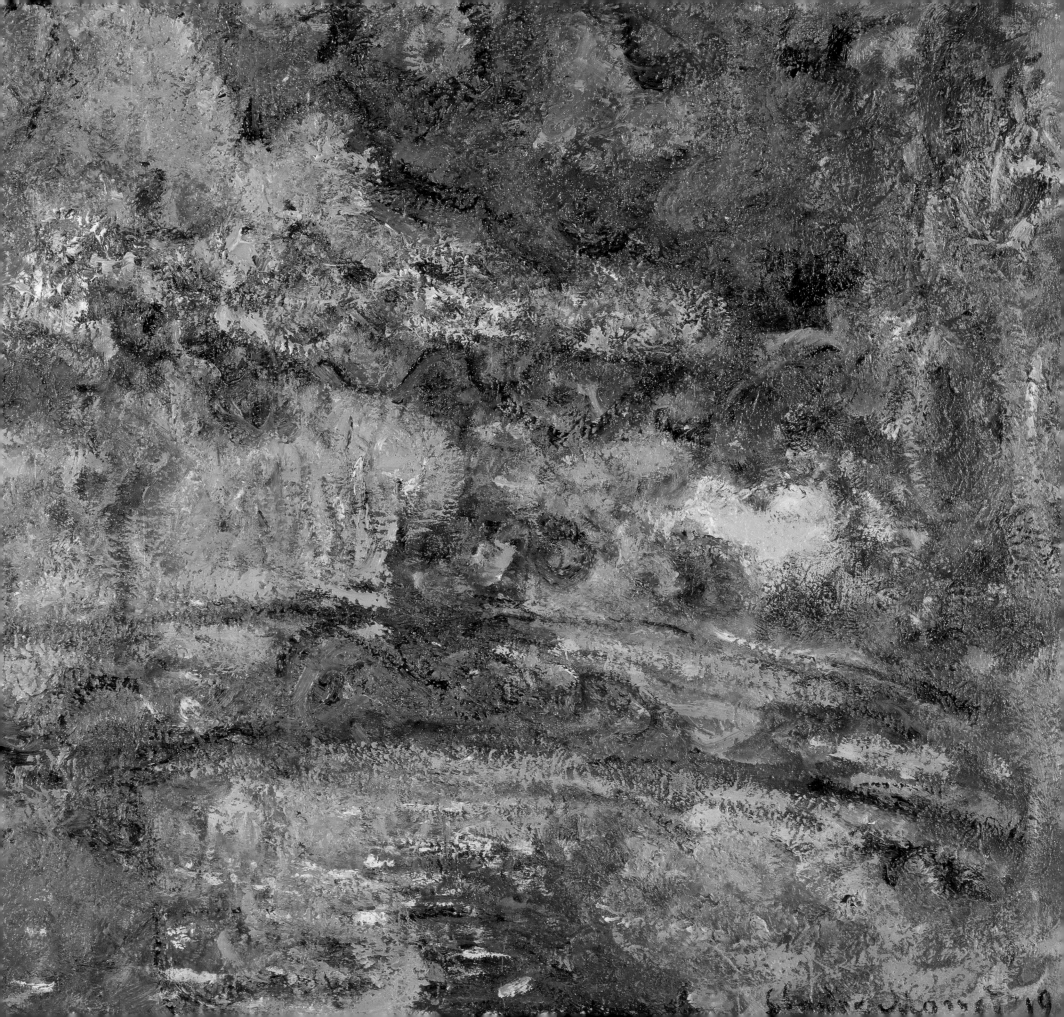

'...in order to succeed in conveying what I feel, I totally forget the most elementary rules of painting, if they exist, that is.'

The Path Through the Irises (1914–17), detail

In the film, the large canvas Monet is working at is nevertheless small enough to be set on an easel in the garden, but it is also clear that by then, the larger panels, each 2 x 4 m (6 ft 6 in x 13 ft), were going well. As early as February that year, he had written to Maurice Joyant (1864–1930), yet another dealer, wanting to know 'the exact size of your gallery – length and height. When I come to Paris I will tell you why I ask; it will suffice for now to know that I am working a great deal, which is still the only way to avoid thinking about what is happening.'

The New Studio

At this point in the conflict to which Monet implicitly refers, Clemenceau's position made him the man responsible for mobilizing the French army. For purely logistical reasons but also for others, too, his friendship proved to be vital at this time, just as it would remain throughout the great project of his last decade, as the political prime mover organized materials for building the new studio to be brought by train to Giverny, followed by the many large (2 x 4 m/6 ft 6 in x 13 ft) canvases Monet would need.

In fact, it was not until the summer of 1915 that Monet decided that he would, after all, need a much larger studio to enable him to work comfortably on such a huge undertaking. But the decision having been made, the massive 276 sq m (2,971 sq ft) space, including two huge skylights, was finished by the early autumn. Monet almost immediately regretted what he saw as the building's aesthetic clumsiness, but even so, he was soon inviting people to come and see the progress he had made on these new images, and may have been looking to finish them quickly now that his new workspace was ready. Throughout 1916, with the war entering its most deadly phase, beginning with the Battle of the Somme less than a hundred miles away, he worked at a furious and unstinting

Water Lilies (1915)

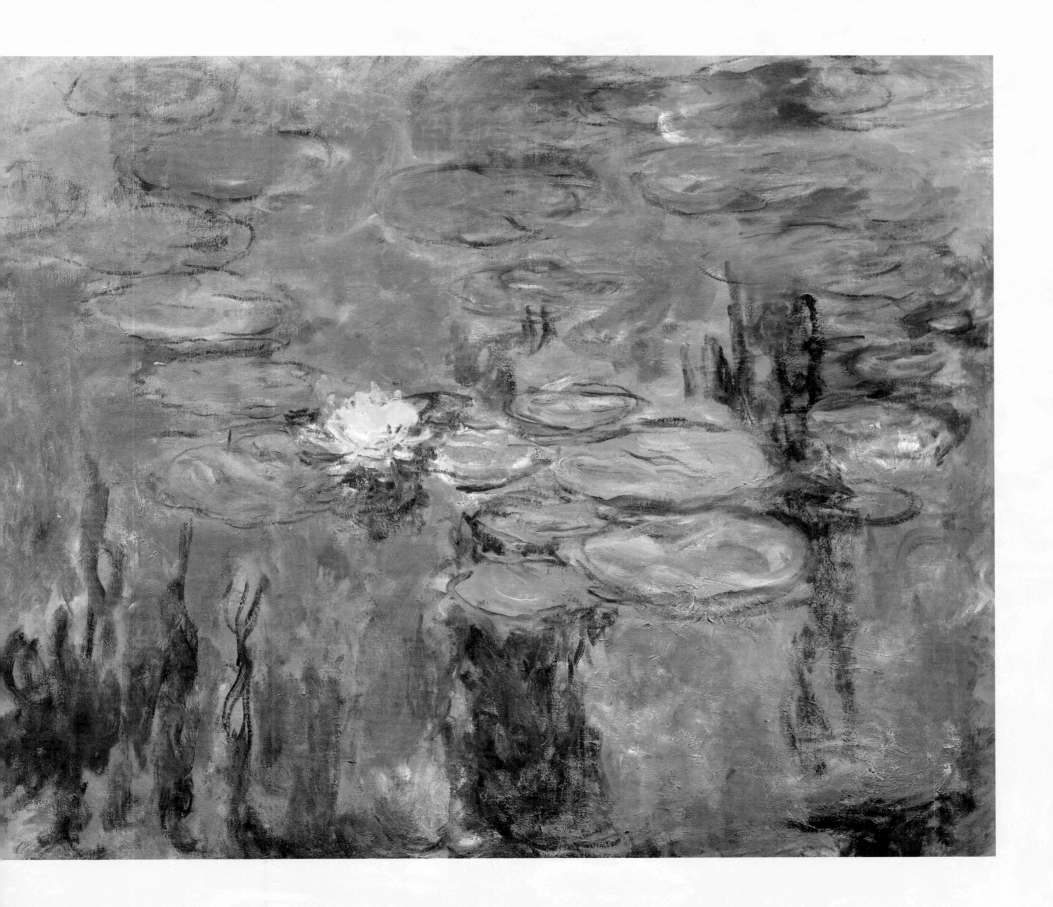

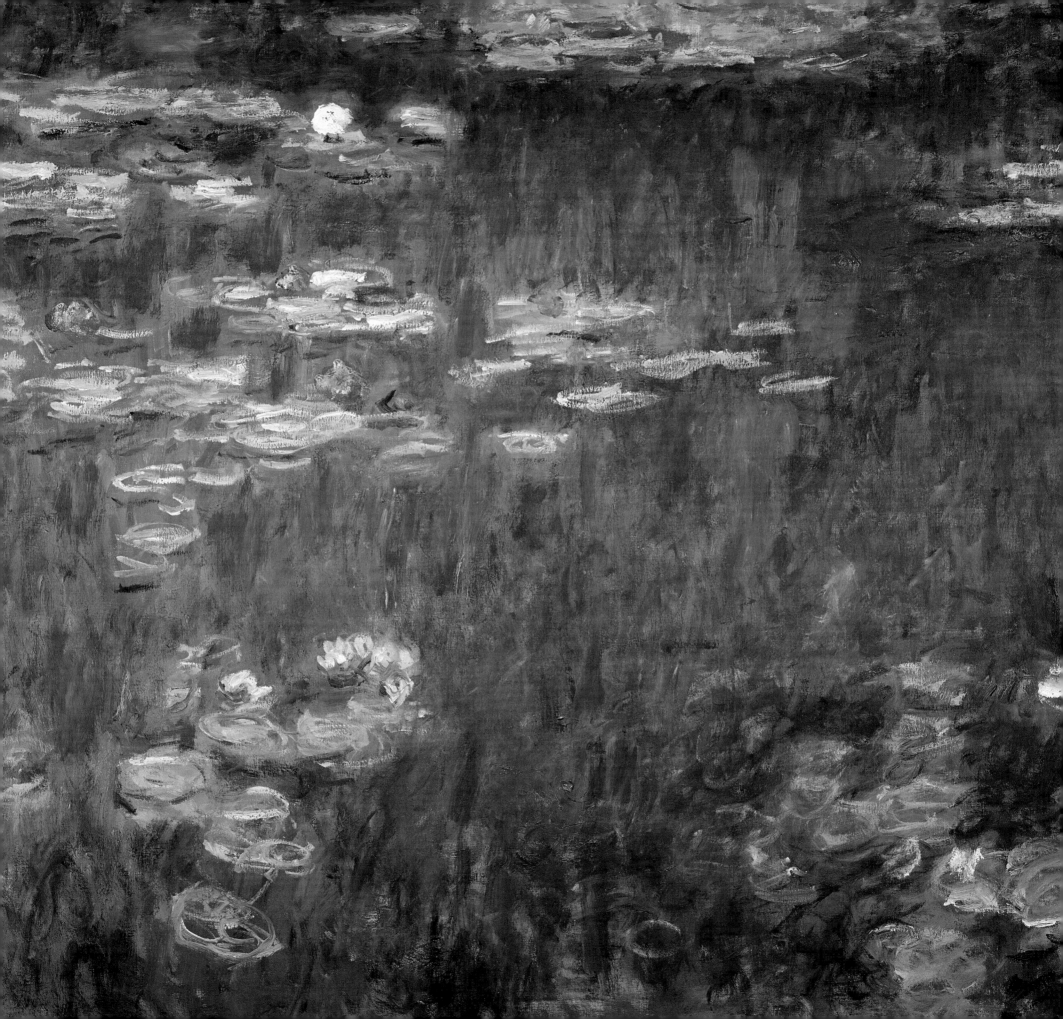

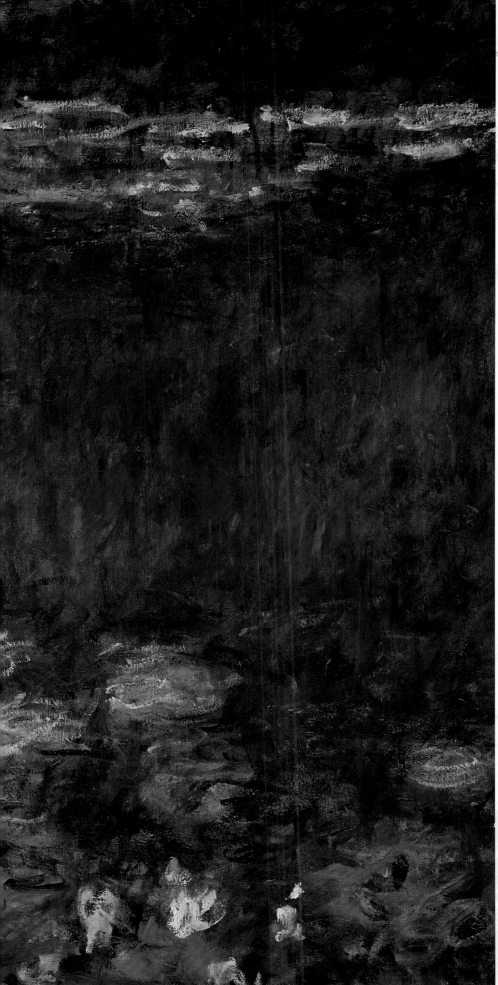

pace, haunted by the sound of howitzers going off at Beauvais not 50 miles to the east, as they pounded the German lines further off.

The Wartime Studies

Taking refuge in his garden, real and imagined, like never before – not to escape a bleak reality but because making images worthy of such sacrifice was the least he could do – Monet now worked with remarkable dedication even for him. By November that year, he felt that some of the panels were almost finished, but then, unable to resist reworking them, altered some so disastrously that there was nothing for it but to burn them. He broke away from the scheme, returning to the large, square, sketch-like panels he had begun in the summer of 1914, studies exploring a mixture of motifs and treatments that seem preparatory to the same material which appears in the large panels of the *Grandes Décorations*. These very rough pieces of work include numerous tenebrous images of water lilies, which may have been studies for the suite of panels that became known respectively as *Green Reflections* and *Reflections of Trees*, the darkest two of the eight panoramic vistas that were finally selected for the permanent decorative ensemble.

Barring one exception, the studies were never sold in Monet's lifetime and were certainly never exhibited. As well as being frequently very dark, they reveal a new vehemence of gesture and boldness of mark, with foliage and plant fronds depicted using long, incredibly thick, crude strokes that suggest an artist trying to find his range and perhaps a sense of fluency that was not automatic even for Monet when working at such a large and unfamiliar scale. Their rough handling and loose application of paint, with areas of unprimed canvas showing around the edges, suggest that these were only ever intended as notes or aides-memoire for the formal panels to come. Still, as Monet himself would have remembered, one person's sketch

Green Reflections (1914–26), left section

'As for me, I will stay here all the same, and if these savages must kill me, it will be in the midst of my canvases, in front of all my life's work.'

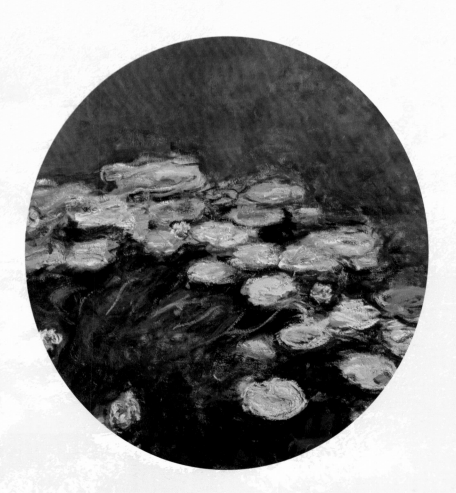

is another's finished picture: these wild studies may have remained in his studio for decades, but at the time of their rediscovery, in the early 1950s, their apparently improvisatory nature seemed to anticipate the jazz-inspired methods of gestural abstraction developed by Jackson Pollock (1912–1956) and Willem de Kooning (1904–97) during the previous few years.

The War Comes Closer

By November 1917, Monet's confidence in the large panels had recovered and another huge effort meant he was happy to let Durand-Ruel and his sons come to see how he was getting on. They found and photographed 12 panels, though even these, after so much work, would be considerably altered by the time he eventually stopped tinkering with the series in the final year of his life.

In spring 1918, with the war entering its decisive phase, the German army launched one final attempt to advance on Paris, just as they had in 1871, although the consequences of defeat this time would surely be far worse. At this point, the Bernheim-Jeune brothers suggested they store his works in their vault, while the Rouen Museum had also offered to take them. But Monet turned them down, still determined to die among his paintings if it came to that, and above all to continue his work until the bitter end, whether that came at the hands of the enemy or in some other, more natural way. As he told the Bernheim-Jeunes in August, 'I don't have much longer to live, and I must dedicate all of my time to painting, with the hope of arriving at something that is good, or that satisfies me, if that is possible.'

Strengthened by this resolve, Monet made good progress on the large panels for a time in 1918, but then for some reason broke off to begin a new suite of 1 x 2 m (3 ft 3 in x 6 ft 6 in.) canvases of the pond. Small enough to have been painted in situ, they were similar in colour and composition to the later paintings shown in the exhibition of 1909, but

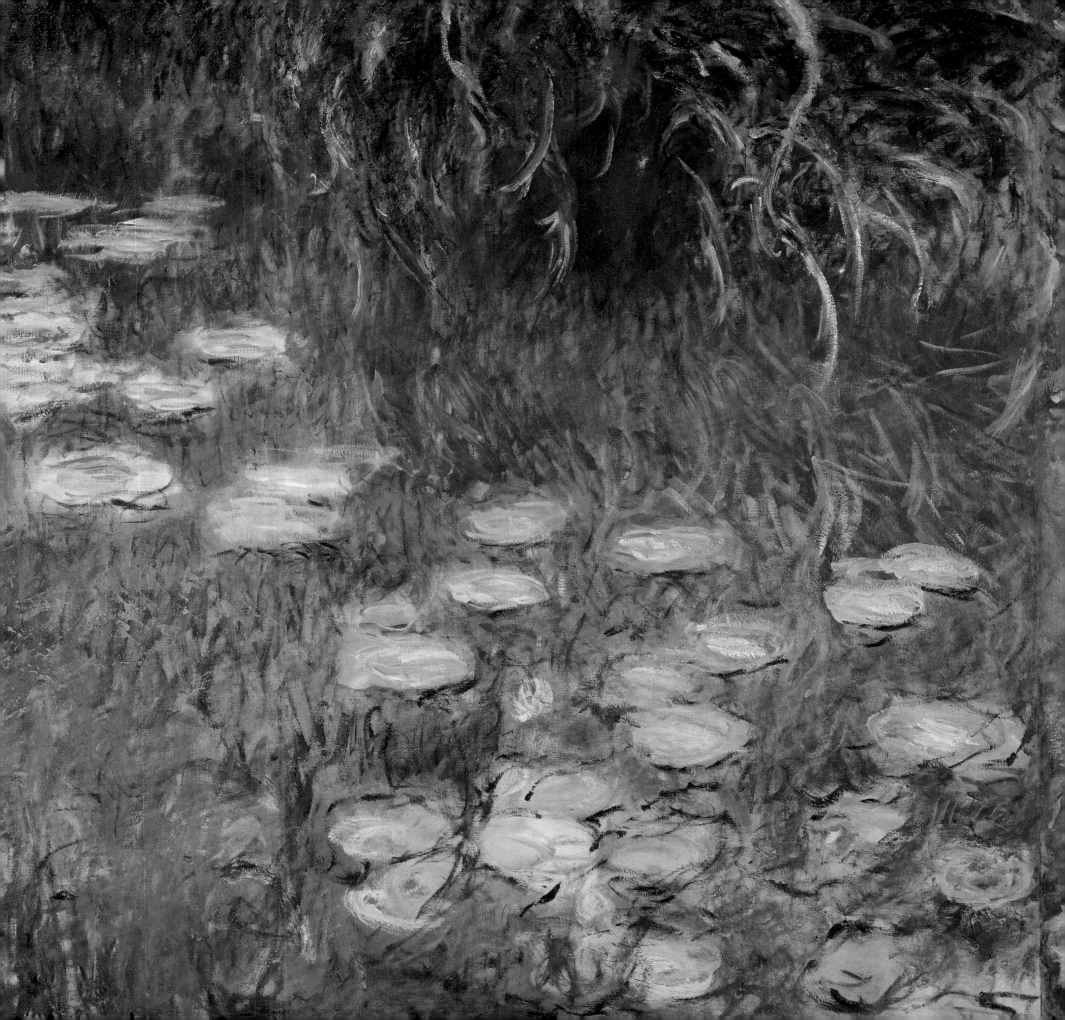

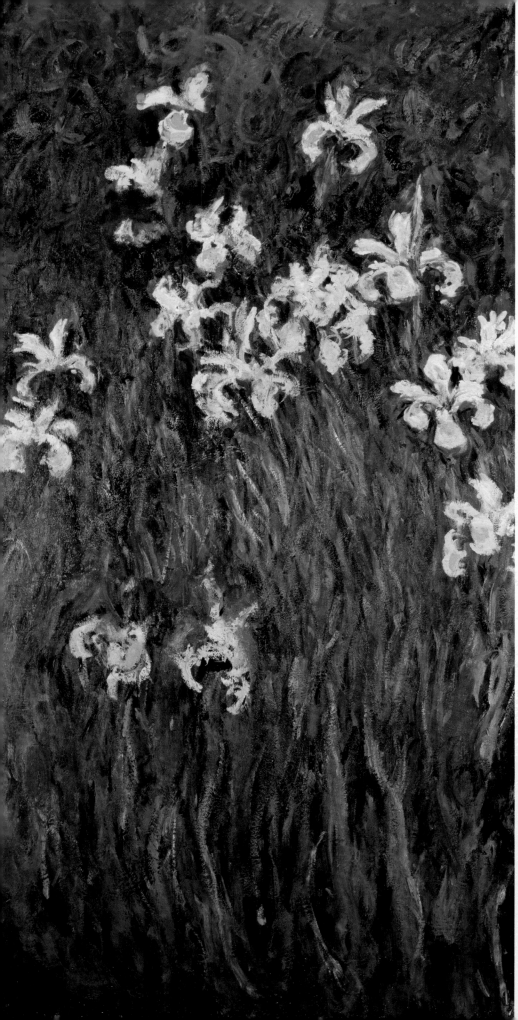

Yellow Irises (1914–17)

with a far looser, freer handling. It is clear that while these were not strictly studies for the *Grandes Décorations*, neither were they a separate series intended for exhibition, fine paintings though they often are.

Breaking Off

What caused this most single-minded of painters to constantly break away from his great final work? It was certainly not the want of adequate surroundings; the new studio, though a little chilly, was more than large enough, and the panels were placed on dollies, wheeled platforms which Monet could move back and forth as he followed his customary practice of assessing the effect of a whole series together. It might have been the poor reports of the war, which at times must have filled him with despair. There had been so much material and human damage, including that suffered by his own son Michel, who returned home from the front, deeply traumatized, in early 1917; the prospect that this might all have been in vain would have unsettled anyone. But even more likely was the progress of the condition that must have shaken Monet's basic confidence as a painter.

By 1916, the clouding of his eyes had rendered him unable to tolerate any outdoor light beyond the soft golden hours before dusk and immediately after dawn. Monet's preference for darker values and crepuscular colourings in the *Grandes Décorations* may have been as much a practical decision conditioned by his faltering eyesight as it was possibly a metaphorical reference to the twilight of life. Light was no longer his friend, the object of veneration it had once been, but a source of torment and distorted perception.

The Weeping Willow Series

Increasingly, too, Monet found that standing back from his work only increased the misperception, making smaller pieces seem probably more

manageable. The various series of smaller garden pictures he embarked upon after 1918, being landscape paintings on a conventionally reductive scale, may have stemmed from a desire to comprehend what he was painting without the need to stand back. The first of these small series was begun before the war had ended, depicting weeping willows beside the pond or else alone in the centre of the canvas, a motif whose pathos was immediately understandable in the context of so much suffering. Indeed, the pathos extends beyond the symbol itself into the treatment of it. Looking up from the pond or the plants along its banks which had occupied so much of his attention in the numerous studies made throughout the war, Monet was again confronted with air, atmosphere, envelope. As always, there were decisions to be made about how this was depicted. The paintings of the rose pergola seen from across the pond, painted in 1913 in what must by then have seemed innocent times, even after the terrible losses of those years, are clear, even picturesque images. But picturesque landscapes right across northern France and Belgium had been ruined by violence on an unprecedented scale. For this among other reasons, landscape painting would seem an absurd pursuit to the younger generation in the wake of such destruction. But Monet was a landscape painter whose aesthetic mantra was 'truth, nature and life'. Was a vision of the wholeness he found in nature possible any longer or, as many now felt, was it all just sentimental claptrap whose falsity had been so brutally exposed?

The *Weeping Willow* images offer some kind of answer, the drooping branches cascading in lamentations of green but also reds and yellows in a total field of oscillating colour that fills and animates both the air around the tree and the picture surface itself. The eye is swept continually downwards in hypnotic weeping waterfalls of colour that viscerally reinforce the emotional content of the image at the same time as this is abstracted into patterns of line and colour that are in fact profoundly decorative. If there is an envelope in this painting and the others in this

Weeping Willow (1918–19), detail

'I'm working more and more, but how hard it all is! I am enslaved to my work, always wanting the impossible....'

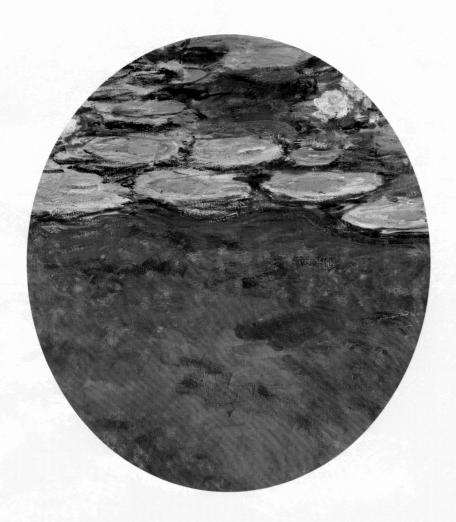

series – a 'light spread over everything' – its name is certainly grief, but grief transformed into pure visual beauty.

An Offer to the Nation

The painting made an immediate impression on Clemenceau, since 1917 the French prime minister (for the second time), when he visited Monet just a week after the Armistice had been signed. Monet had written to him the day after the signing, proposing a gift to the nation of two of the large panels he had been working on – in celebration of 'the victory', as he put it. And Clemenceau, the great leader whose decisiveness had helped turn the tide of the war, was delighted to be offered an excuse to get away from the burden of his duties and visit his old friend on the most pleasant official business he had conducted in years.

Monet's offer consisted of two works to be chosen by Clemenceau himself and then hung, at the painter's insistence, in the Musée des Arts Décoratifs. Appearing to decline the large panels, one canvas the prime minister picked out immediately was the *Weeping Willow*, the other a small *Water Lily* panel; but it was clear that the canny old politician had something far more generous in mind. While the smaller paintings he had chosen were indeed marvellous works, gifts that would have been warmly received by the State, in fact Clemenceau was overwhelmed that day at seeing the large panels on their wheeled dollies, enveloping the viewer with their visual absolutions, soothing vistas of a paradise that now seemed more lost than ever.

With typical clarity, in an instant, he had made up his mind to secure this magnificent ensemble, for once in its entirety, or as close to entire as he could get. After all, hadn't he been the one who had encouraged Monet to embark upon the venture in the first place? Who better to prise these

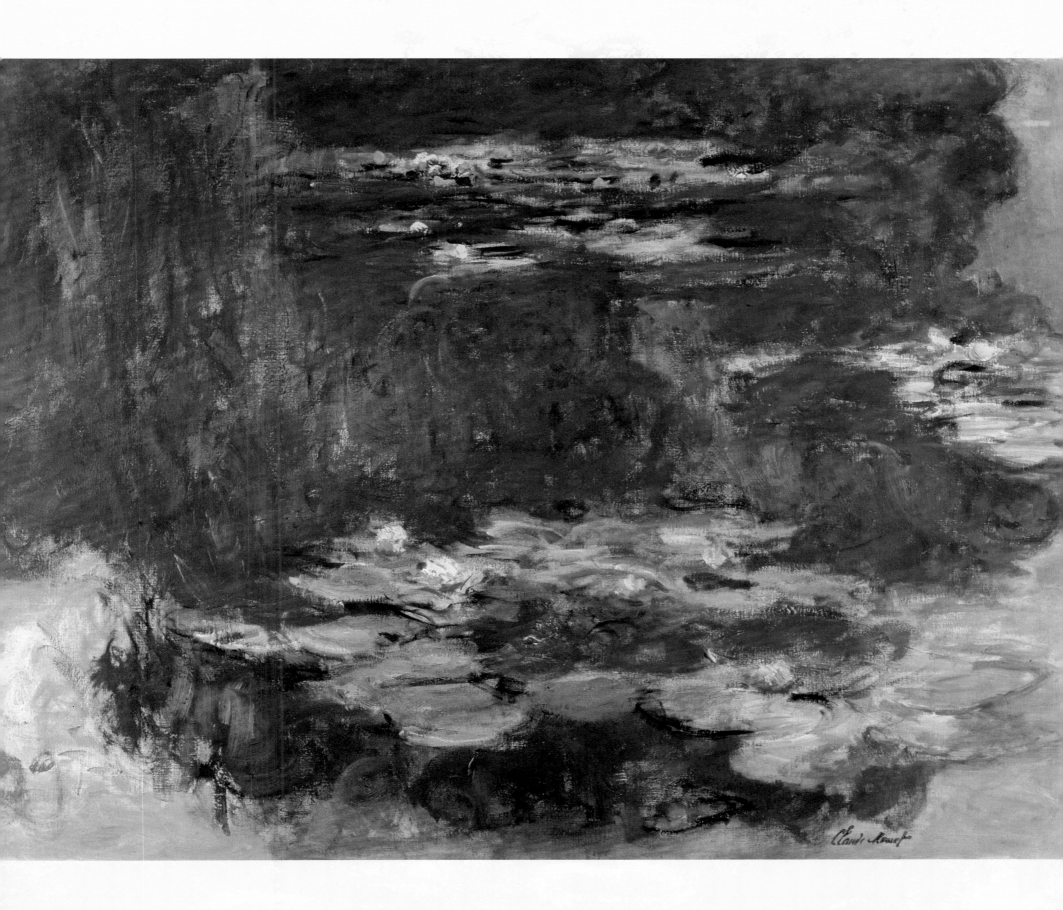

'I'm on the verge of finishing two panels, which I want to sign on Victory day.'

wonderful images from the painter's fastidious grasp? But this practical man of action also foresaw difficulties, immediately raising the problem of access to the continuous, unbroken wall of colour that Monet had proposed, joking that the only way in might be through the roof. Doors were indeed something Monet hadn't reckoned with, and thus he began another series, this time of blossoming wisteria, to be interposed as a frieze above the doorways so as to ensure an unbroken sweep of images around the projected circular space.

The London Panel

In fact, the ensemble we now know as the *Grandes Décorations* is considerably different from what Clemenceau would have seen that day. Indeed, most of the 30 large panels Monet had completed by that stage would not remain unaltered. One that might have done, *Water Lilies* (after 1916) and thus may well reflect the state of his thinking in 1918, today hangs in the National Gallery in London. Compositionally, and in terms of colour, it bears a strong resemblance to a number of smaller panels Monet completed in 1916 and 1917, including one of only two of these final *Water Lily* paintings which Monet allowed to leave the studio in his lifetime, both of these in response to requests for donations by ambitious directors of museums in Nantes and Grenoble.

The London picture may be seen as typical of the late group of paintings which nominally take water lilies as a motif, a set that could also be said to include works now in America and in the Swiss city of Zurich, among other places. The London image takes the pale water landscapes of the 1908 *Water Lilies* as its point of departure, but following the freewheeling experiments evident in the pond and garden studies of 1914-17, verisimilitude is a practice even more disregarded in this image than in those earlier paintings. The yellow-green clumps of lily pads are now

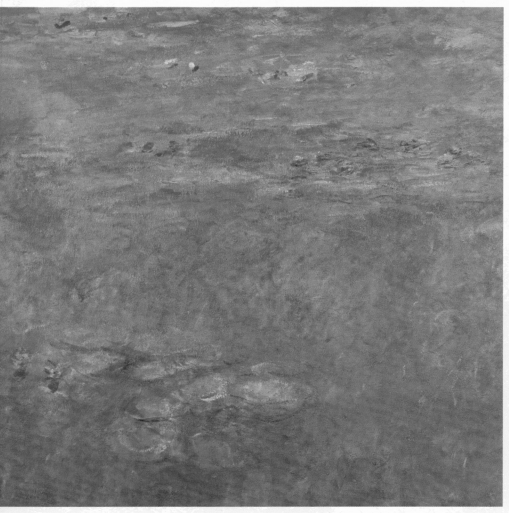

Water Lilies (after 1916), detail

hardly distinguishable in colour from the reflections in the pond, which are themselves so diffused that we cannot say with certainty what is being reflected. The orange, red, white and pink flowers are the main anchors for the painting, but there is little for them to anchor in. The light is ambiguous; there are neither shadows nor reflections, or more likely both have been absorbed into what we might call the painting's colourscape and thus its meaning. The envelope is all-pervasive, without depth, without surface, yet tirelessly teasing us with suggestions of both.

The Challenge of Interpretation

Reinforcing the ambiguous sense of how the presence of daylight implicit in the painting might be defined, the distribution of colours signifying different conditions of illumination is even and harmonious throughout: yellow, pink and blue seep into every part of the canvas. There is a vaguely vertical portion of yellow at the top right, but any structural elements are only tenuous and seem in imminent danger of dissolving. In fact, verticals and horizontals are so incidental that it is better to talk of fields of colour as the painting's basic structural units, albeit that these continually interpenetrate to a degree unprecedented even for Monet. Any verticals are merely twisting wisps; all planes are defined organically. The image is revolutionary in every possible way: in colour, certainly, but in subject matter (or its lack) too, and in pictorial structure.

The painting's very ambiguity, the influence of 'abstraction and imagination' on the 'art of the landscapist' (co-opting terms one critic applied to the 1909 series), leads to both the rise and the dissolution of innumerable readings. Indeed, the surface having been worked over so many times, the layers upon layers of paint alone suggest the presence of different perceptual realities in the same picture. As the gaze alights upon one structure of colour and shape, another suggests itself just as forcibly;

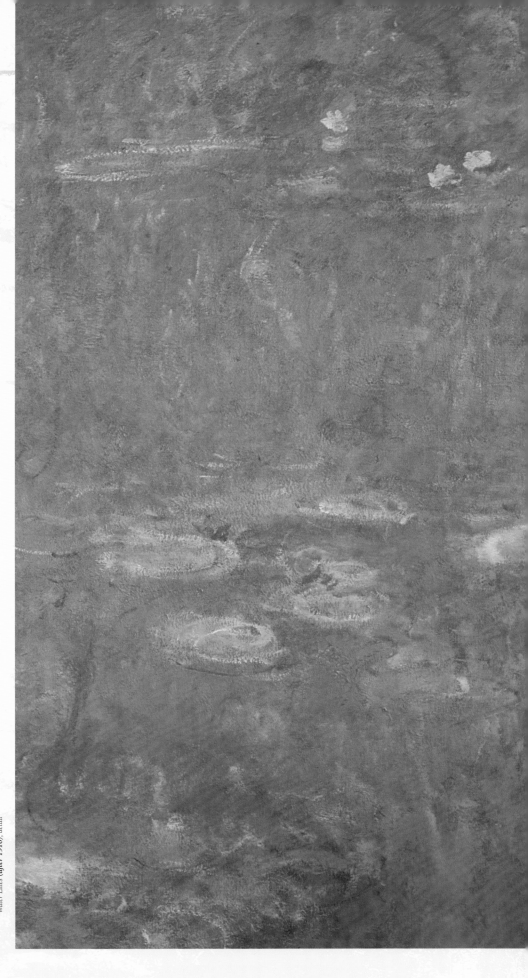

Water Lilies (after 1916), detail

'I'm pursuing my idea of the Grande Décoration. It's a very big undertaking...'

but none can permanently assert their own reality. This surely is what Monet himself referred to as 'the instability of a universe that changes constantly before our eyes'. Note, not a world, but a universe; he seems to have been fully aware of the cosmic dimensions of these paintings, the transcendent plane on which his vision now resided or to which, at any rate, it was now addressed.

Standing Back

Moreover, standing in front of this ambiguous painting, it is very easy to become confused as to its true scale. It seems as if these water lilies are giant specimens, but in fact they may be no more than life-size; it seems that we are looking at a vast panorama, but the painting's dimensions may be no bigger than the section of pond that was used as its living template. From a distance, indeed, it seems far more comprehensible as a pond; but then many of Monet's images throughout his career only resolve themselves fully from a distance, their component colours and marks, so fascinating at close quarters, harmonizing into rich subtleties of modelling and tone from several metres back. Such a need for resolution through visual reassembly is implicit in the deconstructive colour analyses typical of Impressionism, especially Monet's Impressionism. But these images do what painted landscapes had never done. Landscape painting was (and still mostly is) a genre that compresses an often vast field of vision into a microcosmic simulacrum. In these pictures, on the other hand, the painter studies tiny parcels of the natural world and renders them according to his own measure with the intimate attentiveness of a painter of still life.

The Light of Awareness

This continuing tendency towards different kinds of readings depending on how far we stand back from the painting is consistently achievable with many of the late works, notwithstanding the fact that by the late 1910s, Monet was no longer able to stand back himself if he wanted to see anything clearly at all. Given his eyesight problems, he was obliged increasingly to judge his work from close in and could only guess (albeit with considerable education) at its effect from a distance, just as the ageing Beethoven, by then profoundly deaf, would hammer away at his piano in a vain attempt to hear his late quartets. But even from a distance the sense of a reflecting surface can only be inferred; the envelope has fully imposed its unifying presence, dissolving the distinction between weed and water, water and air, air and light. As such, it is not unreasonable to suppose that the envelope in question is no longer the mysterious amalgam of air and light of the series paintings – the reality without which we could not live – but the most fundamental reality of all: the envelope of the painter's own conscious awareness. Moreover, perhaps in the light of this awareness, the illusion of painting as a reflection of the world is almost broken; the level of 'abstraction and imagination' in the picture is an admission that, after all, any painting is primarily an arrangement of colours on a two-dimensional surface – an act of sublime trickery, a work of art – and the world it depicts, in the end, is indivisible from the painter's own mind.

Water Lilies (1914–17)

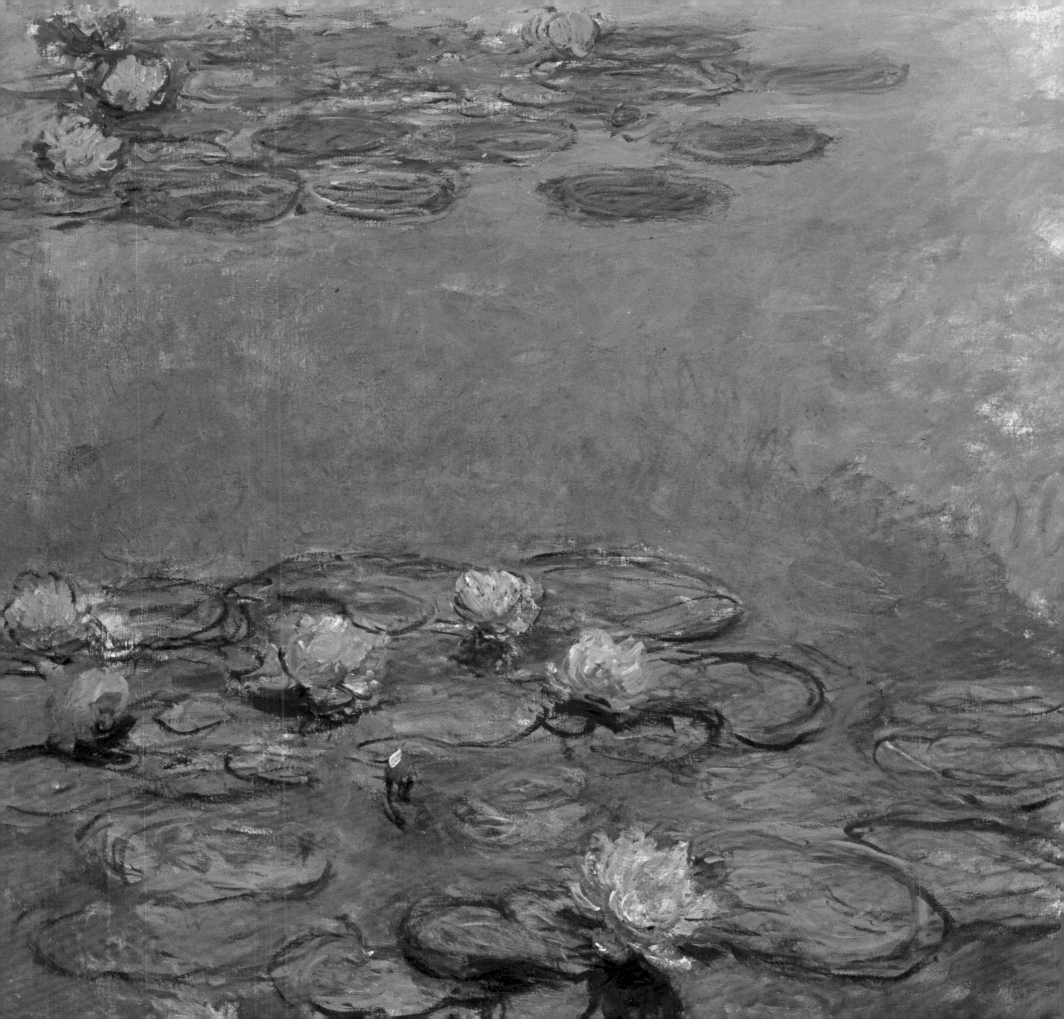

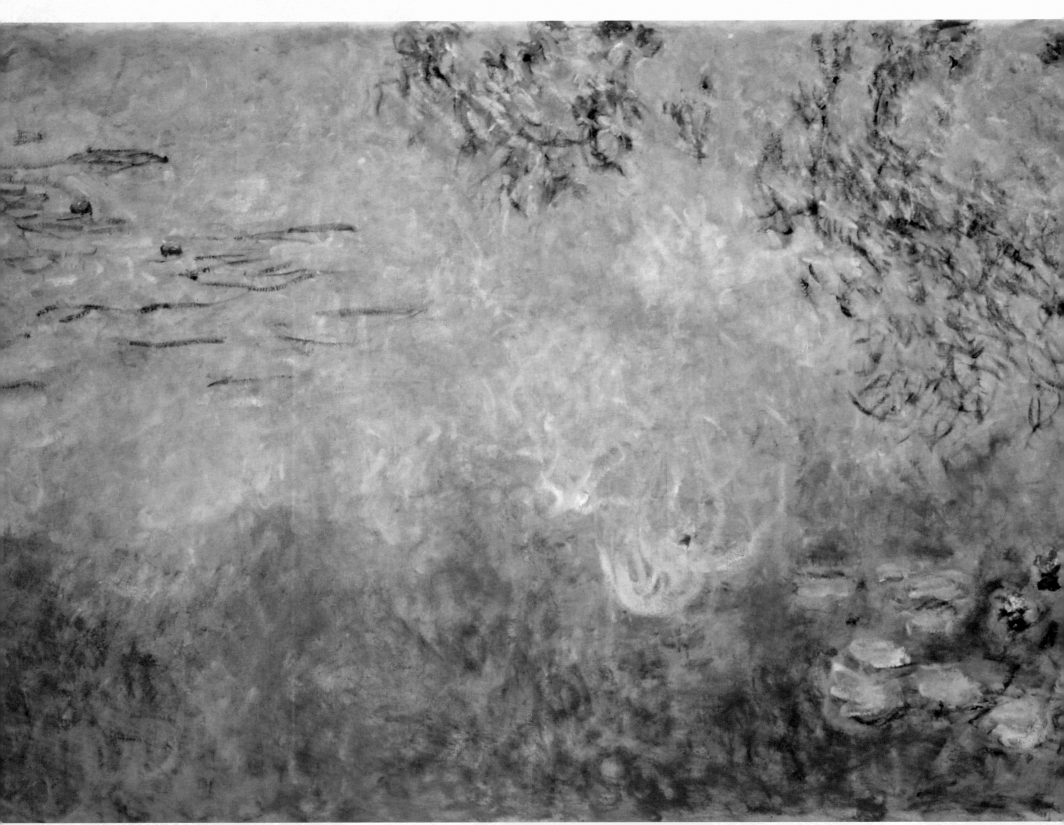

Water Lilies (*Le basin aux nymphéas avec iris*) **(1914–22)**

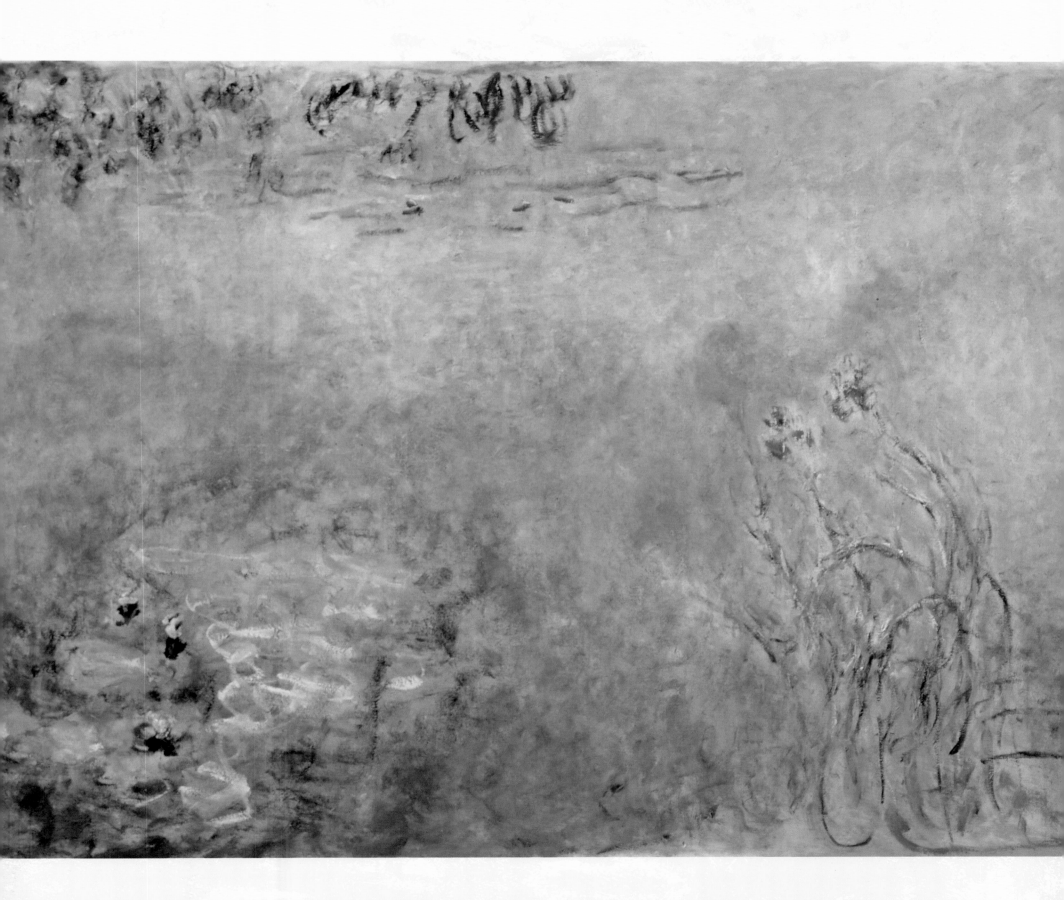

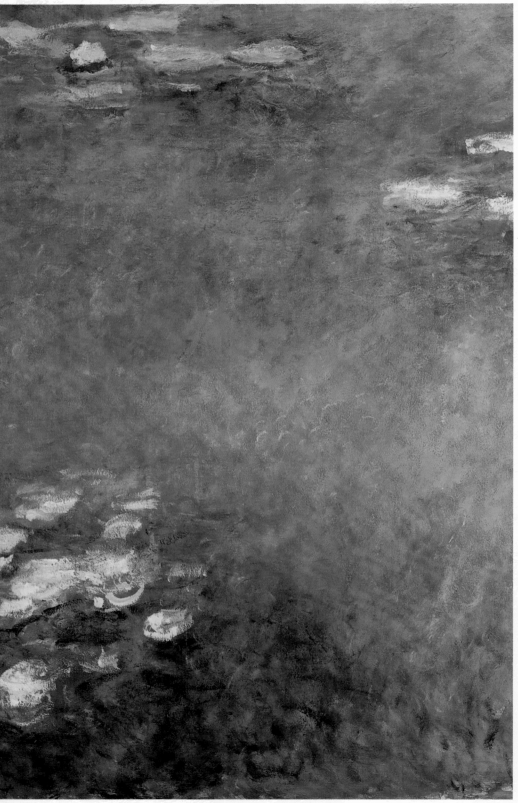

Water Lilies (1915–26), detail

An Agreement

As that day in November 1918 grew longer, Clemenceau, the supreme negotiator, soon to exact a terrible price from the defeated German nation at Versailles, also managed to persuade his old friend to consider a larger bequest: to offer the complete *Grandes Décorations* – an original proposal of 12 panels out of the 30 Monet had finished by that stage – for permanent display in an appropriate setting in Paris, to be decided in due course to the satisfaction of all concerned. Monet would later refuse the honour of election to the Institut de France, still a self-proclaimed independent as he had been since the early battles he and his fellow Impressionists had waged with the Salon. But he could not resist Clemenceau's offer of glory, though even now, in his hour of triumph, he made sure to exact the price he wanted for his apparent munificence and the remaining labour it would certainly involve.

Thus, when in 1920, negotiations began that would eventually result in his great bequest, he made it an absolute condition that the State should buy his monumental pastoral group portrait *Women in the Garden* – the great early work which the Salon had summarily rejected in 1867 – for the astronomical figure of 200,000 francs. He would have savoured the triumph, partly in a spirit of restorative justice for the professional and aesthetic slights he had suffered back then and partly perhaps in wistful tribute to his first wife, Camille, the model for three of the four young women in the picture. But he could not resist the official tribute of a permanent temple to his art, his Arcadian gift to the nation, an honour bestowed symbiotically by Monet on France and by France on its most famous artistic son. He recognized, too, that the *Grandes Décorations*, taken to the bosom of the nation in this way, would long outlive him, and would come to represent not only the crowning of his artistic reputation and the enshrining of his legacy, but the fulfilment of his most cherished artistic dream.

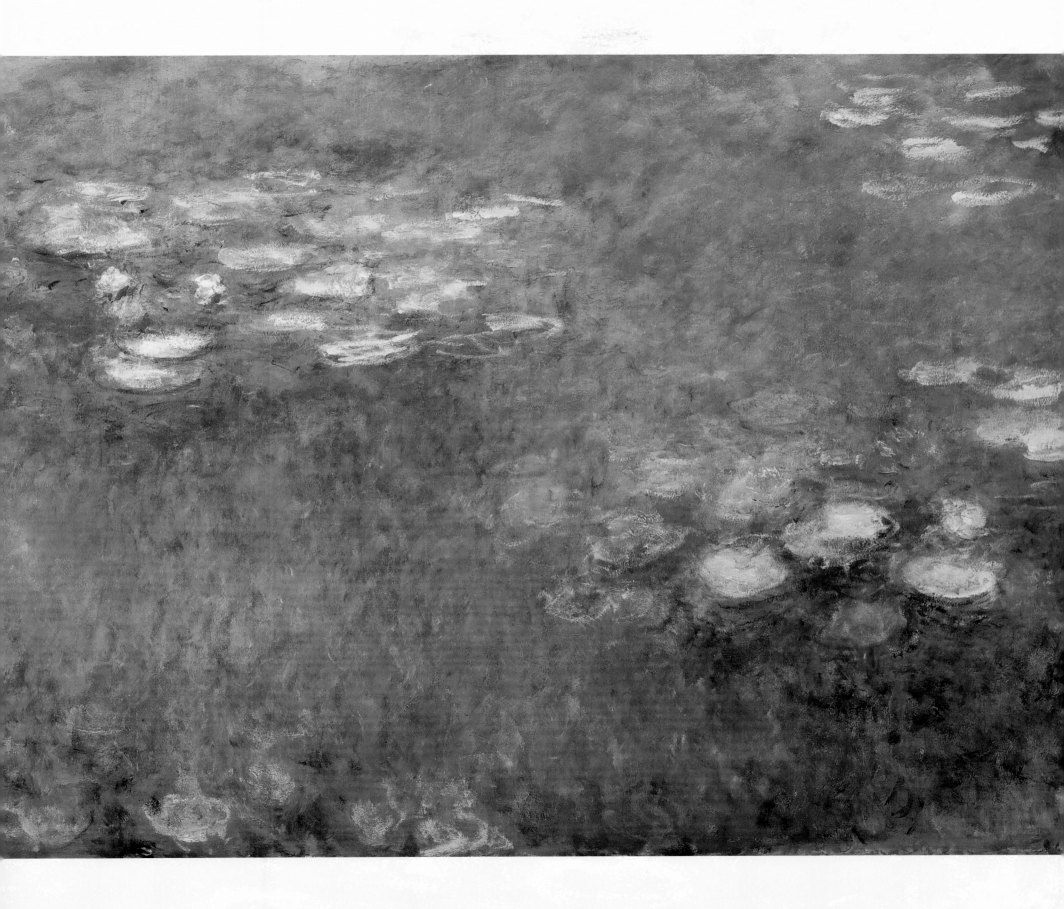

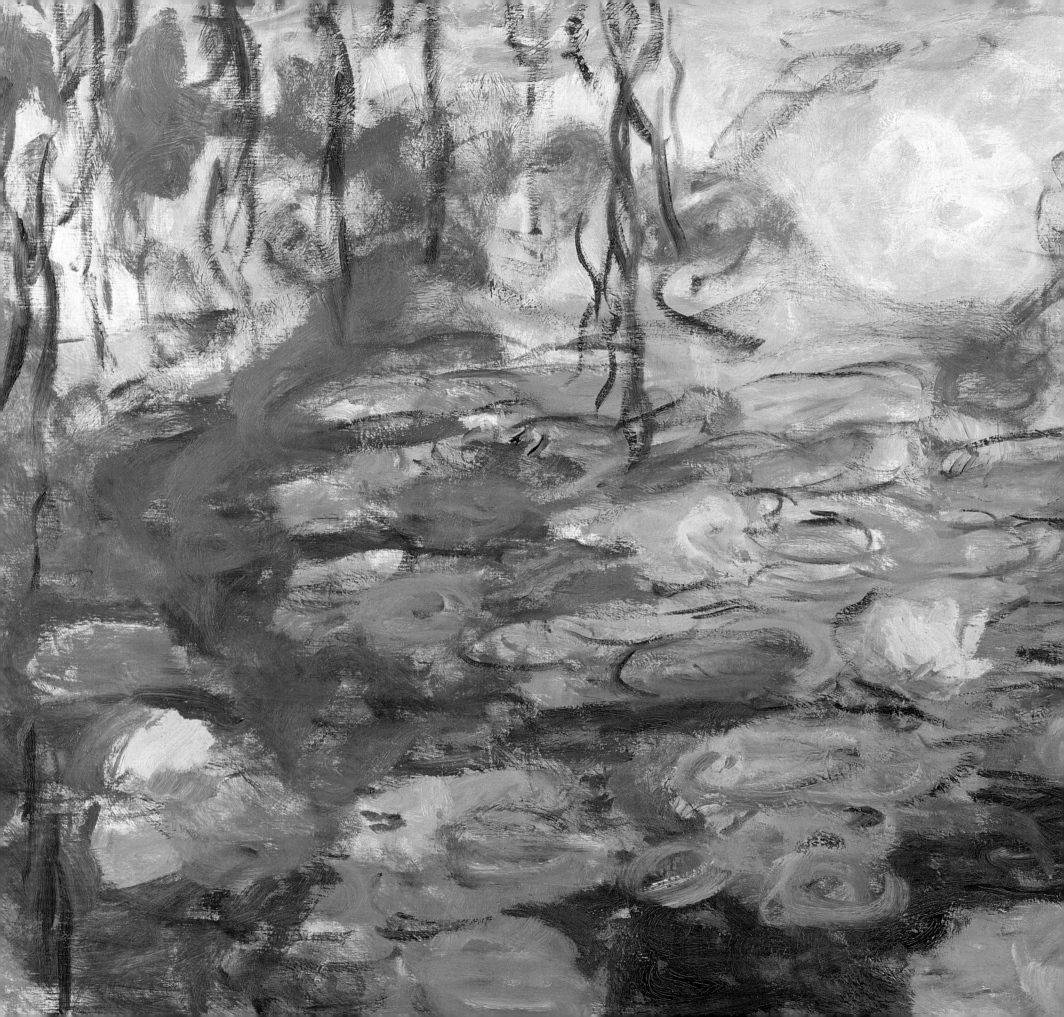

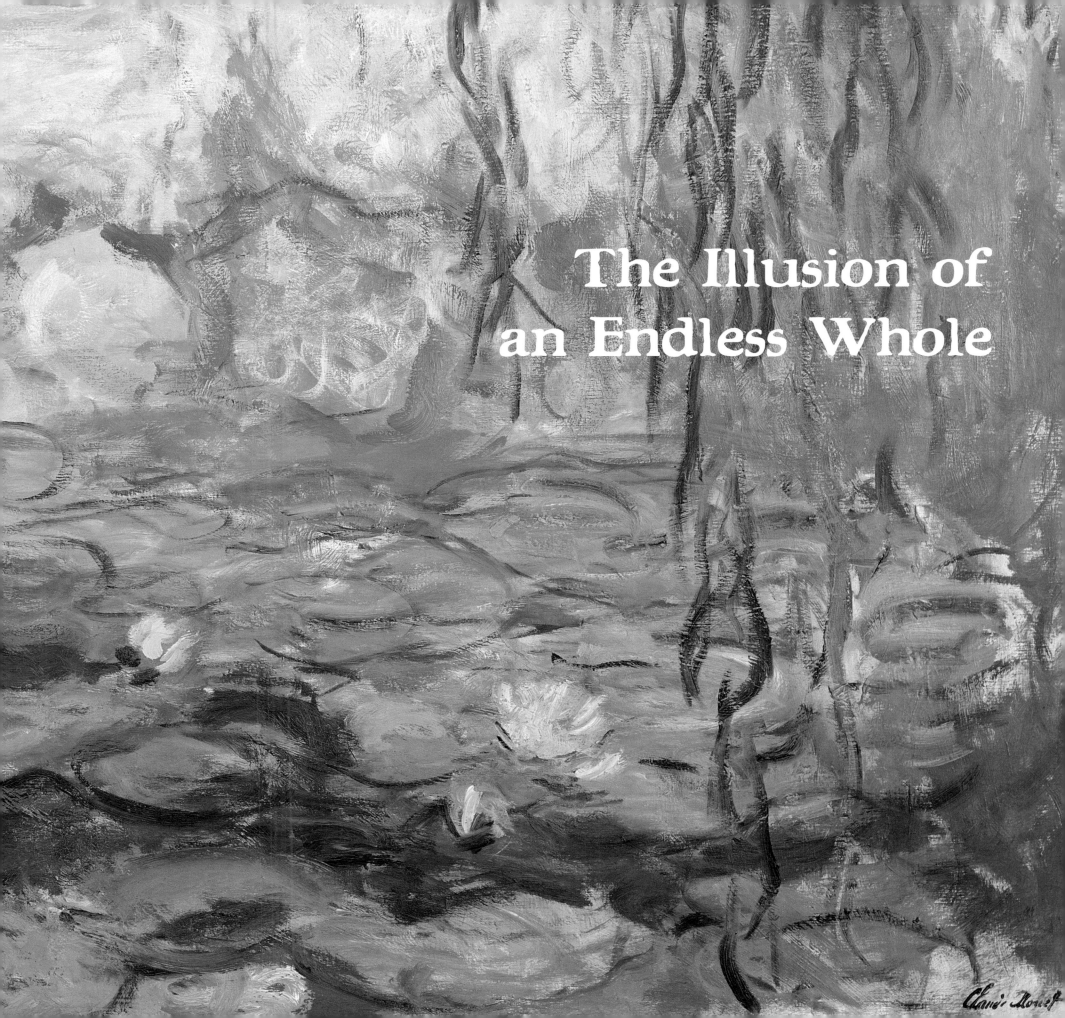

The Illusion of
an Endless Whole

IN THE SUMMER OF 1926, among the many visitors who came to Giverny was a young American photographer, a Mr Nickolas Muray (1892–1965), whose black and white images are some of the last we have of the elderly painter. Sitting on a bench beside the rose arches that concealed the railway track and the road that ran through his property, Monet, with his lily pond behind him, looks thin and frail and vaguely fatigued by what he must have known would be his final illness. Having always enjoyed robust good health, his lifelong smoking habit had finally caught up with him in the form of a diagnosis of incurable pulmonary disease; he did not have long to live.

With the assignment completed, the young American packed away his camera and extended an arm to the inscrutable old man as they walked at a slow pace along the rose-covered pathway to the house. Making his apologies for not being able to give the photographer any more time, Monet shuffled off rather uncertainly to his studio to have another look at the panels that would soon be given to the nation, just as he had promised they would; though not quite yet. He did not want to let them go while there were still small things he saw that might be improved whenever he felt strong enough to try.

The Final Effort

It had been the greatest effort of Monet's life to get them finished. The project had tormented him ever since he had shaken on the gift with his great friend Clemenceau a week after the Armistice. It had become a kind of dance with death, though it might also have occurred to him that the

'My only virtue is to have painted directly in front of nature, while trying to render my impressions in the face of the most fugitive effects.'

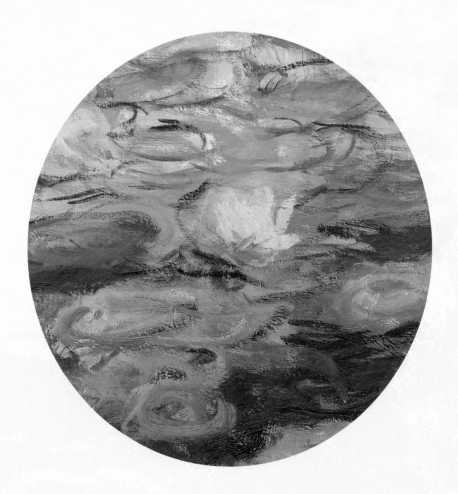

'I can no longer work outside because of the intensity of the light.'

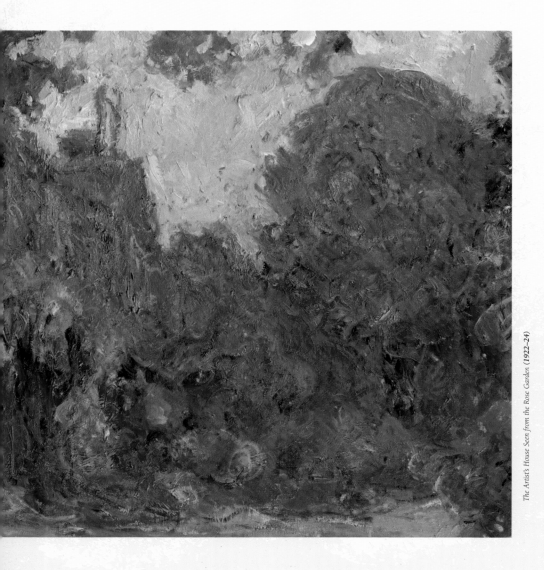

The Artist's House Seen from the Rose Garden (1922–24)

dance had kept him going for longer than he might otherwise have hoped. He could scarcely believe that he, Monet, was the only one left of the Young Turks who half-jokingly had called themselves Impressionists after a withering review some 50 years earlier had first used the term to dismiss their happy, hopeful work. Now they were all gone, those originals; even his old friend Renoir, the year after the war had ended.

Monet must have been grateful for the accolade that France would bestow on him once he finally let his treasured panels be carried off to their appointed home. Even that had taken a long time to decide. Despite the distractions of the conference at Versailles, Clemenceau worked tirelessly on Monet's behalf in 1919 and the following year, in which he also lost the presidential election. Such an outcome seemed to deal the project a fatal blow, but Clemenceau, the consummate political animal, somehow managed to convince officials in the Ministry of Fine Arts to consider the site Monet himself had suggested in the grounds of the Hôtel Biron. This had been the home of his friend Auguste Rodin until his death in 1916, and very soon afterwards had become the museum that housed the great bequest to the nation that the sculptor had stipulated in his will. It was Rodin's largesse (and Clemenceau's persuasion) that had inspired Monet to make his own gift.

The Rotunda

The architect Louis Bonnier (1856–1946) was engaged to draw up plans, although these were not entirely to Monet's liking: in place of the elliptical structure he felt was the ideal space for the huge murals he was already engrossed in making, the proposed building was to be a rotunda, a shape which may have had irksome connotations. Monet would have been well aware of the similar structures from his youth, built to house the numerous cycloramas that had once been so fashionable. One name he would certainly have remembered was Henri Félix Emmanuel Philippoteaux

Rose Path at Giverny (1920–22)

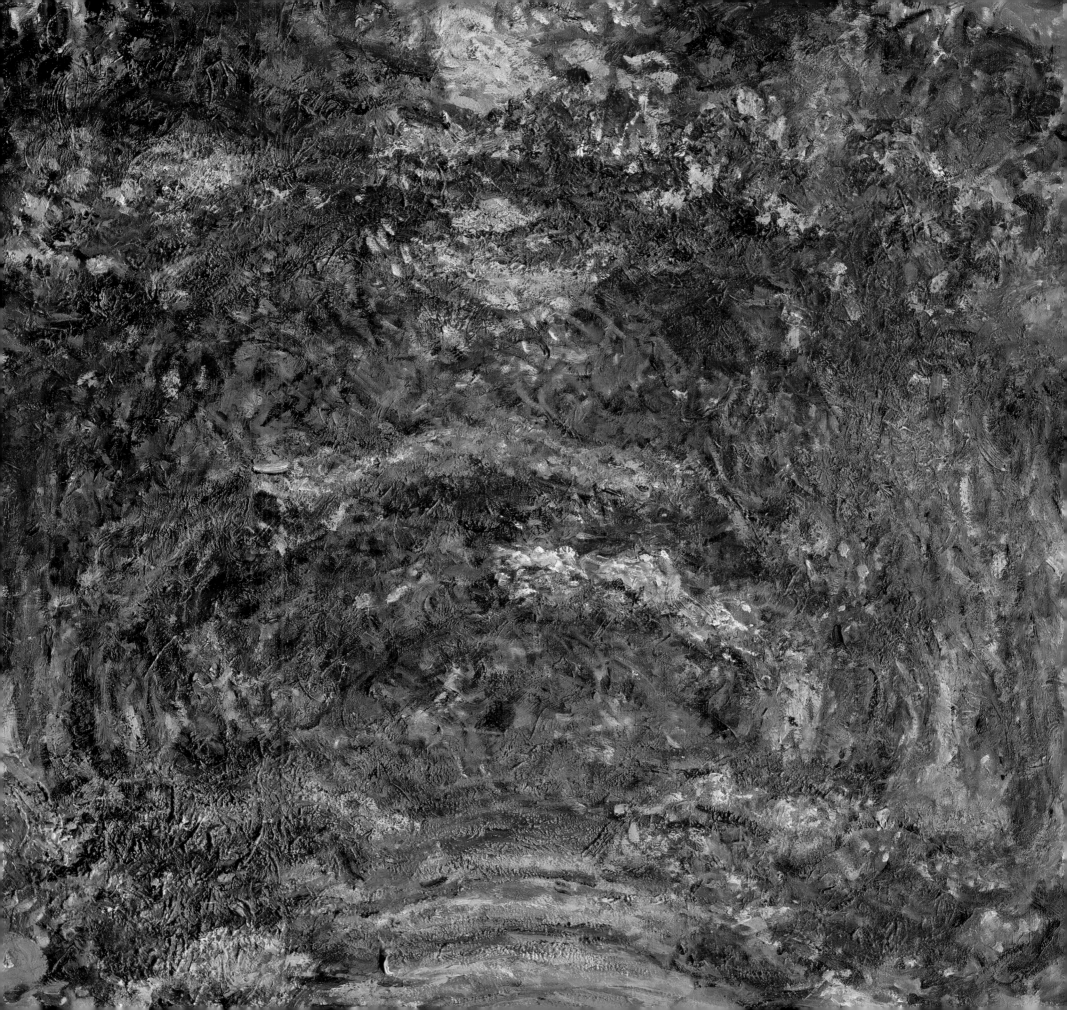

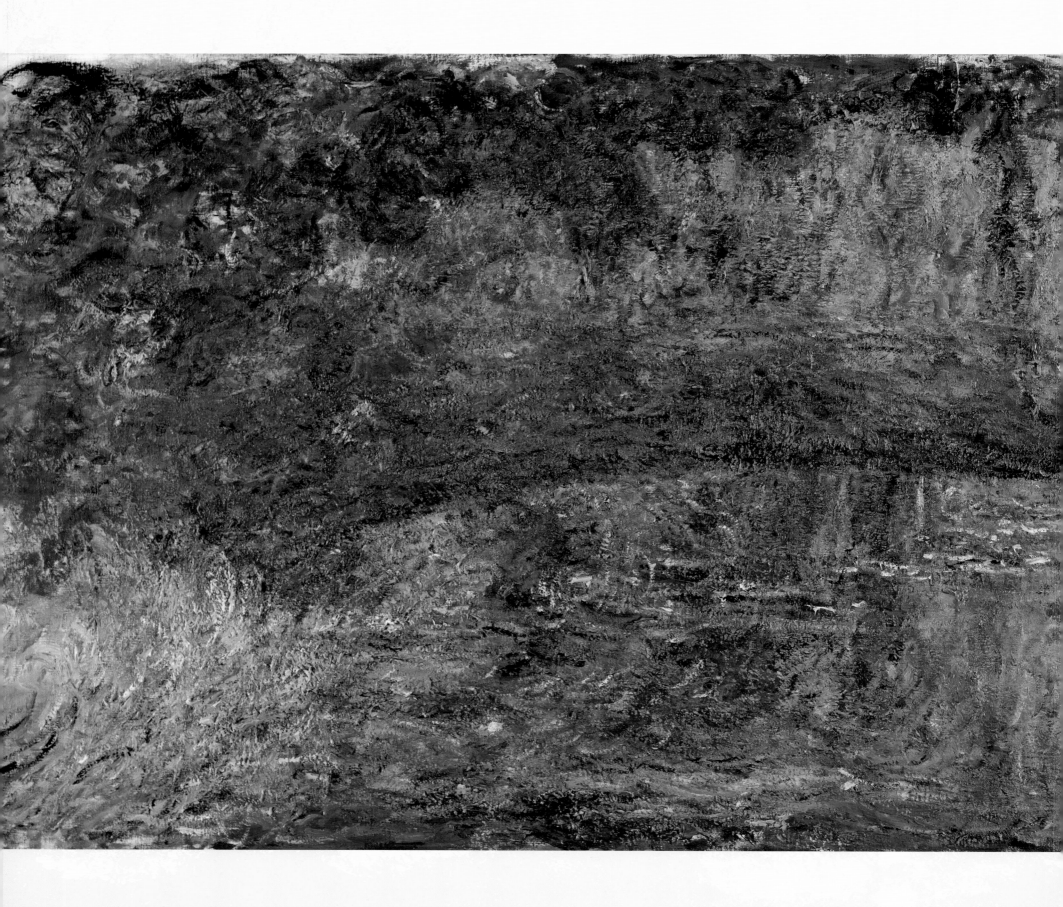

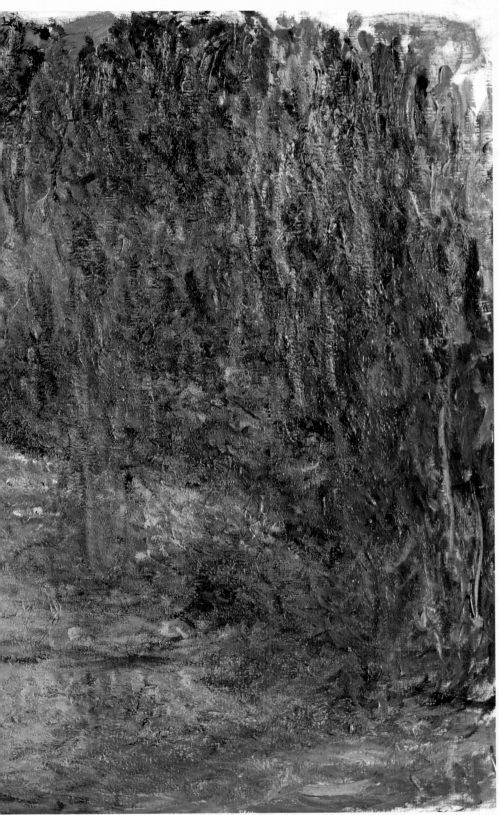

The Japanese Bridge (1918)

(1815–84), creator of a panorama depicting the Siege of Paris. A vast circular painting of traumatic events Monet himself had not witnessed, having been a refugee in London at the time, the visual spectacle had been massively popular when it opened in the mid-1870s, not long after the drama depicted had taken place. Philippoteaux's son, Paul (1846–1923), had carried on the tradition of dramatic, enveloping history painting set amid landscapes that seemed to vanish into an endlessly receding background; examples of his work in both Europe and America enthralled visitors with their virtuosic simulation of real-life events.

A Panorama

But Monet's scheme could not have been further removed from this kind of dramatic *trompe l'oeil*; in any case the IMAX cinema of its day, by the 1910s the cyclorama's claims to realism had, in fact, been superseded by the spectacle of moving pictures. But Monet had never been interested in that kind of realistic depiction. The viewer who stood among the *Grandes Décorations*, this last great work, would not be seduced by the perspectival audacity – a kind of hyper-reality – in which the cyclorama had traded, but comforted by an enchantment of the real, with tones the artist had once described as 'vague, lovingly nuanced, as delicate as a dream'.

The younger Philippoteaux's panoramic murals of the battles of Gettysburg and Waterloo can still be seen today in their original locations. How absurd such unthinking glorification of battle must have seemed in the disenchanted 1920s. Everyone knew someone who had fought at the front and died, or had returned home shattered in mind or body. Monet's *Grandes Décorations*, offering – as he had once put it, 'an asylum of peaceful meditation at the centre of a flowery aquarium' – would give a different answer to the question that posed itself again and again in the collective mind in response to that senseless conflict: why?

'I don't have much longer to live, and I must dedicate all of my time to painting, with the hope of arriving at something that is good...'

The Orangerie

Having accepted the original design, Monet had gone back to work on the panels, but then in April 1921, Bonnier's plan was nevertheless rejected on the grounds of cost; these were straitened times, after all. So a compromise venue was put forward in the form of either the Jeu de Paume or the Orangerie, both located in the Tuileries Gardens in the heart of the French capital. Knowing that he was less than happy about the whole business, Clemenceau persuaded Monet at least to consider these alternatives, and after site visits to both buildings, the artist opted for the Orangerie, on condition that the shape of its rooms would be substantially modified.

Appropriately for his intended work, the existing building had once been Napoleon III's greenhouse, a rectangular space that, if anything, Monet felt was slightly too narrow for his purposes. In the end, in order to see some kind of positive outcome, he decided it would do, providing the two main adjoining rooms could be reshaped into the pair of asymmetrical ellipses he preferred. Between them, the two rooms would house 18 panels in all, a number that rose first to 20 and then, in January the following year, to 22; although even that amount would represent only half the number of large panels extant at the end of his life. Bonnier was sacked for reasons that are not entirely clear, and a new architect, Camille Lefèvre (1853–1933), was engaged to draw up fresh plans. Then, on 12 April 1922, Monet signed over the projected work to the State. The cost of the renovation, though considerably less than the original scheme, was still estimated at some 600,000 francs.

A Huge Undertaking

In addition to the much larger ensemble to which he had now agreed, Monet also realized he would need to rework several of the motifs to take account of the narrowness of the rooms, a factor that would be still more pronounced once the curving of the walls had been carried out. The new panels he began were intended to complement the existing 12, but rather than the layout originally planned – a continuous circle depicting a single scene; a bona fide panorama, indeed – the scheme now settled upon, which took account of openings for doors, would comprise eight separate but complementary works distributed over two rooms.

It seems an almost foolhardy enterprise for a painter of his age to have taken on. Monet had only ever painted a few very large exhibition pictures, and all of those as a young man. Now he was committed to working on a heroic scale that was not only daunting but may have seemed slightly at odds with the aesthetic values he had always held. It is true that he had talked of a set of decorations for many years, having created the decorated door panels for Durand-Ruel in the 1880s. But when we try to understand where the grandiosity of such an idea had come from, other influences also seem to suggest themselves.

Rose Path at Giverny (1920–22)

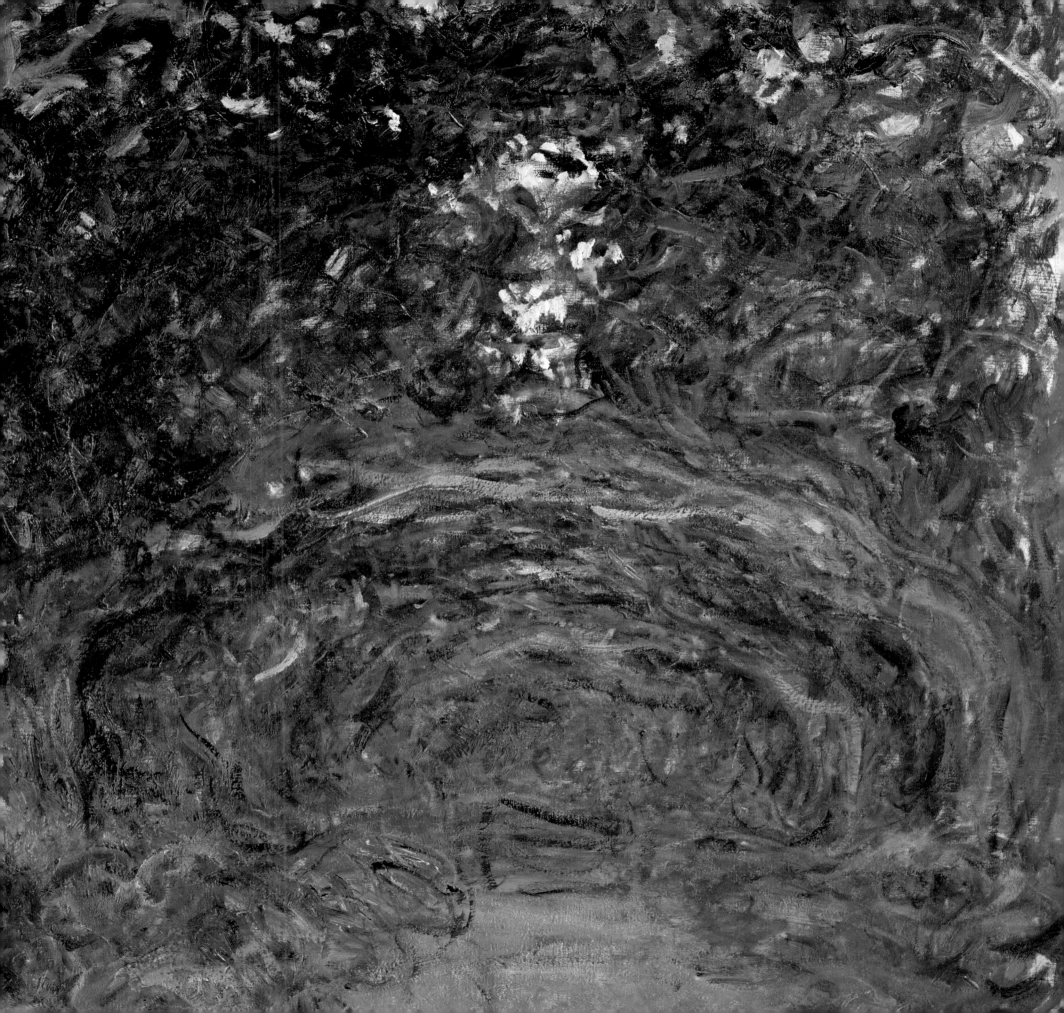

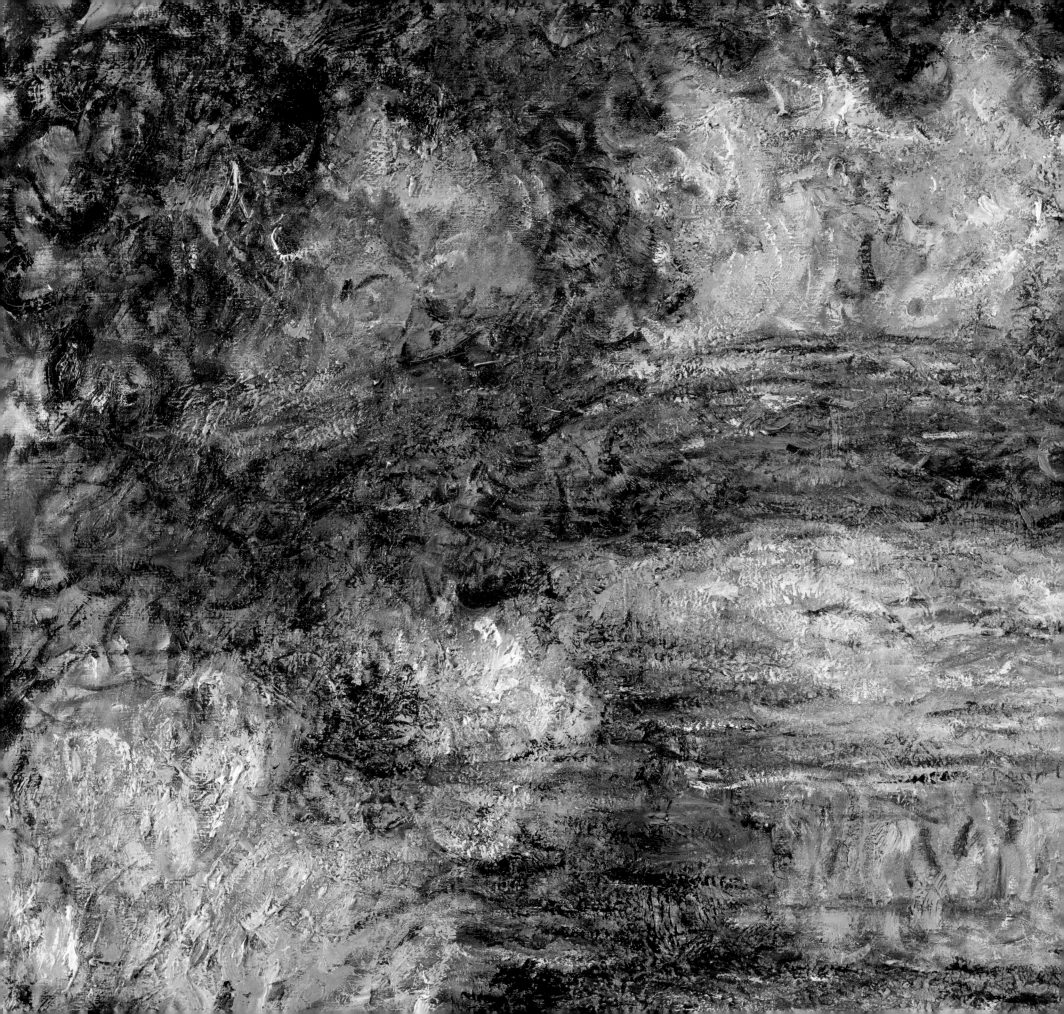

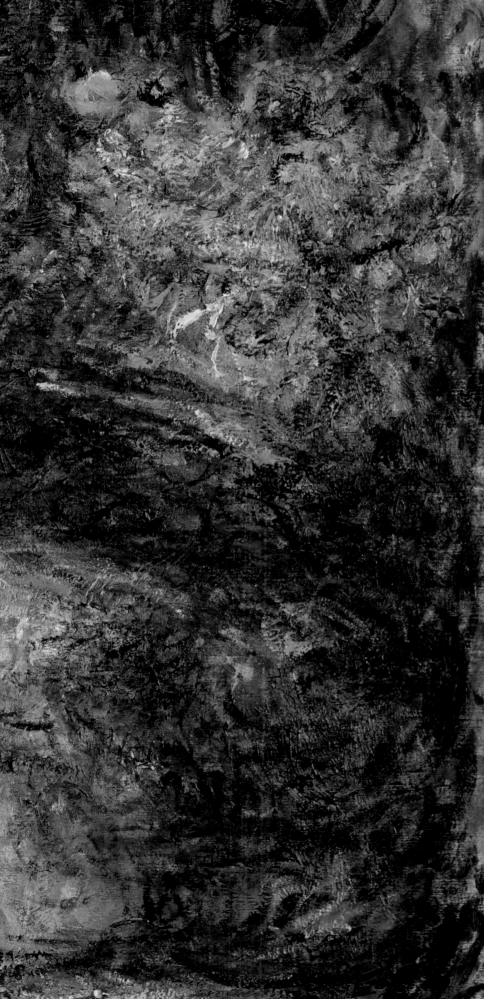

Decoration in the Belle Époque

The modernist aesthetic has given us almost a century of buildings that celebrate plainness and simplicity – the 'machines for living in' espoused by Le Corbusier (1887–1965) – but prior to the First World War, the decorated interior had been a mainstay of European architecture for many times as long. French art alone had a long tradition, including the Baroque decorations of Charles Le Brun (1619–90) and the Rococo frivolity of the decorated interiors of François Boucher (1703–70). Even among his peers – although they rejected many of the staid ideas of the past – the impulse to decorate and the desire of patrons to commission such works remained strong: Monet's friend, patron and fellow artist Gustave Caillebotte had decorated his own dining room, while two of Monet's younger admirers in the early twentieth century – Pierre Bonnard (1867–1947) and Édouard Vuillard (1868–1940), inspired by the peerless examples of Italian Renaissance palazzo murals and church frescoes – had taken commissions to decorate private residences with 'apartment frescoes', as Vuillard called them.

However, the *belle époque* of the late nineteenth and early twentieth centuries also saw the rise of Art Nouveau, a style of decoration in Europe and America that transformed both private and public interior spaces into brightly lit indoor groves lavishly adorned with painted, tiled, turned, glazed, metal-worked and sculpted natural forms that Monet would have come into contact with in cafés and restaurants during trips to Paris. Artists inspired by the exuberance of the style were also creating monumental schemes expressing philosophical ideas, the best example of which is Gustav Klimt's (1862–1918) *Beethoven Frieze* in Vienna, a high watermark of decorative Jugendstil, the Germanic equivalent of Art Nouveau.

'I have always loved
sky and water, leaves
and flowers. I found
them in abundance
in my little pool.'

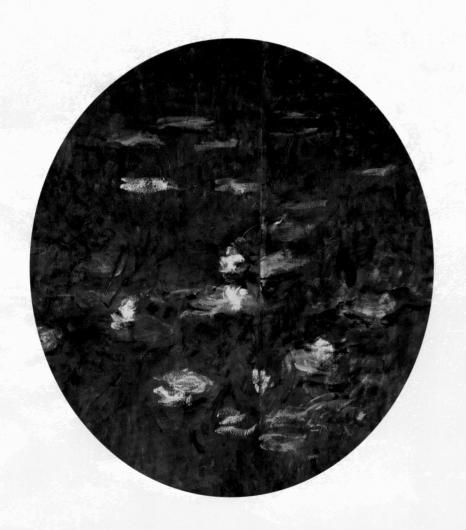

Further Influences

But if nature was reasserting itself as a decorative environment in a godless, industrial age, there is still a dimension in the *Grandes Décorations* which suggests an attitude to the world that is more than merely decorative. Monet had long been influenced by the aesthetics of Japan, in particular the great subtlety of Japanese printmakers such as Hokusai and Hiroshige in exalting the everyday. In the case of the *Grandes Décorations*, some writers have pointed to the influence of Japanese painted screens, where a single image conveyed across several panels would often feature cropped natural features such as the species of trees and flowers he had planted in his garden. This approach to the depiction of a subject, making it appear casually glimpsed, had profoundly influenced Monet's artistic practice since the 1860s when he first began collecting Japanese woodcut prints, and is obvious in three of the groups of panels in the *Grandes Décorations*: *Water Lilies: Morning*, *Morning with Weeping Willows* and *The Two Willows*.

Other writers have leaned towards the influence of medieval tapestries, pointing to the three images chosen from Monet's *Water Lily* paintings to be woven into tapestries at the Gobelins factory in Paris, by then, shortly before the war, under the stewardship of his great friend Gustave Geffroy. However, the atmosphere of hushed reverence conveyed by the *Grandes Décorations* suggests another model whose antiquity parallels the tradition of tapestries for which Gobelins in recent centuries has been the modern standard-bearer: namely, the envelope of colour and light that suffuses the atmosphere of the great Gothic cathedrals of northern France with the ineffable mystery those buildings were created to address. Monet must surely have experienced such an atmosphere on many occasions; certainly the brilliance of medieval stained glass is a quality to which his work, in particular its prismatic sense of colour, had been more than once compared.

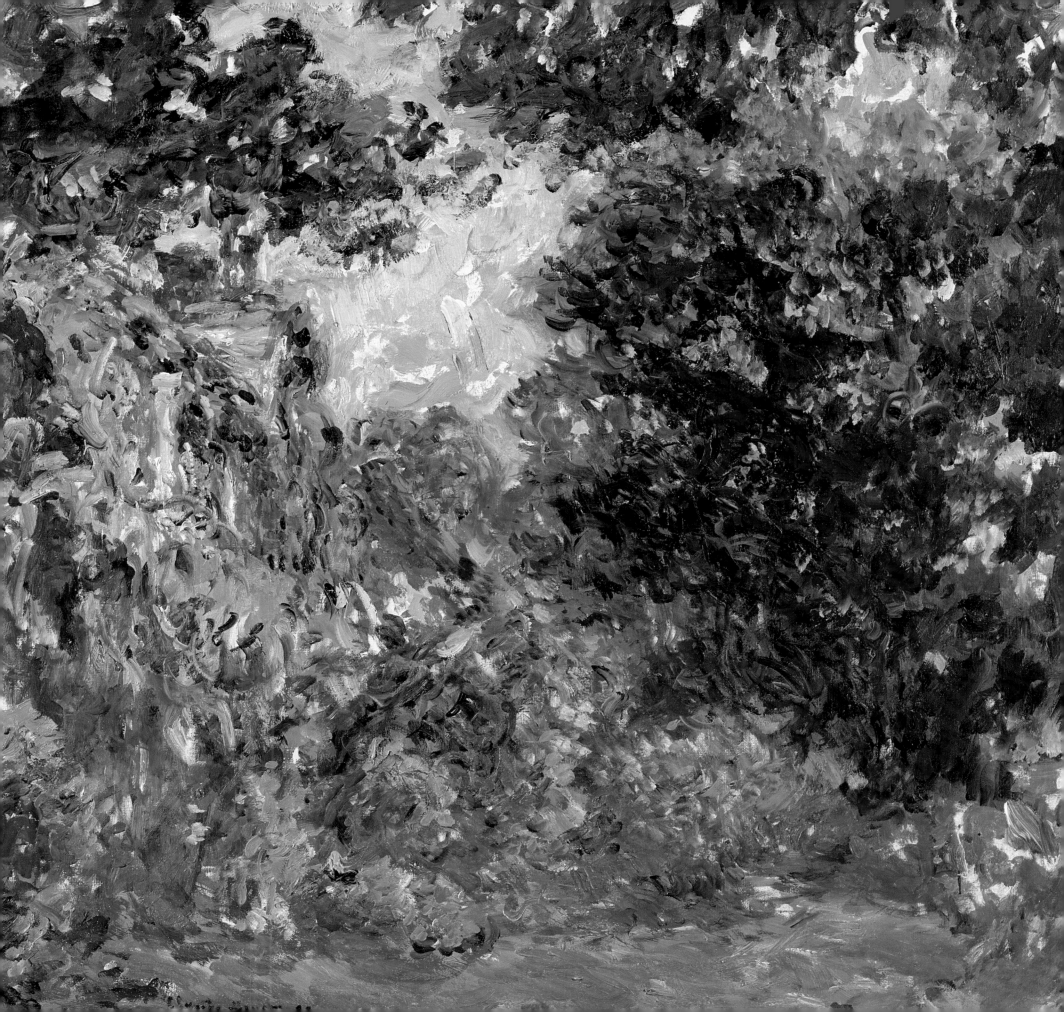

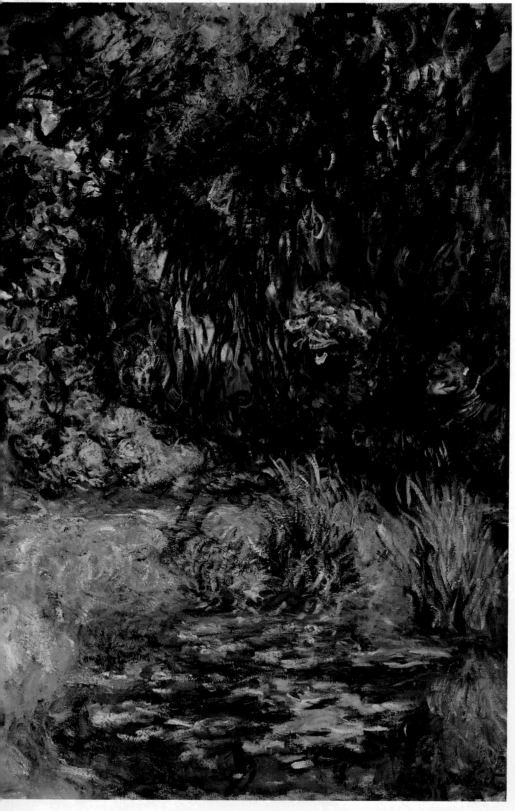

Corner of a Pond with Water Lilies (1918)

A Sense of Awe

Of course, the atheist painter of Rouen Cathedral was a worshipper not of God but of nature and of light, who once declared, 'I only know that I do what I think best in order to express what I experience in front of nature'. This had been Monet's artistic mantra from the start. But strip away the object of veneration, whether God or nature, and we are left with a common sense of awe that seems to transcend our immediate experience of the object as we look it.

All of these models may have exerted an influence of some kind, for a work as complex as the *Grandes Décorations* at the very least contains multitudes, appearing to channel a wealth of thoughts and impressions into its timeless expanse. And whatever the models, Monet's intention was to do what he had done with his garden – to create a total environment, akin to an interior garden, with paintings so large they could not be properly understood simply by looking at them. He would offer the viewer a sense of what it felt like to be in his garden, by means of a sensuous envelope of paint encircling a curved space which, in being so narrow, makes it difficult to stand back far enough to see these images as individual paintings. In doing so, the artist was effectively obliging the viewer to forgo their intellectual response and simply experience the environment the images created.

The Late Garden Series

At the end of the war, however, Monet was still far from certain which of the many images he was working on would be included in the final scheme, or even of the exact setting in which they would be seen. And at the same time, since the last months of the war, he had also been painting another set of images that had nothing to do with the large panels –

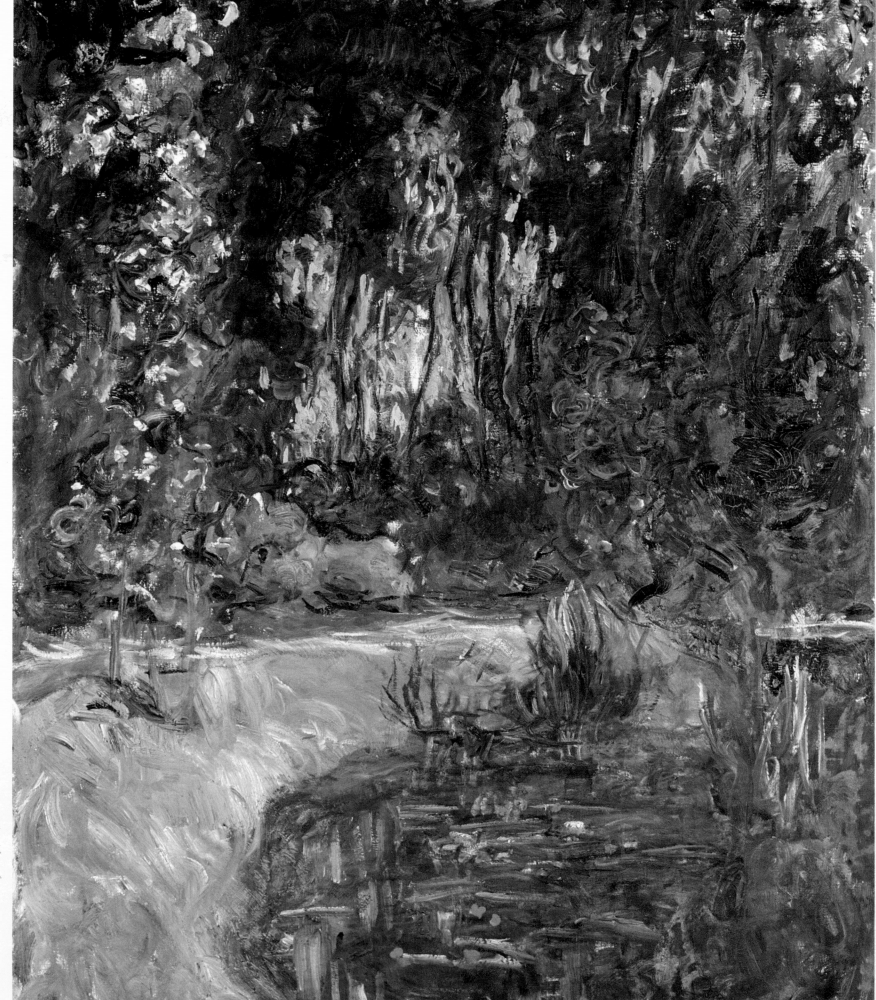

Garden of Giverny **(1923)**

pictures depicting motifs from his garden in two and eventually four discrete series whose approach seemed a radical departure from anything he had done before. The group of weeping willows from 1918 was followed by an extensive series of the Japanese bridge, now smothered in twisting wisteria, which featured in the first *Water Lilies* series of 1899–1900. Later on, two other motifs also possessed him: the rose arches over the Grand Allée leading from his house to the pond; and the house seen from the rose garden, the same motif he had painted in 1912 when he first became aware that his eyesight was failing.

A Crisis of Sight

Monet's sight had got a lot worse since then and by 1919 was appalling, giving him a level of anxiety that certainly contributed to the ferocious pace he kept up in those years, as well as the increasingly desperate reports he gave of his condition. 'I want to paint everything before my sight is completely gone,' he said, clearly realizing that time and his body were against him. Indeed, so unreliable was his eyesight that by 1920 this devoted recorder of nature's fugitive effects admitted that he was no longer able to work outdoors, telling one interlocutor that, rather than his observations, he painted from the impressions in his memory. By the following year, he was admitting with grim defiance and with a fair estimation of his own stature, 'I will paint almost blind, as Beethoven composed nearly deaf.'

Such determination was of little use. In spring 1922, at the age of 81, Monet had at long last signed an agreement with the State that committed him to a huge schedule of work, requiring him to deliver the finished murals by April 1924. But now he felt unable to continue, defeated by what he recognized was a serious visual impairment. He wrote to Clemenceau that his eyesight had dramatically deteriorated, to which the

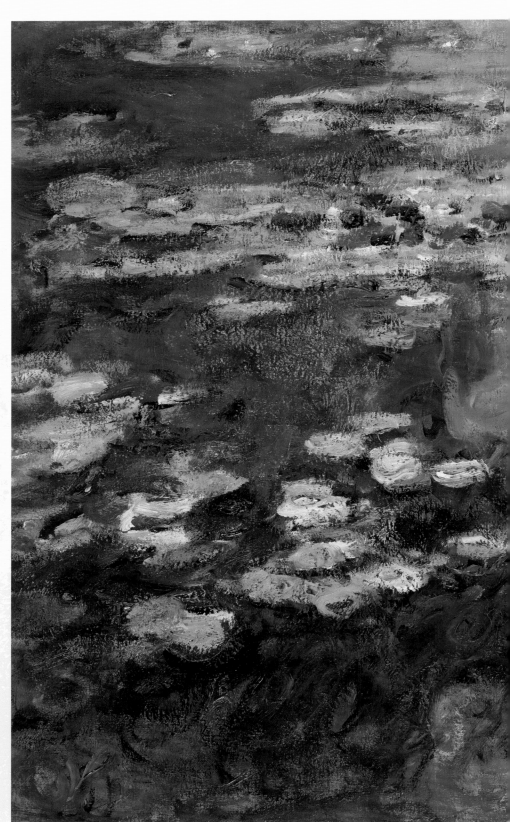

The Lily Pond (1917–19)

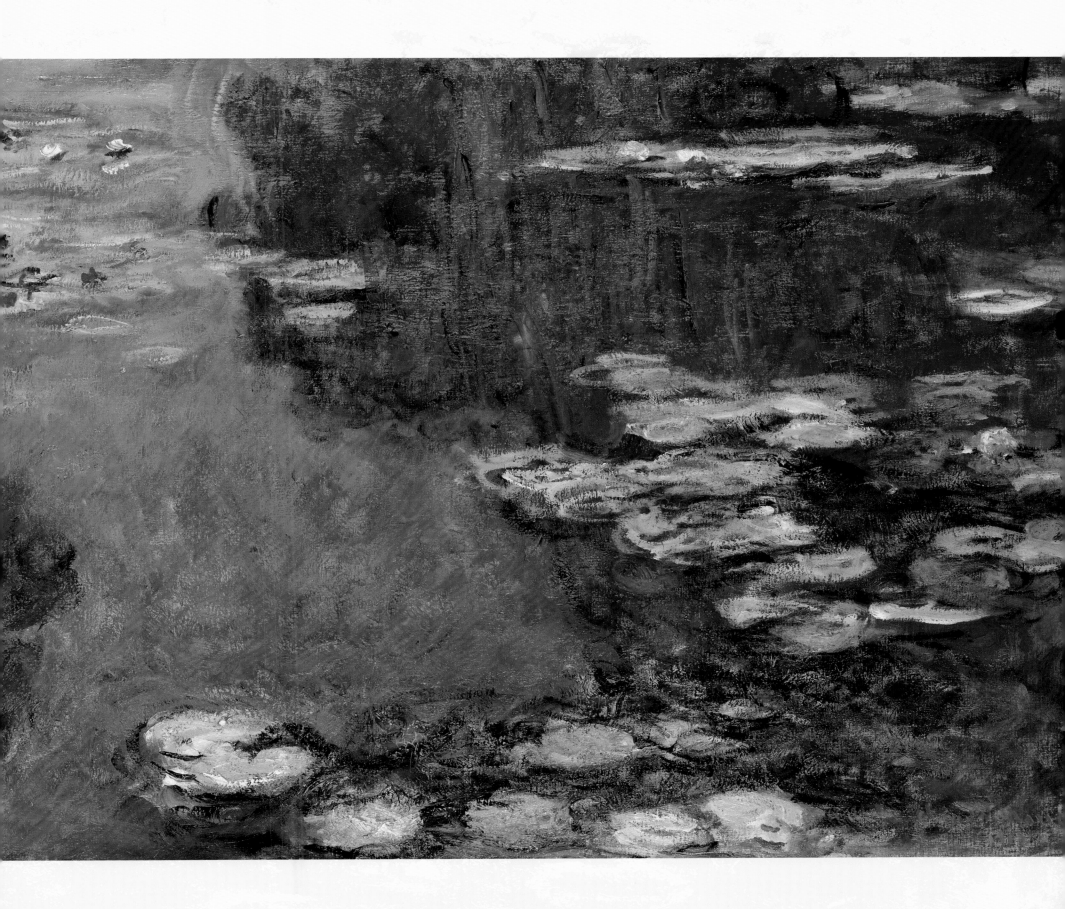

'I'd prefer to be blind and keep my memories of the beauties I've always seen....'

The Artist's House from the Rose Garden (1922–24)

former prime minister reacted angrily, reminding Monet of the written promise he had made to the nation. It made no difference to the physical facts as the condition worsened with alarming rapidity. By late summer, with his sight a complete fog and still under pressure from his friend, Monet had bowed to the inevitable and agreed to see an ophthalmologist. Dr Charles Coutela was a good friend of Clemenceau and saw the painter at once, but the diagnosis only confirmed medically what Monet already knew by experience: only 10 per cent of the vision in his left eye remained, while his right eye was completely blind.

The Dying of the Light

The garden paintings Monet had begun in 1918 seem at first glance to reflect his predicament. Indeed, such is the apparently expressionist chaos of these paintings – certainly without precedent in Monet's oeuvre – that it is tempting to see in them the expression of a private anguish, a rage against the literal dying of the light that marks them out explicitly as autobiographical works. But they were not so private that Monet refused to let any of them leave his studio. Indeed, he had sold one of the paintings of the Japanese bridge by as early as 1919, and would have sold more if their astonishing wildness of colour and gesture had not put off even his most loyal buyers. Moreover, the painter's career trajectory should make us ask why these hectic, supposedly more emotive images are necessarily more expressive of the inner man than any of the equally colourful but serene images of water lilies from the previous two decades, or indeed images of any of the other motifs he had tackled during the 1890s. Indeed, the great mural decorations upon which Monet was constantly working at the same time as these garden pictures – which nowhere exhibit the extremes of colour or texture that so characterize these paintings – have themselves come to epitomize the meditative serenity with which these garden images seem so at odds.

The Japanese Bridge (1923)

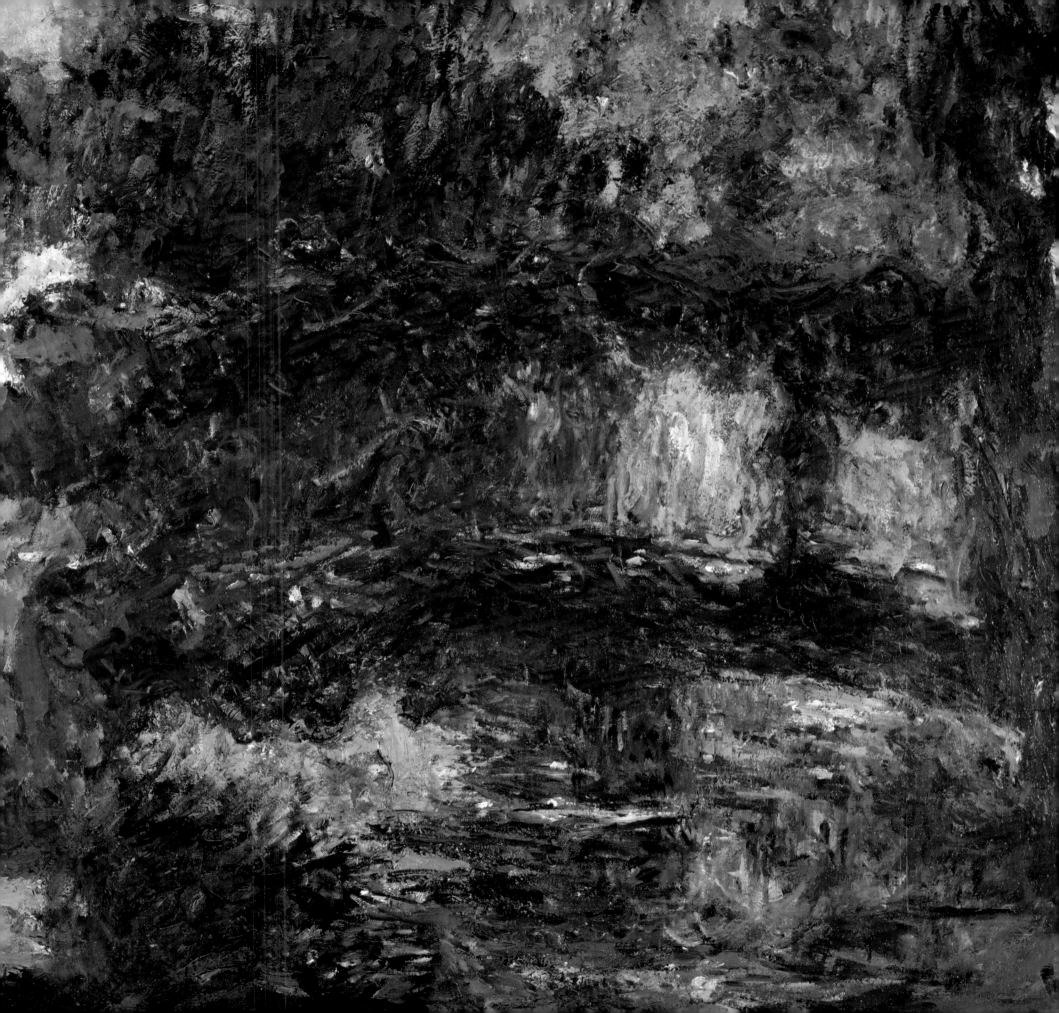

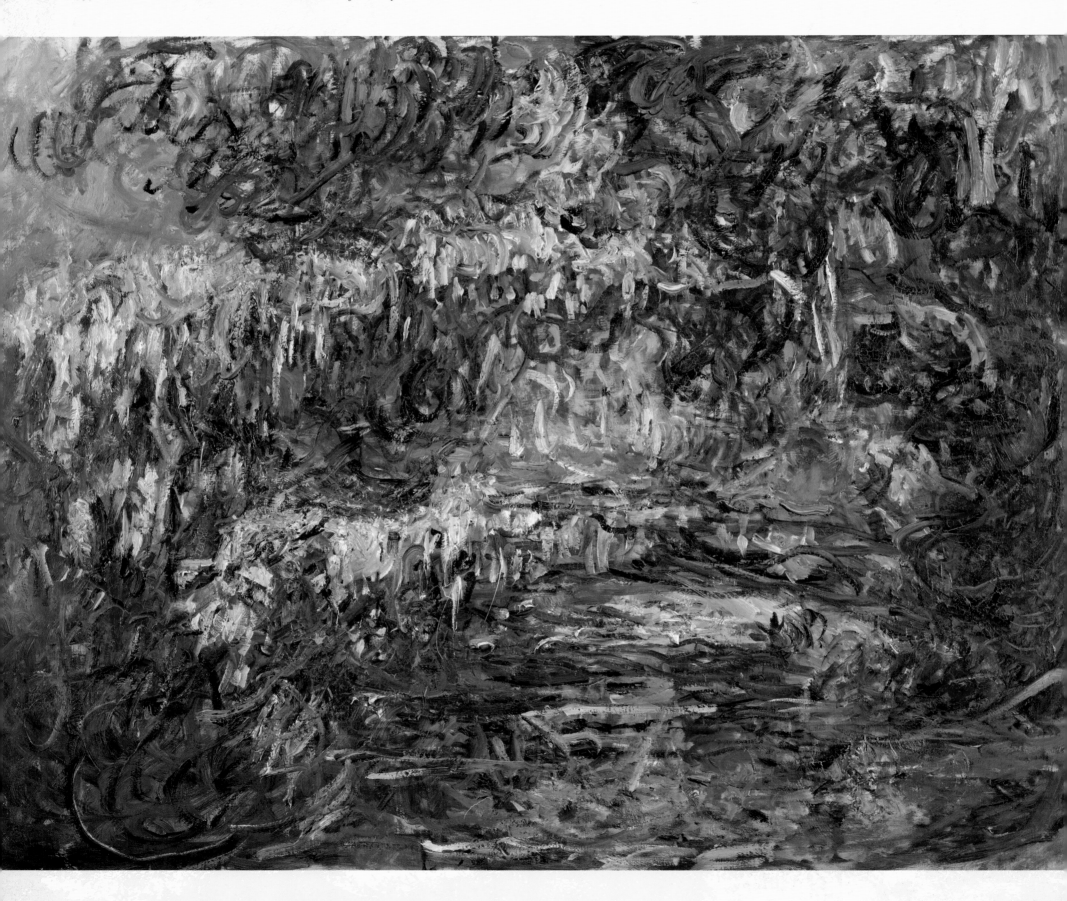

There is no doubt, however, that by the early 1920s, Monet's deteriorating eyesight was compromising his ability to assess his painting – including his ability to confidently assess colour values – with any accuracy, such that he would subsequently come to regret the revisions he made in 1922 to some of the large decorative panels. But given his habit of blithely destroying any images with which he was less than happy – a practice that continued until the last summer of his life – the fact that these extraordinary paintings remained in his studio at his death would tend to refute any suggestion that they were in some way aberrations he did not intend.

A Total Instability

So what is going on in these tumultuous paintings? What hidden information is Monet trying to communicate about himself or the world in which he lived? Are these panchromatic pictures of a convulsively unstable world the sign of a mind driven to distraction by the imminent loss of what to a painter is the one indispensable faculty; or are they instead another manifestation of an old obsession? Was his perception of the envelope, the binding agent of light and matter, now so attuned to 'the instability of a universe that changes constantly before our eyes' that such chronic instability had become an artistic strategy affecting every technical decision he made? Doesn't the immolating strangeness of these paintings, the sense of forms so fluid they are melting into their surroundings, follow quite naturally from the dissolving water landscapes of this and the previous decade? The envelope as a principle, as a fundamental idea of how the world is in essence, would certainly seem to point in that direction, though, of course, all interpretations are themselves unstable and incomplete. And, despite any continuities we may recognize with Monet's earlier work, the late garden paintings do stand out as by far the most dramatic, and thus the most puzzling, of his career.

Mystery

Monet's friend, the painter Theodore Robinson (1852–96), another American resident at Giverny in the last decade of the nineteenth century, later spoke of Monet admitting on one occasion that his underlying artistic goal was 'mystery', a word that was also used by friends such as Mirbeau and Geffroy in pieces they wrote on Monet's work. It is a quality his paintings share with those of many artists of his time, from Symbolists such as Odilon Redon (1840–1916) to Expressionists such as Edvard Munch (1863–1944), but in Monet's case the forms it took were neither otherworldly nor disturbing but linked to the observed miracles of everyday experience, the results of simple awareness of his surroundings. It was enough simply to observe the phenomena nature and light placed in front of him, to sit still and look and experience, and then to find a form by which to convey the character of what he had experienced. In this task the cropping of motifs he found in Japanese art was a tutelary strategy that finds its most radical expression in the doubly cropped willows in the three panels – *Water Lilies: Morning*, *The Two Willows* and *Morning with Weeping Willows* – that sweep around the walls of one of the rooms at the Musée de l'Orangerie.

The Layout of the Orangerie Panels

In fact, the final choice and layout of the panels is crucial to their overall effect, which leads us to ask why those panels and that arrangement were selected. The 22 panels are arranged almost equally over two rooms – 12 in one room, ten in the other – with the long curves of each ellipse containing a three-panel picture of the same width facing its partner image on the opposite wall. At the end of each ellipse, between doors connecting the two rooms, is a smaller wall space, while the other end of the ellipse is rounded off, though in the outer room (Room I) there are further doors leading to an

atrium, while in Room II the end wall curves around like the slightly flattened base of an egg. To this longest curve the widest painting, *The Two Willows*, is fixed, while on the two symmetrical curves of the ellipse it is framed, as we look at it, by the other two very similar willow paintings, *Water Lilies: Morning* and *Morning with Weeping Willows*, each about three-quarters of the width of *The Two Willows*. At the narrow end between the connecting doorways is the two-panel painting *Reflections of Trees*, roughly half the width of *The Two Willows*. In Room I, *The Clouds* and *Morning*, two paintings of identical width to the opposing pair of willow paintings in the inner room, span the long curving walls between *Green Reflections* at one end (identical in width with *Reflections of Trees* in the other room) and *Setting Sun*, the smallest painting, which sits between the doors leading out to the atrium.

A Deliberate Balance

The arrangement of the paintings is balanced and harmonious, with exact or near symmetries of size, composition, motif and colour held in tension by subtle variations. It is especially helpful to compare these panels with the paintings that did not make the final scheme, from which we get a clearer idea of the balance of drama and pattern, description and decoration, movement and stasis Monet achieved in choosing the arrangement he did. There are dramatic contrasts between some of the panels occupying the same room, but these are used to create the sense of balance and harmony and unity of mood that traditionally characterized decorated interiors of the past. Above all, when judged against the intensity of colour in the late garden paintings, the colour of the *Grandes Décorations* is largely naturalistic, though subdued, 'lovingly nuanced, as delicate as a dream'; there are even, in the case of the willow trunks, elements of a structural clarity which had not been a feature of Monet's work since the first series of *Water Lilies* at the turn of the century. But these factors are balanced against the vague, amorphous obscurity of

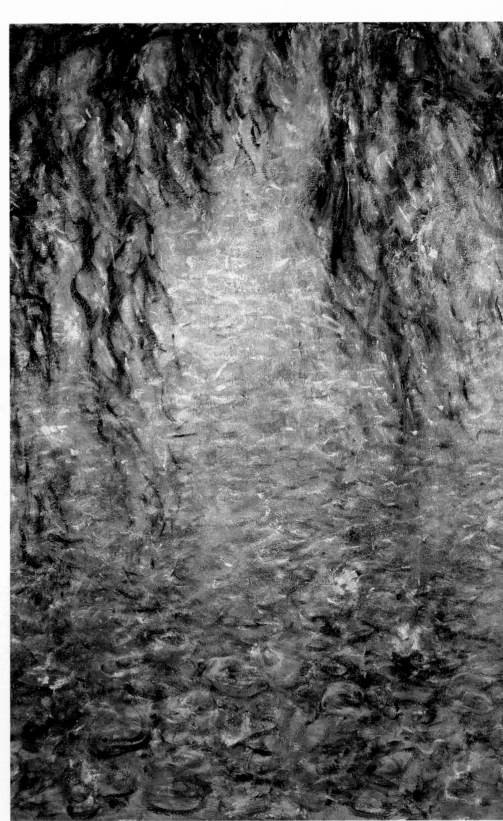

Morning with Weeping Willows (1914–26), detail of right section

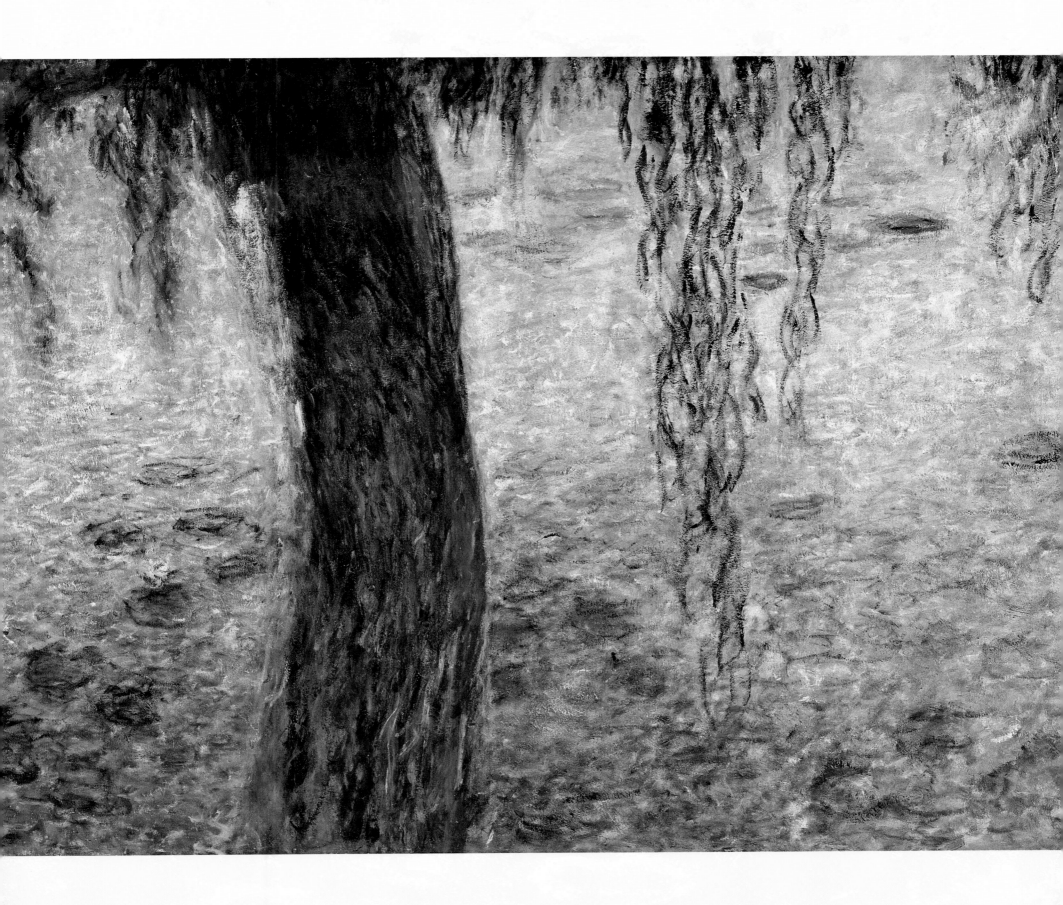

'Now I'm almost blind and I'm having to abandon work altogether.'

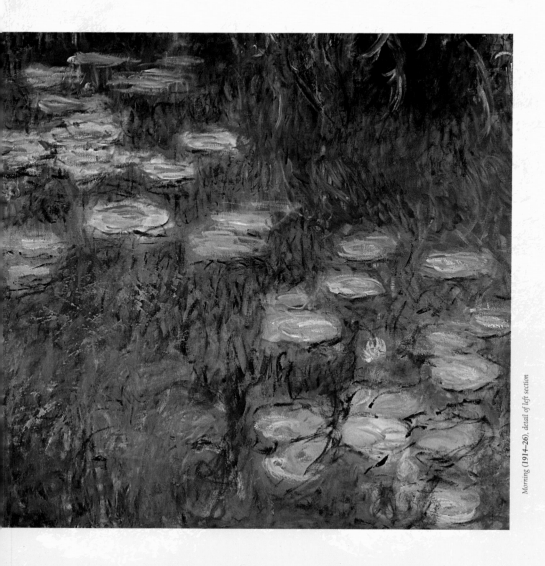

Morning (1914–26), detail of left section

Reflections of Trees, while in the other room the delicate blues and lilacs of *Morning* and *The Clouds* are set beside the nocturnal solemnity of *Green Reflections* and the blazing twilight colours of *Setting Sun*. Every image is a depiction of reflections in water; collectively, they project the complexity of illuminations Monet had explored in the series paintings. However, they are more than a mere summation of the perceptual discoveries he had made over the course of his life. The world they depict is the surface of a pond at different times of the day but the surface is myriad in character, as if some influence other than the fruits of observation was being brought to bear upon each individual image and on the whole ensemble.

By the time these paintings were underway, of course, Monet's deteriorating eyesight made observation of nature incredibly difficult. Forced to paint from memory, and drawing from a lifetime of recollected looking, his gaze has turned inwards, the cropped trees appearing as if glimpsed through the misted lens of a dream: half-glimpsed images, half-remembered and half-imagined in the space between sleeping and wakefulness, between blindness and sight, between life and death.

Under the Knife

In late 1922, the point at which Monet found he could no longer paint at all, the mural decorations were far from finished. Seeing that he had no choice if he hoped to fulfil his promise and realize his final ambition, in the new year, the painter reluctantly agreed to let Coutela operate on his right eye. In fact, two operations were carried out before the end of January, and he was back at home by late the following month; then a third operation was carried out in June. These interventions appeared to have been successful in restoring vision to his right eye, but Monet was distressed at the results, saying that although he could now read a bit, he could not see either in

The Water Lily Pond (1917–19)

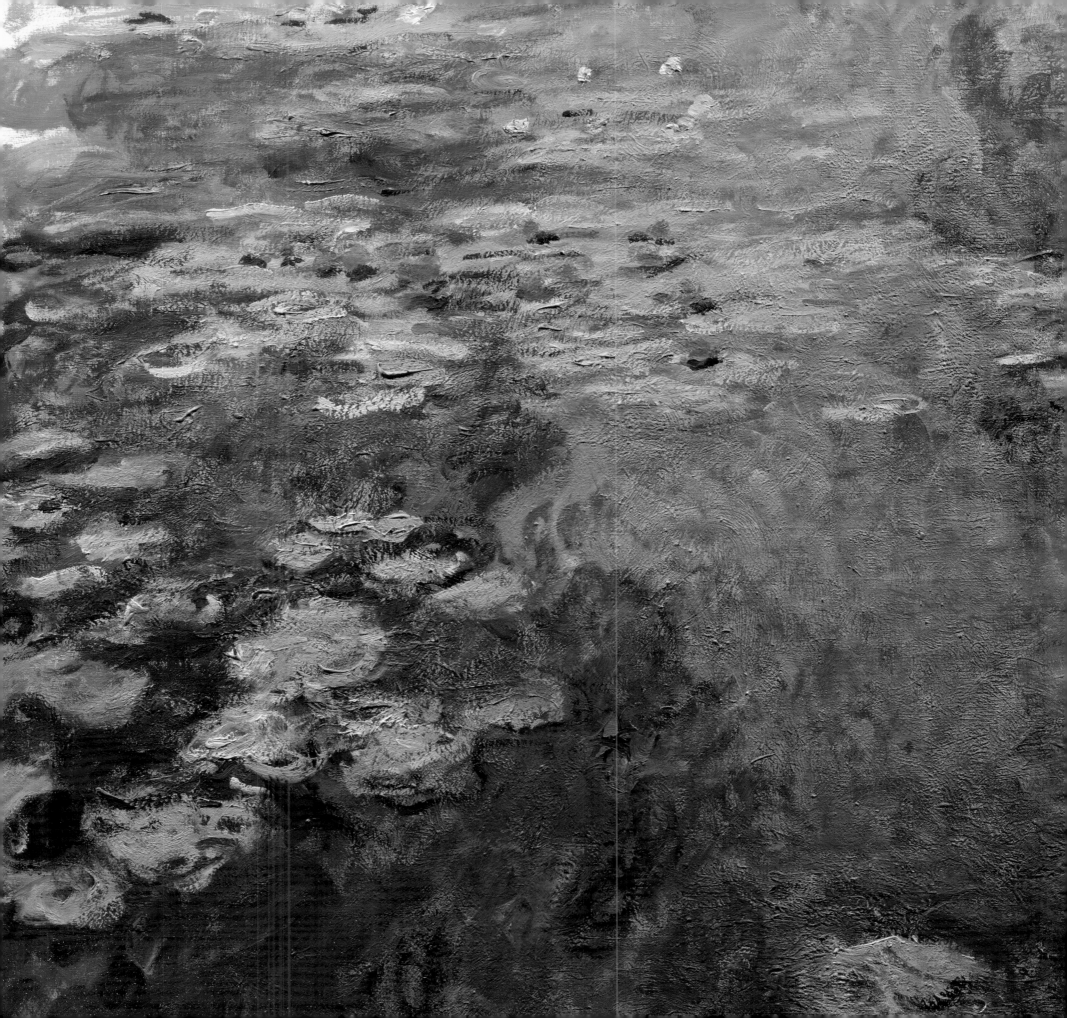

daylight or at any distance, and his field of vision was 'plagued by black specks'. The spectacles Coutela had provided were also largely ineffective, and to make matters worse, Monet was soon diagnosed with xanthopsia, a perceptual imbalance which caused everything he looked at to be strongly tinged with yellow. For Monet, this was obviously intolerable. He had once said he would like to have been born blind and 'to paint like a blind man who has been given his sight'. Now he wrote to Clemenceau that he would 'prefer to be blind and keep my memories of the beauties I've always seen'.

Distortions

The xanthopsia gradually diminished, only to be replaced by cyanopsia, which turned the yellow bias into a blue one. All the while, his left eye continued to get worse, but Monet refused another operation and, resolving instead to do battle with these distortions, went back to work. Naturally, he struggled to cope, unable to have any confidence in the adjustments he was making to compensate for the continuing aberrations in his vision. By now the building was ready, but the April deadline agreed in the contract came and went, forcing Clemenceau to use all his influence to secure an extension. Then in October 1924 Monet, still experiencing distortions of colour, told his friend once again that he would not be able to keep his promise.

The former war leader was incensed but Monet was adamant, and in early 1925 he wrote to Paul Léon, the Minister of Fine Arts, of his decision to withdraw from the contract. This time, in his furious reaction, Clemenceau not only exhorted Monet to remember his pledge to the nation but even threatened to end their friendship if the painter did not resume the work. Perhaps he feared the damage it would do to his own reputation should what detractors may have seen as an expensive vanity

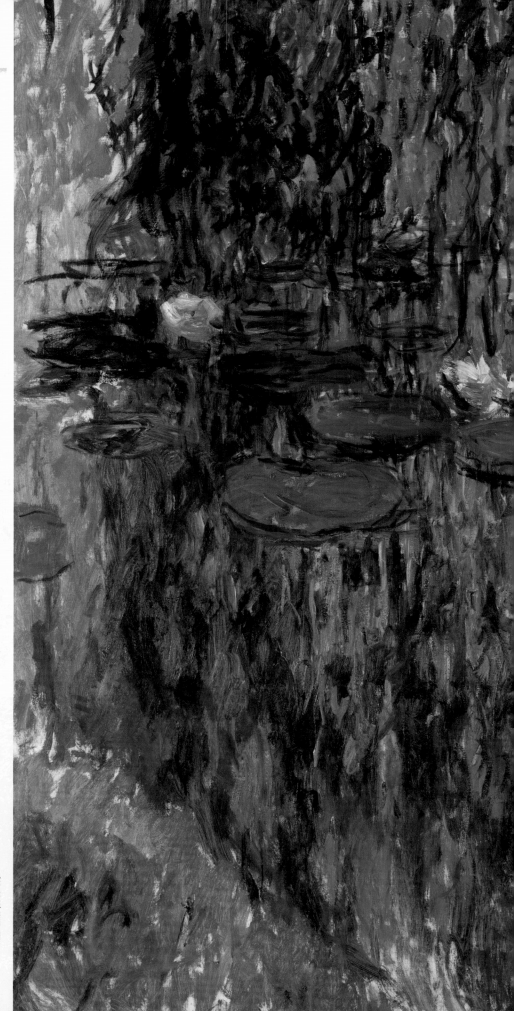

Water Lilies (1916–19)

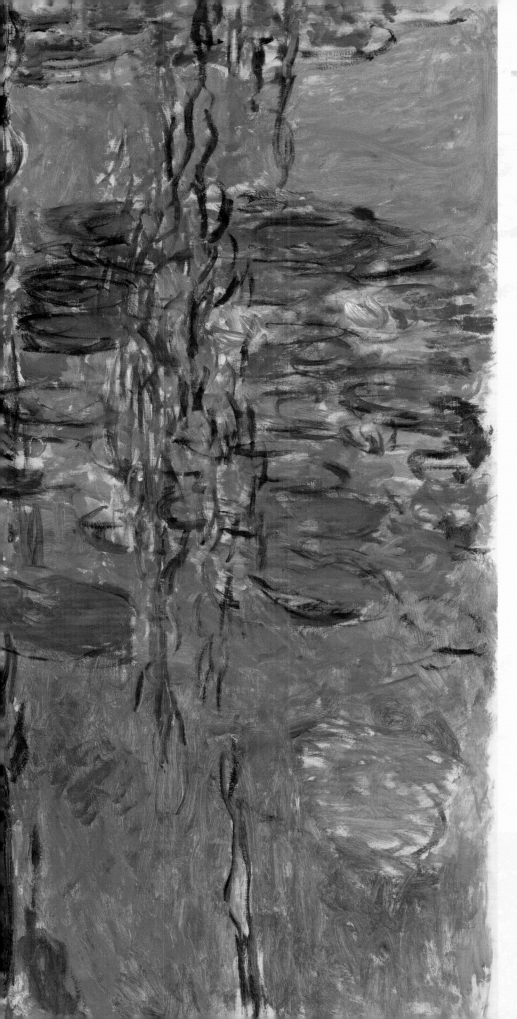

project ultimately fail to materialize. Or perhaps, ignoring Monet's protestations, the great French leader and even better friend was in a good position to judge both the painter's real capacity and the kind of response he needed to motivate himself one final time. It was a cruel strategy but it worked, though not without some assistance from the latest technology.

The Meaning of Experience

In spring 1925 the painter André Barbier (1883–1970) drew Monet's attention to a new German lens, made by Zeiss. The painter told his latest oculist, Dr Jacques Mawas, that he now painted by the colour of the tubes as indicated, relying on his internal recall of the qualities of those colours rather than the evidence of his eyes. 'I know that red and yellow are on my palette,' he said, 'and a special green and a certain violet. I cannot see them as I used to, and yet I remember exactly what colours they used to make.' Monet was coping, falling back on memories not only of his chosen motifs but of the basic materials used to depict them. Obviously, such a situation was far from ideal.

Painting now from memory, Monet relied on experience, which as a *plein air* painter he had always valued above all other qualities. But the meaning of the word 'experience' had changed over time, from the sense of a momentary impression we intuit from a work like *Bathers at La Grenouillère* of 1869 to the meditated series of moments that characterize the series paintings of the 1890s, to what in the *Grandes Décorations* becomes a comingling of accreted moments collectively weighed in the balance and apparently understood at last. The light in these late images is dim and dreamlike, its qualities remembered more than observed. We might even describe it as the light of wisdom. It is an idea that Monet may not have entirely dismissed.

Vision Restored

In April 1925, realizing the painter's eagerness to get back to work, Mawas quickly procured the new Zeiss lenses, first adjusting the prescription to deal with the cyanopsia and then simply covering the inhibiting left eye with a black disc. The result was a dramatic improvement that reinvigorated Monet's appetite for work. Equipped with better spectacles, which he claimed had totally restored his sight, the painter felt sufficiently rejuvenated by the improvement in his good right eye to make one final effort. Even the death of Marthe Hoschedé-Butler in May that year (the second Hoschedé spouse to predecease the unfortunate Theodore Butler) did not deflect him from his goal. He barrelled on again, fully confident that he would, after all, complete this Herculean scheme. His left eye continued to deteriorate, distorting his perception of depth and all but destroying his distance vision; he was no longer able to step back at all to view his work and yet by now must have been able to judge effects without needing to, as these giant panels, which can seem so dense with colour and texture when viewed at close quarters, do indeed resolve themselves as globally coherent worlds when seen standing back as far as the space allows. And at stages in between, new realities – new arrangements of pictorial facts – assert themselves, the two-dimensional surface revealing a multitude of meanings which only the viewer is in a position to activate as they approach or withdraw from the image. Reality, as viewed in these paintings, is not singular, but reflects 'the instability of a universe that changes constantly before our eyes', above all, according to the mutable nature of consciousness itself.

A Question of Scale

In fact, the scale of the *Grandes Décorations* is of an order of magnitude Monet had not attempted since early bravura paintings like the unfinished *Déjeuner sur l'herbe* (1865–66) – in that instance, not the product of vision, which back then had yet to grow, but of vaulting ambition, the desire to pit his talent

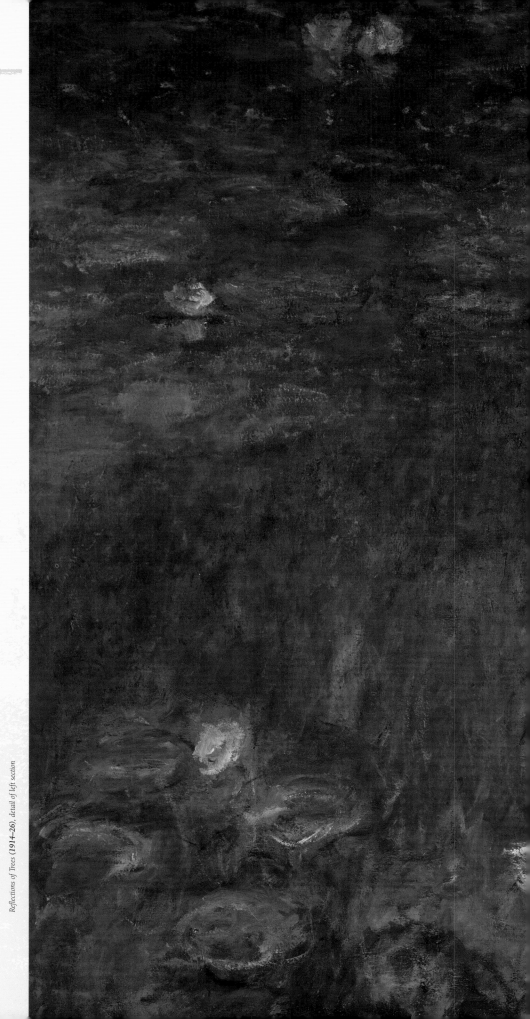

Reflections of Trees (1914–26), detail of left section

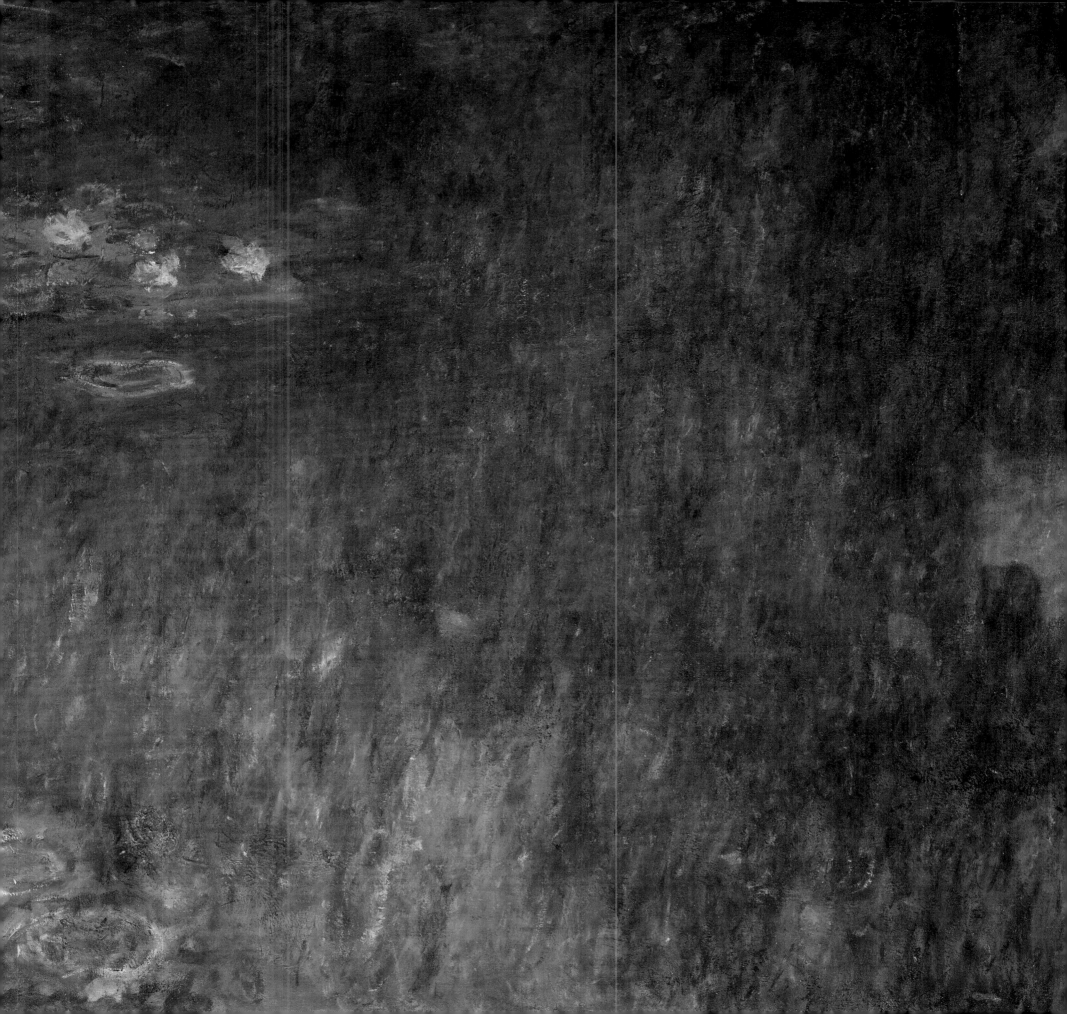

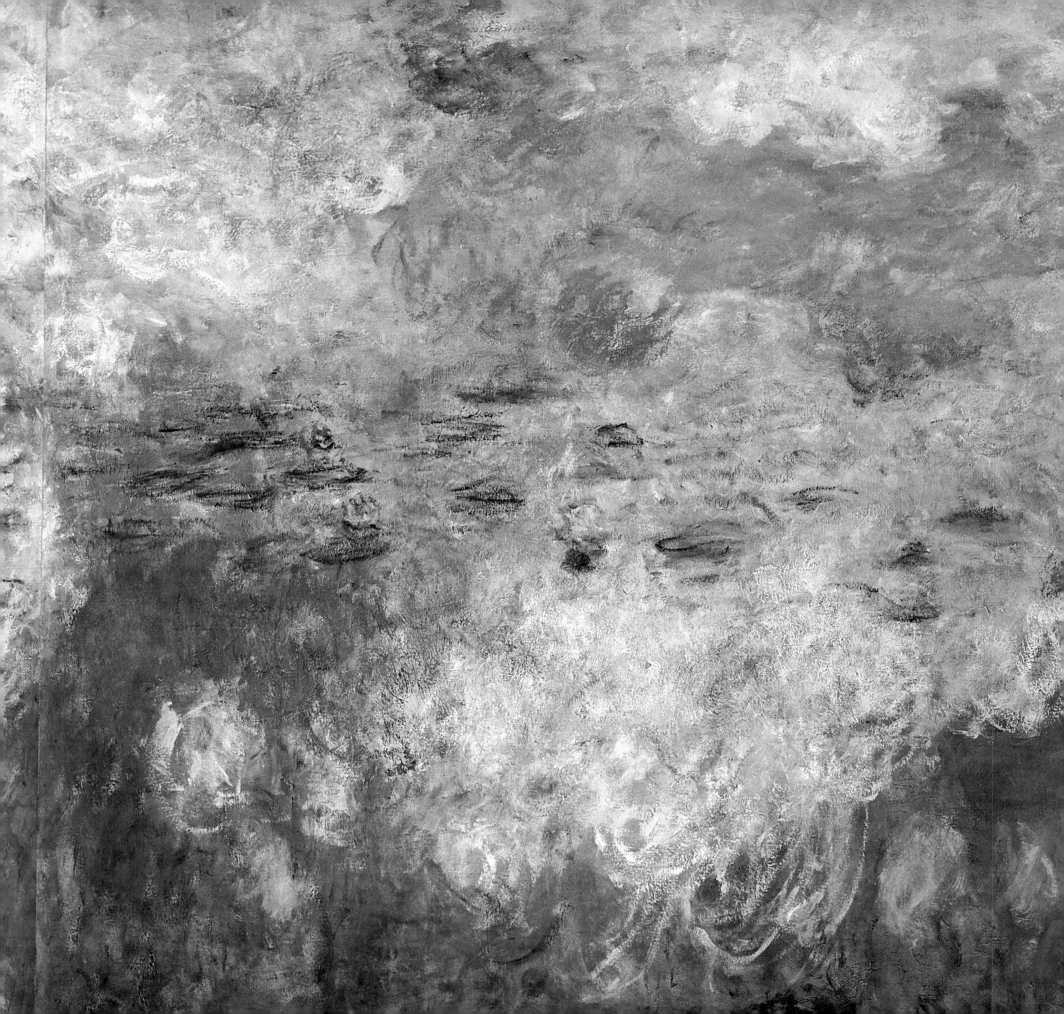

against the obvious example of Manet. In this sense of scale, the *Grandes Décorations* close a circle whose arc the intervening six decades had been steadily tracing. During that lifetime of looking and labour, Monet had produced mostly pictures which deliberately avoided the monumental – partly the result of the portable demands of *plein-air* painting and partly out of a need to make pictures that would sell; but also perhaps because the grand exhibition picture was an aesthetic convention he was trying to avoid. In turning again to pictures of such size, Monet was bringing a lifetime of observation and learned aesthetic priorities to what is perhaps the most complex realization of his fundamental impulse to lend dignity to the everyday – making something truly monumental out of a few ordinary patches of lilies in a common or garden pond; seeing a world in a grain of sand.

The Final Winter

By now, this final obsession was occupying Monet's every waking moment. As he told a journalist in 1925, 'I no longer sleep because of it. At night I do not cease to be haunted by what I am attempting to realize. Each morning I arise broken with fatigue. The dawning day gives me courage. But my anxiety is born anew as soon as I set foot in my studio.' But it was more than just his duty that drove him to complete the panels; it was an urgent need to finish this last and greatest statement, to complete this series of giant fragments of a seemingly endless whole.

Monet estimated delivery in the spring, informing Clemenceau in February 1926 that he was only waiting for the paint to dry. When on 4 April his friend Geffroy died, the panels were ostensibly finished and ready to be shipped, though it was obvious to everyone that the painter did not want to let them go, so attached was he to this final great world he had created – one which seemed at last to unite the two worlds that meant most to him: his garden at Giverny and his art. That summer he spent time simply sitting

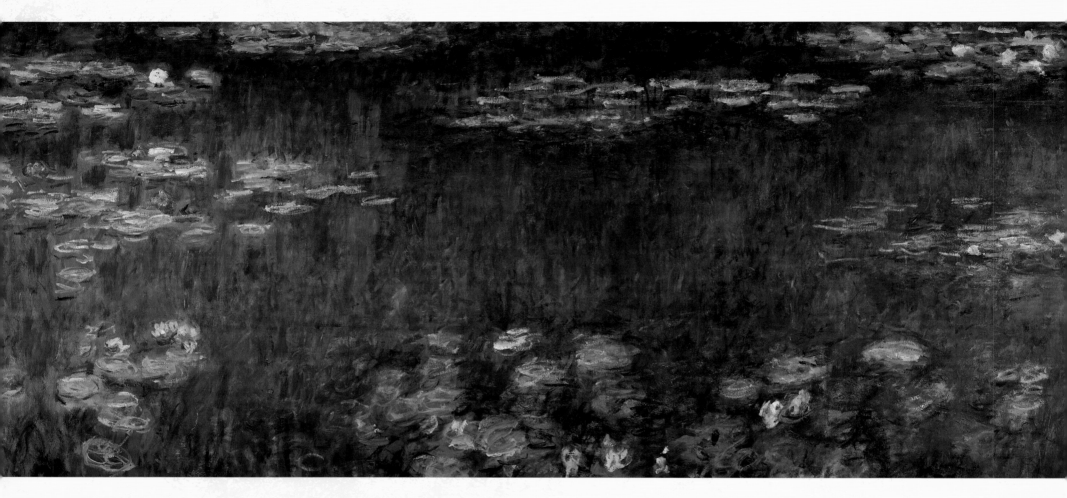

by his pond, just as he appears in the photograph (*see* p. 6), no doubt contemplating his achievements, among the greatest of which was the garden itself. As he had told one of the many interviewers that beat a path to Giverny in the final years of his life, 'My garden is a slow work, pursued with love. I do not deny that I am proud of it.' Indeed, Monet never tired of taking visitors on a tour of his domain as the numerous photographs taken in these final years, showing the artist with assorted guests, bear witness.

Sickness and Death

Then in late August, two months after receiving the terminal diagnosis he had probably suspected for some time, with Blanche's help Monet

destroyed by his own reckoning some 60 canvases he felt were not up to scratch, although as late as October he was still touching up several more. By November he was too weak to leave his bed, though he still received regular visits from Clemenceau, his closest friend in these final years. They talked about gardening, with Monet on one occasion expressing his delight at a shipment of Japanese lily bulbs he had just received. He must have realized that he would not be alive to see them bloom, just as he knew that they would do so whether or not he was.

Monet died of pulmonary sclerosis on 5 December 1926. Following his express wish, the funeral was simple, with a mere 50 mourners in attendance – family and close friends such as faithful old Clemenceau.

Green Reflections **(1914–26)**

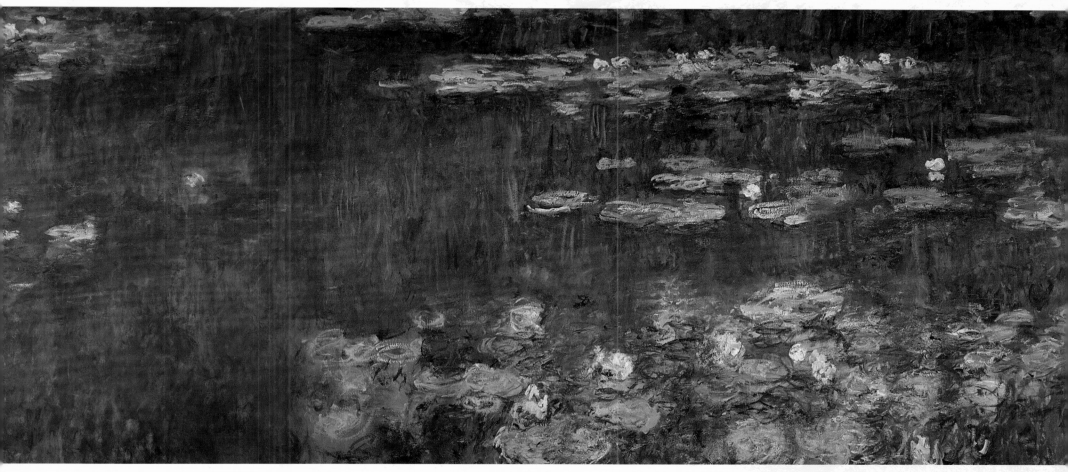

There was no religious service and there were no wreaths or flowers, which Monet saw as 'vain honours', having explicitly stated shortly before his death what a 'sacrilege' it would be 'to plunder the flowers of my garden for an occasion such as this'. His gardeners acted as pallbearers, carrying the coffin to its last resting place in the Hoschedé family tomb, next to Alice, her first husband Ernest and her daughters Suzanne and Marthe, as well as Monet's own son, Jean. He had outlived them all, as he had all those with whom he had sparred and conspired in art: Manet, Caillebotte, Morisot, Sisley, Pissarro, Cézanne, Degas and Renoir. But art, like nature, would continue all the same: Bonnard, who lived in nearby Vernnonet, and Vuillard, both good friends and younger admirers in those final years, were present that day. The only tribute was a sheaf of wheat atop the simple wooden coffin.

Installation of the Panels

Later that same month, the 22 panels selected for the Orangerie were taken from the studio and the following spring installed in their permanent home, glued directly on to the walls of the elliptical rooms and illuminated mainly by diffused natural light. The first reviews of the new museum, in May 1927, were divided along generational lines. The *Grandes Décorations* were predictably lauded by the older members of the press and positively venerated by Clemenceau in a book on the murals that he published the following year. The younger critics, on the other hand, were scathing, dismissing them by turning the concept of the work invariably

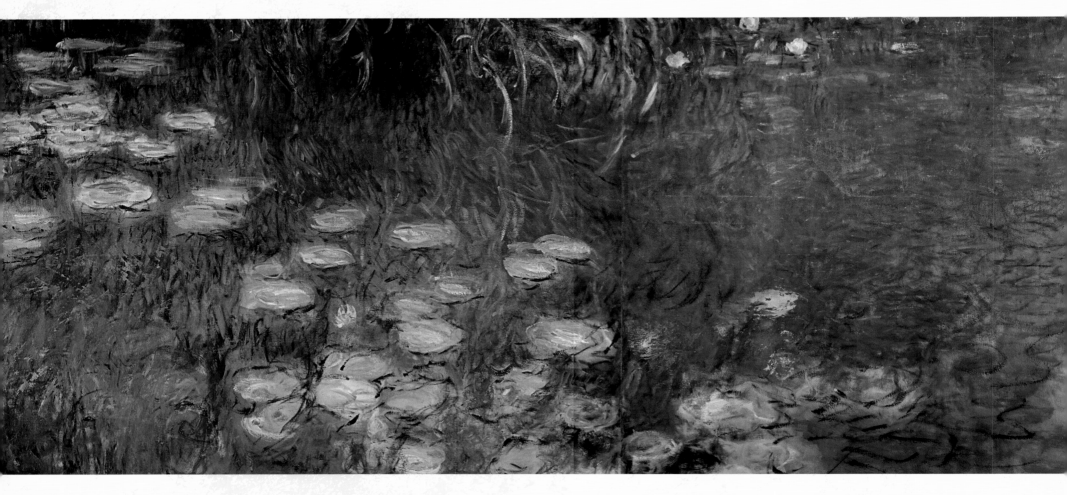

back on its maker. For them, decorations, especially on this scale in this new age of clean, bright spaces, industrial efficiency and anti-individualism, had connotations of a 'theatre set' or, most damning of all, 'wallpaper'. Such supposedly visionary schemes seemed offensively pretentious and infinitely mockable in a cultural climate that viewed the subjective aesthetic Monet's work epitomized as the root of the egotism and complacency that had seen the Continent sleepwalk into the worst of all wars. It was wholly unjust, but in many ways an unexceptional form of cultural patricide such as frequently happens to even the greatest masters in the years that follow their deaths. In this case, the *Grandes Décorations* were forgotten, languishing in what must have seemed like a mausoleum throughout the 1930s, unvisited even by those drawn to the other great

art treasures of the French capital. Worse still, the roof leaked, and then the building, including some of the panels, was damaged by the Allied bombing of Paris as the American troops advanced on the city in the summer of 1944.

The Sistine Chapel of Impressionism

After the war, as the Monet-Hoschedé family pressured the government to restore the building, the murals at last began to find their place in the public mind. Especially important was an article published in 1952 by an unlikely champion, the surrealist artist André Masson (1896–1987). Entitled 'Monet le fondateur' ('Monet the Founder'), Masson proclaimed the Orangerie as the

Morning (1914–26)

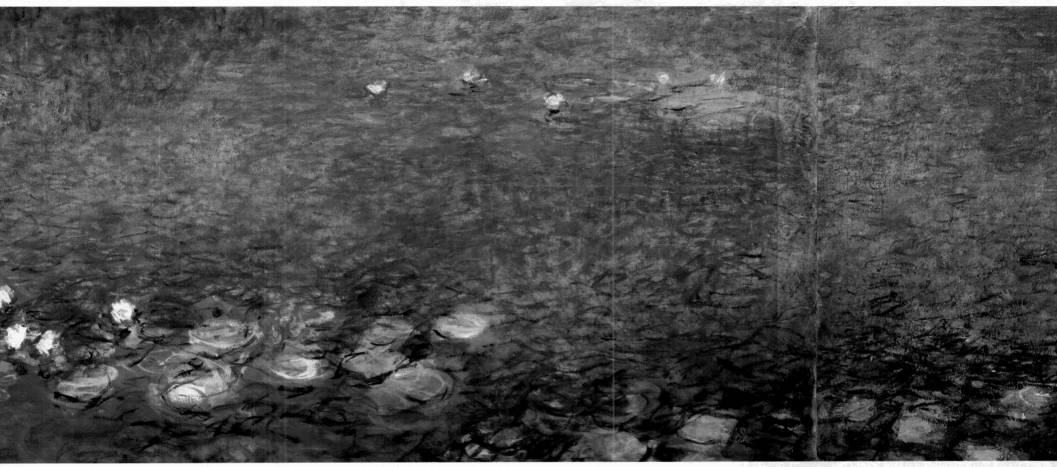

'Sistine Chapel of Impressionism', an idea that chimed with many as the reputation of the late works continued to rise throughout the decade.

How strange it is that works which in the aftermath of one terrible war were seen as decadent, as epitomizing all that had been wrong with the society from which they had emerged, would in the wake of the next be reimagined in terms that could not be more different. Such extremes of interpretation are probably to be expected with paintings whose meaning is so unfathomable and ambiguous being so legion, so vast. In the last years of his life, Monet is reported to have replied with evident bluntness to an unknown remark made by Clemenceau, saying, 'Your error is to wish to reduce the world to your measure, whereas, by enlarging your knowledge of things, you will find your knowledge of self enlarged.' It is cautionary advice that, if heeded, should hold at bay any attempt to interpret these paintings once and for all.

Renovations

Finally, the French State stepped in to renovate both the building and the paintings, two of which still had fragments of war shrapnel embedded in the canvas. In July 1978, the *Grandes Décorations*, newly cleaned and restored in a building which had also been modernized, were reopened to the public, since when they have risen steadily to the status of modern icons they enjoy today. At the same time, the house and garden at Giverny, where Monet's

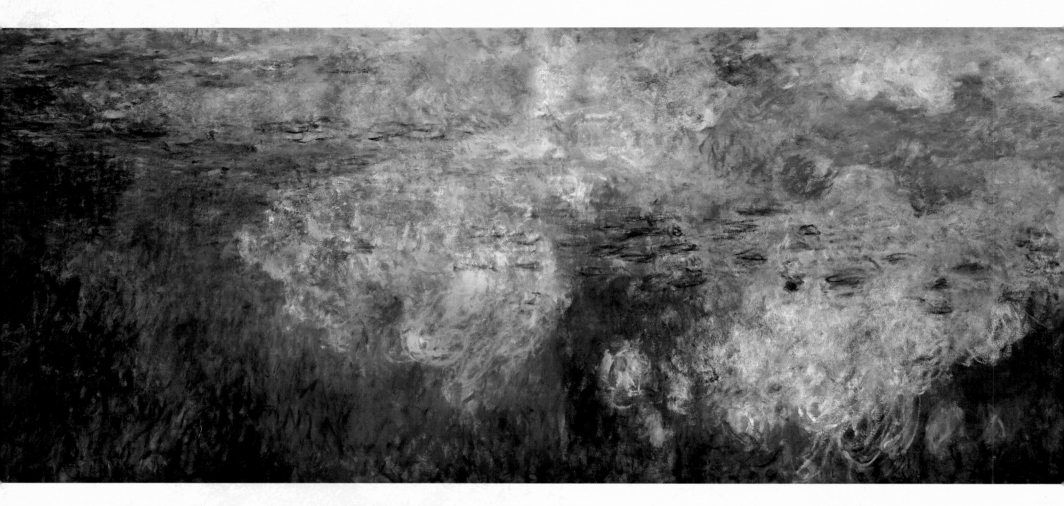

younger son Michel had continued to live until his death in a motoring accident in 1966, had also fallen into disrepair, the garden having gone completely to seed. After an equally extensive effort to renovate a legacy which had been left to the State, the house and garden, restored largely in the end through donations from wealthy American benefactors, were opened to the public in 1980 and now attract some half a million visitors every year.

Monet's Legacy

The power of the late paintings is no longer disputed, but following Masson's article, recognition of that power in the first instance came, quite naturally, from the US, whose art collectors in the mid-1880s had probably saved

Monet's career, just as a century later they saved Giverny. Europe had been a tired, disillusioned and still deeply troubled continent in the interwar years, but history was proving the doubters wrong. Once the huge number of unsold late works began to emerge from Monet's studio in the early 1950s, where they had lain unnoticed for some three decades, it was predominantly American museums that grabbed with both hands any images that became available. American collections already held the largest stock of Monet's work outside France, and the same institutions now acquired some of the finest among the 22 large panels that had not been selected for the Orangerie. American reverence for the natural world, which is part of the country's founding myth, made them easily comprehensible for a public by then used to seeing the fruits of Abstract Expressionism and Colour Field painting.

The Clouds (1914–26)

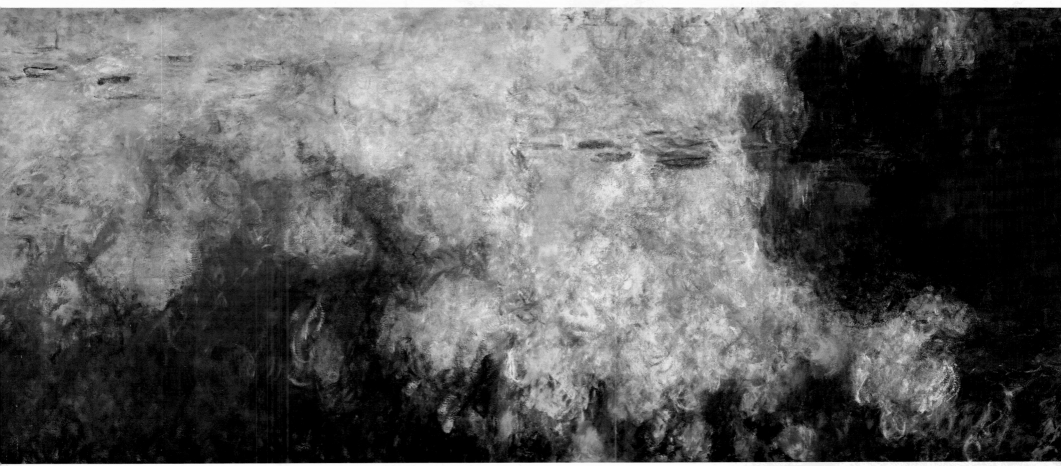

In that light, Monet's late works and aesthetic concerns appear not only timelessly contemporary but seem to anticipate the work of numerous artists of the second half of the twentieth century, as well as, in the case of the *Grandes Décorations*, the immersive aesthetic of so much contemporary art. For instance, how can we make sense of the *Rothko Chapel* (dedicated in 1971) without Monet's example? And doesn't the patterned interaction with the earth that we see in the work of Land artists such as Robert Smithson (1938–73) and Richard Long (b. 1945) find its echo in Monet's devoted surfaces? Further, an artist such as James Turrell (b. 1943), given his lifelong fascination with how we experience light, is surely pursuing aesthetic questions that preoccupied Monet for most of his life.

Above all, in a similar way to the work of those other artists mentioned, Monet's late paintings allow modern people, many of them non-believers like him, the vital experience of reverence and awe – a sense of being part of something that is so much larger than ourselves – in a world that tends to crush such fundamental needs beneath the heel of economic necessity.

Towards the end of his life, to one of the many journalists who came to interview him, he said, 'All I did was to look at what the universe showed me, to let my brush bear witness to it.' Once again, Monet reminds us of the nature of his mission: bearing witness not to the world but to the universe as he found it in his garden at Giverny, in the fleeting reflections of light on the surface of a pond.

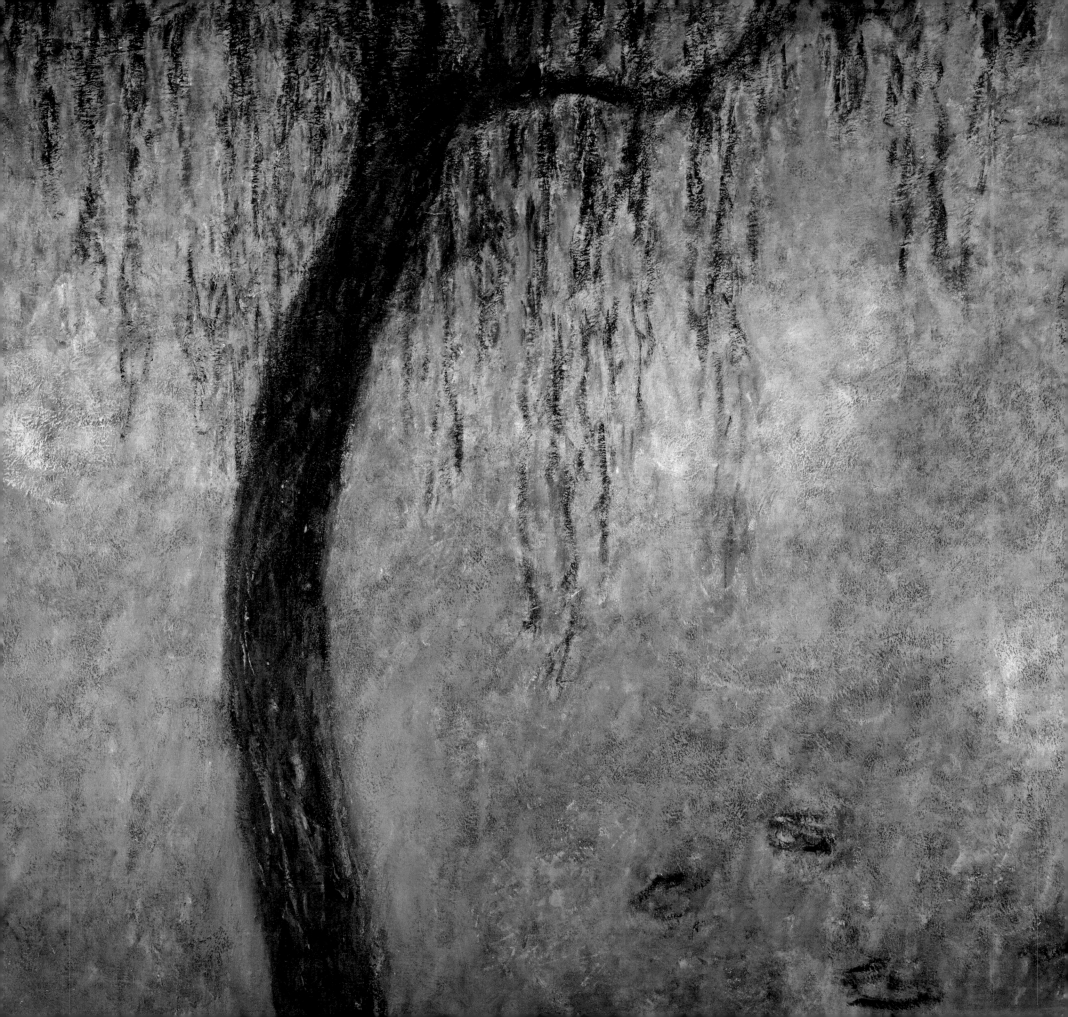